The Copyright Zone

If you license or publish images, this guide is as indispensable as your camera. It provides specific information on the legal rights of photographers, illustrators and artists, covering intellectual property, copyright, and business concerns in an easy-to-read, accessible manner. *The Copyright Zone*, Second Edition (originally published as *The Photographer's Survival Manual*) covers:

- what is and isn't copyrightable
- copyright registration
- fair use
- model releases
- contracts and invoices
- pricing and negotiation, and much more.

Presented in a fun and easy to digest style, Jack Reznicki and Ed Greenberg J.D., LLC help explain the need-to-know facts of the confusing world of legal jargon and technicalities through real world case studies, personal asides, and the clear writing style that has made their blog thecopyrightzone.com and monthly column by the same name in *Photoshop User* magazine two industry favorites.

The second edition of this well-reviewed text has almost doubled in size to ensure that every legal issue you need to know about as a photographer or artist is covered and enjoyable to learn!

Ed Greenberg, practicing litigator in New York City for over thirty years, has represented some of the top photographers and illustrators in the business as well as the average Joes and Janes striving to make a name for themselves. He has been on the faculty and a guest lecturer in the Master's Program in Digital Photography at The School of Visual Arts in New York and has lectured nationwide on photographers', artists' and models' rights on behalf of NAPP, PPA, APA and EP.

Jack Reznicki is an internationally renowned commercial people and children photographer based in New York City. Jack's creative problem solving has helped promote products and services for many companies such as Toys "R" Us, Tylenol, *The Wall Street Journal*, Hyatt, Kodak, *Reader's Digest*, Crest, AT&T, Playtex, and several *Time Magazine* covers.

"I love these guys and their straightforward and straight talking way of explaining complicated and important issues to photographers and artists. This book is a must read for any serious creative person."

Scott Kelby, President and CEO of KelbyOne

"Ed's sense of moral outrage at corporate theft of an artist's work is, I believe, the backbone of how effective Ed is at what he does. The man is relentless. It's rare that you feel in completely safe hands with your lawyer, but Ed is one of them. With Ed on my side, I pity – but only slightly – the lawyers on the other side trying to defend their corporate clients who have cynically stolen artists' work to be used for their own profit."

Nick Brandt, fine art photographer

"Talent and passion are only part of being a successful photographer— understanding your rights and how to protect your image is the essential other part. Buy this book – you need it!"

Katrin Eismann, Chair, MPS Digital Photography Department, School of Visual Arts

"In an ever-changing cultural and business environment, the smartest thing any creative person can do to protect him or herself is to become armed with the best, most up-to-date and accurate information possible. This clearly written and concise manual will be every creative's best friend."

Anita Kunz, Society of Illustrators; Officer, Order of Canada

The Copyright Zone

A Legal Guide For Photographers and Artists In The Digital Age

SECOND EDITION

**EDWARD C. GREENBERG, J.D.
AND JACK REZNICKI**

Focal Press
Taylor & Francis Group

NEW YORK AND LONDON

First published 2010 by Lark Books

This edition published 2015
by Focal Press
70 Blanchard Road, Suite 402, Burlington, MA 01803

Simultaneously published in the UK
by Focal Press
2 Park Square, Milton Park, Abingdon, Oxon OX14 4RN

Focal Press is an imprint of the Taylor & Francis Group, an informa business

Notices
Knowledge and best practice in this field are constantly changing. As new research and experience broaden our understanding, changes in research methods, professional practices, or medical treatment may become necessary.

Practitioners and researchers must always rely on their own experience and knowledge in evaluating and using any information, methods, compounds, or experiments described herein. In using such information or methods they should be mindful of their own safety and the safety of others, including parties for whom they have a professional responsibility.

Product or corporate names may be trademarks or registered trademarks, and are used only for identification and explanation without intent to infringe.

Library of Congress Cataloging-in-Publication Data
Greenberg, Ed, 1953– author.
 [Photographer's survival manual]
 The copyright zone: a legal guide for photographers and artists in the digital age/
 Edward C. Greenberg, J.D. and Jack Reznicki. — Second edition.
 p. cm.
 ISBN 978-1-138-02257-7 (pbk.) — ISBN 978-1-315-77701-6 (ebook) 1. Photography—Law and legislation—
 United States. 2. Copyright—Photographs—United States. 3. Artists' contracts—United States. I. Reznicki,
 Jack, author. II. Title.
 KF2042.P45G74 2015
 346.7304'82–dc23
 2014029449

ISBN: 978-1-138-02257-7 (pbk)
ISBN: 978-1-138-91057-7 (hbk)
ISBN: 978-1-315-77701-6 (ebk)

Typeset in Minion
by Florence Production Ltd, Stoodleigh, Devon, UK

Contents

Bundle of Rights

Although extremely valuable, copyright as a concept remains misunderstood, misused, misconstrued, and generally abused by photographers to this day. Their confusion seems to be the product of fear, and as Rod Serling's classic work on the television series *The Twilight Zone* proposes, all fear comes from the unknown.

Knowledge is empowering and, in this case, the only people who should be intimidated by a knowledge of copyright law are those who intend to steal from you. So what is copyright? Simply put, it is a right that gives creators the control of their "original" work for a "limited" time. Copyright law states that the owner of copyright in a work has the exclusive right to make copies, to prepare derivative works, to sell or distribute copies, and to display the work publicly.

Intellectual Properties

Copyright and intellectual property were once topics that put people to sleep. That changed when people like Microsoft's Bill Gates and Facebook's Mark Zuckerberg became two of the world's richest men. Throw into the mix companies like Twitter that hit the stock market with a valuation of just over $25 billion on its first day of trading. Or Google which is valued north of $300 billion. All that wealth is realized on the value of intellectual property—or rather, the value of licensing the rights to their property. Take Mr. Gates, he made his billions by selling permission to use a product—a computer operating system. He neither made nor sold computers; what he did was license worldwide Microsoft's intellectual property: the Windows operating system. Unlike a camera, the purchase of which empowers you to use or dispose of it as you please, you don't own the Windows program; you simply purchased a license to use it. You don't buy Facebook or Twitter's social media capabilities, you simply agree to the "Terms of Service" (TOS) when you first register and log into their sites. And you don't

need to even register with Google, you just use it as a "free" search tool. We'll talk about what "free" really means in the Social Media section of this book.

When it comes to the music you legally purchased and loaded on your mobile device of choice, you don't own the music you bought; you do have the licensed right to listen to it. It's licensing that makes the owners of intellectual property very wealthy. With that much money floating around, intellectual property and copyright issues mean big business. In fact, intellectual property (IP) law is one of the fastest growing specialties in law schools and law firms. Many companies today have expanded their workforce with people who specialize in the creation and licensing of IP. But intellectual property concerns don't stop at large corporations; they've trickled down to small businesses and even to individuals. Talk to an NFL photographer or a concert photographer. They are usually well versed in copyright and licensing as it comes up all the time these days. Ask any wedding photographer how many brides want not only all the images of their weddings, but also all the rights to those images. These facts send a clear signal:

today's photographers (or image creators) need a deeper, more comprehensive understanding of copyright—and not just laws and statutes. Knowing a bit about the history of intellectual property will give you a better perspective on what's happening today, how copyright is being interpreted, and how some people—unsophisticated lawmakers among them—see copyright laws as restricting and inhibiting intellectual freedom. If you Google just the phrase, "copyright law threatens intellectual freedom," you'll get over 1 million hits. That's right: Copyright protections are under attack.

Creative people are often surprised to learn that copyright protection doesn't primarily exist to protect their rights as an artist. The Founding Fathers did not include copyright in Article 1, Section 8 of the Constitution to ensure that photographers, or any artists, could make a buck. Rather, they did it to "promote the progress of science and useful arts" for a "limited time" to allow the creator to protect his or her work and profit from it. After that time has elapsed, your work is meant to improve the "commons of the mind," as Thomas Jefferson put it.

Copyright is also the only "right" mentioned directly in the Constitution itself. The other rights (or "freedoms") often talked about like the right to bear arms, exercise free speech, peaceably assemble, practice one's religion and so forth, all came later in the first ten amendments to the Constitution, known as The Bill of Rights. Copyright even existed in each of the original colonies predating the U.S. Constitution itself. It was unanimously voted into the U.S. Constitution. Unanimous!!?? How often do politicians all agree? That may have been the last time. We think the Founding Fathers were more aware of the value of intellectual property than photographers are today.

★

Bundle of Rights

Title 17 of the U.S. Code

This copyright law clarifies and lists additional rights you as a creator possess. These rights are often collectively termed "a bundle of rights." Here are the individual rights that collectively form your bundle:

The Right of Reproduction. You have the right to control how, when, and where your work is reproduced. You can specify and control this right through how you license your work.

The Right of Derivatives. This is a very important right, as it covers anything done with or to your work. If the work is altered in any way—say, retouched, cropped, or turned from color to black-and-white—then your original expression is protected. This right also means that if someone changes your image by a certain percentage, they cannot claim the resulting photo is a new work that they are now free to own and use. Hence Photoshop images that are cropped and retouched are likely to be considered

derivatives. In fact, the idea of a photo being changed by a "percentage" is an idea that in and by itself doesn't fly. How does one measure these percentages? Is there a "Change-o-Meter" device out there? A small change in a photo, adding the face of a celebrity into a photo, may be a tiny "percentage" change, but have a huge impact. And making a major background change, like changing the sky, a very large "percentage" change, can have very little impact.

The Right of Distribution. You have a say as to how the work is distributed. If you don't want your work shown on TV, you can specify that. Don't want it on a cereal box or cigarette package? Don't want it displayed east of the Mississippi River or anywhere in Latvia? Say so, because you control the distribution.

The Right of Performance. This does not apply to visual art like photography, but rather to performance art like music, theatre, and dance.

The Right of Display. This one is the visual artist's performance, and it means the right to control how the work is shown. For instance, you can say that your black-and-white image cannot be colorized. Or vice versa. You could state the work can't be cropped in any way. Some of this falls under VARA (Visual Artists Rights Act). See the VARA sidebar for more information.

MORAL RIGHTS: A VARA GOODA LAW

Moral Rights is a concept that artists have an ethical right to control their creations and protect the integrity of their work and their own reputation. So called "moral rights" in intellectual property exist in various countries outside of the USA. There is also a portion of the Copyright Law, which does recognize certain moral rights within American borders. The Visual Artists Rights Act, known as VARA, became part of U.S. Law in 1990. VARA (17 USC Sec. 106A for those keeping score at home) grants certain rights and protections to creators absent from the rest of the Copyright Law. Unfortunately

VARA doesn't apply in most copyright controversies. VARA essentially covers limited, fine art visual artworks, painting, sculptures, drawings, prints and photographs produced for exhibition. Within this group it can be argued that only single copies or signed and limited editions of 200 or less are actually protected.

New York, California, Massachusetts, Maine, Louisiana and about ten other states have state laws that work in conjunction with VARA. Most are roughly similar to or dovetail with the Federal VARA statutes that apply to issues of alteration, defacement, misattribution, and so on.

Some sunshine: VARA grants authors exclusive rights to claim ownership, prevents the use of the author's name on a distortion, mutilation, or modification of the work which could damage the author's reputation and can serve to prevent the destruction or alteration of a work by other than the creator. These rights survive the sale of the work. Statutory damages under VARA might be available even if the work was not timely registered. Sounds great, doesn't it?

And now the rain: VARA's scope is very narrow, exceptions abound and creators often waive any rights they may have under it. VARA deals only with works of visual art. Photographs and illustrations clearly fit the bill but it specifically excludes: packaging, posters, charts, newspapers, advertising, books, magazines and on and on. The bottom line is that VARA is most likely to be used by creators of fine art, "very" limited edition prints, sculptors, painters and the like who have not been commissioned by someone to create that work.

VARA gives qualifying authors the following rights:

- To claim authorship.

- To prevent the use of one's name on any work the author did not create.

- To prevent use of one's name on any work that has been distorted, mutilated, or modified in a way that would be prejudicial to the author's honor or reputation.

- To prevent distortion, mutilation, or modification that would prejudice the author's honor or reputation.

- To prevent the destruction of a work of art if it is of "recognized stature".[1]

As you can see, many of the nuts and bolts aspects of using VARA are vague, unclear, ambiguous, or impractical—both for lawyers *and* artists. If, however, you are a fine artist working in a visual medium, it is worth taking a look at VARA and providing a copy to your lawyer. Many attorneys are unfamiliar with the law's very existence. While it may rarely be employed, it can serve as powerful artillery on those limited battlefields where you can roll it out.

[1] Gassaway, Laura. "Copyright and Moral Rights." (Copyright Corner). *Information Outlook*, Vol. 6, No. 12 (December 2002), pp. 40–41.

An Unwritten, But Important Right

Let's add another right, one that's not defined by the U.S. Code, but is real, nonetheless, and just as important as any of the stated rights: the right to say "No." As the copyright holder you have the right to say "No" to any potential user. You may refuse to permit anyone from using your image for any reason—or no reason at all. Make no mistake, the right to say "No" is a big hammer.

The U.S. Code says, "The owner of copyright in a work has the exclusive right." Exclusive means the copyright owner is the only one who can exercise this right. "Only" is, by the way, a word you must add to your licensing vocabulary. For example: "USAGE: 1/2 page in the *USA Today* issue of December 19, 2009 only." The word "only" is a way to exercise your right to say "No" without using that

word. Remember, you can deny a license to anybody for any reason or no reason at all. Your right to say "No" can also give you great leverage in negotiating when there is an infringement. Under certain circumstances, a federal court can issue an order preventing or flat out stopping an infringer or unlicensed user from using your work now or in the future. This is a very important remedy, especially if you are not entitled to statutory damages because you registered late.

For example, say an infringer has put your image on thousands of boxes of pain reliever that is in thousands of stores like Walmart, Target, and CVS worldwide. As the copyright owner, you may obtain a court order recalling all of the offending products. That could be products, tee shirts, or advertising material; in other words, anything utilizing the photo. A Federal Court can issue such an order even before your entire case has been heard. This would cost the infringer millions of dollars, and they would have to reshoot and redesign the package for redistribution, all while their sales plummeted to zero. To avoid this fantastically expensive process, the infringer is often compelled to pay you for a "new license."

Lawyers and laymen who do not litigate copyright cases often forget that this option may be available to an aggrieved creator; some inexperienced lawyers will turn down your case as soon as they hear that the work is not registered. Doing so may be a huge mistake (see the Andrew Leonard case). There are those who view this gift of marvelous negotiating leverage as "commercial extortion." We, obviously, are not among them.

Last Thoughts on Your Bundle

So that's your bundle of rights under the copyright law. They're yours until you sell, transfer, or give away all or some of your copyright. (By some, we mean that it is not unusual for two or more persons or companies to be co-owners of a copyright.) If you relinquish your copyright through any of the previous methods, you are no longer the owner of the image you created. You will have forfeited control over that image. You can't put that image in your portfolio or on your website as an example of your work without the written permission of whomever

you've given, sold, assigned, or transferred the copyright to. That's why we strongly suggest you never sell, transfer, or give away your copyright—unless, of course, someone wants to pay you an obscene amount of money. And you should know that many successful photographers have, in fact, carefully licensed to clients all rights for an unlimited time, and charged them obscene amounts of money.

All the while, they've maintained ownership of their copyright—the keyword here is "licensed."

Remember you don't have to exercise all of these rights, but you may. Doing so gives you leverage in negotiating a settlement and can affect the licensing price.

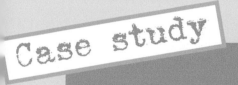

REAL LIFE

Andrew Paul Leonard is a photographer and one of Ed's clients. Mr. Leonard is also an electron micrographer. By shooting through an electron microscope he is one of the few professional photographers who can create color images of stem cells. The black-and-white image shot by Mr. Leonard is digitally "colorized" by him to make the best possible representation of that cell's appearance in nature. Overleaf is Mr. Leonard's most famous image,

which appeared on the cover of *Time* Magazine.

His images were used by Stemtech International, Inc., who published the images on a variety of websites with a copyright notice indicating that the registration was held by Stemtech.

Mr. Leonard took action. He filed suit in Federal Court in Delaware, where the defendant, Stemtech International, Inc., was located. He sought damages for

© Andrew Paul Leonard

After a jury heard the testimony and reviewed the evidence at trial it rendered a verdict in Mr. Leonard's favor on all of the forms of copyright infringement for which he sued. It did not take the jury long to award Andrew 1.6 million dollars in actual damages for the violations of his copyright. The jury also found that the defendant had acted intentionally with respect to each form of claimed infringement.

He did not register the images until after they had been infringed, so he was not entitled to an award of statutory damages. However, the jury found the actual damages to be so substantial that, in this case, they exceeded what a likely statutory award would be. The 1.6 million dollars is real money, anyway you look at it.

If there is an infringement, the fact that the image was not timely registered does not necessarily mean that the creator is without a big-time remedy. Infringers and their attorneys will often dare the author who did not timely register to "sue us." In some situations, especially with photographers who

direct, contributory, and vicarious copyright infringement. (See Chapter 2 for an explanation of the types of damages.) The unauthorized uses of both the image that appeared on *Time*'s cover and another stem cell photo were at issue.

There were numerous pre-trial motions and copious amounts of money spent on lawyers even before the trial started.

charge very big fees, registering the work "late" may have little or absolutely no effect on the amount of money recovered as damages. However, the best case scenario is to always register your images promptly. You are always better off if your images have already been registered.

Here's a rare example: Say Sam Shutter routinely sells his fine art prints of his "Image No. 1" for $250,000 each and a thief rips off Image No. 1 and sells the "offending copy" as a fine art print for say $35,000, Sam's lawyer will have little difficulty establishing in court that Sam's actual damages are at least $250,000. $250,000 is higher than the maximum statutory award of $150,000 (under these circumstances). So, if Sam's attorney's fees are under $100,000, Sam did not suffer financially by his late registration. On the other hand, if Sam made a timely registration he could be entitled to $250,000 *and* an award of his attorney's fees.

Failure to timely file will prevent the winning party from being awarded attorneys' fees. Since 99.99% of all photographers in 99.99% of all situations would benefit by registering in a timely fashion, we don't spend too much time talking about those infinitely rare exceptions to our "Golden Rule"— register right away, always, all of the time, no matter what, no exceptions.

Here, even though the works were not registered prior to publication or within the three-month "grace period," Mr. Leonard had a remedy well worth pursuing. Unfortunately, many attorneys automatically and mistakenly reject cases where there was no registration or one filed after the infringement. Each case must be analyzed on its own merits and unique facts, before a decision on how to proceed is made.

Ambien doesn't kick in. McCarthy is sort of a "mini-Nimmer," weighing in at a manageable 500 pages.

From McCarthy's:

> "Derivative work [copyright] A work which is based on a preexisting work and in which the preexisting work is changed, condensed, or embellished in some way."

That's the top level, basic definition. The fine-tuning of which goes on for pages. What follows is our attempt to flesh out and explain scenarios most often confronted by photographers.

So your photo or artwork has been violated, ripped off, stolen, or "appropriated." As we like to say in plain language, you've been robbed, your work stolen. Someone has taken your original photo and used all of it or just part of it in another completely new work, which is now a derivative of your original work.

On its own "derivative" may not be a bad word. If the originators or their heirs are being compensated under license or consent, the derivative work may be a cash cow for the artist and their family. Classically, in 1900, L. Frank Baum wrote a book, *The Wonderful Wizard of Oz*. Mr. Baum wrote derivative works based on his own original work and, thus, there were more books on Oz. He also produced some silent films about Oz, derivatives of his books. After he passed away, MGM produced the classic 1939 film, *The Wizard of Oz*. The 70s brought another movie and a play called *The Wiz* which licensed derivatives of Mr. Baum's stories. Derivatives do not have to be in the original media, be exactly the same, and they do not have to be something bad, as the Baum family can attest. Receiving royalties and license fees is really cool.

Unfortunately most times nobody is producing a movie, play, or book about your photo. Most often your case will be an apparent rip-off, and thus you will need to prove it's an infringement in federal court. A derivative is always built on an underlying work. In other words, it takes two to tango; two items have to be compared and there has to be substantial similarity. Just being "inspired by" doesn't cut it. You can say that *Star Wars* was "inspired by" the 1930s Buck Rogers movies that were about swashbuckling

outer space heroes. They miss being substantially similar, with the key word, based in Nimmer's view, being "substantially."

Mere similarity of the compared works is not enough, even though substantial similarity *dominates* in determining derivative infringement. There also has to be a standard of originality, where the variation, the derivative, of the underlying work, the original photo, is more than "merely trivial." In other words, you can't lay claim and copyright to a "style" of work. Our good friend Howard Schatz is famous for his photographs of nudes underwater with colorful fabric. While unique in look, Howard can't claim that any and all photos of a nude underwater is derivative and an infringement of his work, unless there is a semblance you clearly see when held side by side. Similar poses of the model, similar fabric, similar lighting, all that could be considered derivative. But unless the two photos are very similar, it falls under influence, not copying and infringement. Early in Jack's career, he was known for a "Norman Rockwell" style. You could clearly see an influence, but there was no copying of any theme or likeness.

How much can be copied without infringing and becoming a derivative inviting a lawsuit? That answer can take up a small book, but a very simple explanation is if a common person can hold the original underlying work and determine that the second work was derived from it, "Bingo!" there is a good chance that a copyright infringement has occurred and the work in question is a derivative of your original, underlying work.

Another term associated with derivatives that gives photographers fits and head scratching bouts is "compilations." A compilation is not a derivative. A compilation is when there is a new product created with multiple underlying licensed copyrighted works. Any magazine, such as *Time*, is a good example. A magazine publisher can get a copyright on their magazine, which is a compilation of work by photographers and writers, who may have only given the publisher a one-time usage license for their work. The magazine does not own all of the work within it, but does own the work that was created by compiling all of the work together. They can own the whole, but not the parts. The original creators, photographers, and writers in this case still own their individual works unless they signed

away their copyright, but they do not own the magazine. The magazine owns the magazine, but (typically) not the photos, stories, or even advertisements contained in it, unless the copyrights in all of those pieces were transferred to the magazine. A compilation is not a derivative work.

Section 103(a) of the Copyright Act provides that the subject matter of copyright as specified by Section 102 includes derivative works. It reads in part: "A work based upon one or more pre-existing works, such as a translation, fictionalization, motion picture version, art reproduction, abridgment, condensation, or any other form in which a work may be recast, transformed, or adapted. A work consisting of editorial revisions, annotations, elaborations, or other modifications which, as a whole, represent an original work of authorship, is a 'derivative work'."

So in plain English, any work based in whole, or in substantial part, upon a preexisting (or "underlying") work, if it satisfies the requirements of originality, may be separately copyrightable. So any "distinguishable variation" of a prior work that is sufficient to support a copyright may be entitled to copyright protection. A new version of a work (even in the public domain), abridgment, adaptation, arrangement, dramatization, or translation can constitute a derivative work. A collective work will qualify for copyright by reason of the original effort expended in the process of compilation, even if no new matter is added. In determining whether a work based upon a prior work is separately copyrightable as a derivative or collective work, the courts do not consider whether the "new" work is an improvement over the prior work. Quality is simply not an issue and not in the purview of the Copyright Office or copyright law.

However, in order to qualify for a separate copyright as a derivative or collective work, the additional work done must be more than just a minimal contribution, it needs to be substantial. The following are examples of changes to an original work that did not meet the criteria needed to qualify for a new copyright. This is good information to know so when someone tries to claim that what they did to your photo makes it a new work, you can say, with knowledge, "Sorry Charlie, that dog won't hunt," or "Sorry Charlie, the folks

in Washington DC have told the judges that that you won't limit," or any other cliché meaning "that won't fly."

- Merely changing the form of a table of facts from a vertical to a horizontal orientation.
- The selection of cities included in a public domain map.
- A change in materials (metal to plastic).
- Changing the scale or size of a work of sculpture depicting Uncle Sam (including certain minor changes in the shape of some features).

On the other hand, the following were held to be sufficient contributions so as to warrant the recognition of a separate derivative or collective copyright:

- Devising a calculated melody score for a song already in the public domain—plus putting it in a form to be read.
- Adapting a public-domain embroidery design to a print fabric design.
- The selection of scenes from a number of Charlie Chaplin films for incorporation into a compilation, in which originality was found in the selection of particular scenes, the order, timing, pacing, and theme.

We wish we had very hard, clear lines to help you determine for all time just what is and what is not a derivative, but the law doesn't work that way. While the right of derivatives is sometimes complicated, there are, in fact, several legal standards used by courts to determine derivative infringements:

The totality method, also known as the "total concept and feel" approach, takes the work as a whole with all the elements included when determining if a substantial similarity exists. The individual elements of the alleged infringing work may by themselves be substantially different from their corresponding part in the copyrighted work, but nevertheless taken together be a clear misappropriation of copyrightable material.

To totally understand this totality method you need to remember the following:

1 Copyright protection extends only to a particular expression of an idea and not the idea itself.

2 The expression—the work itself—must be "original" to the author.

3 The expression cannot be copied from a pre existing work of another author or be from the public domain.

If the above elements are established in an infringement claim, then the court determines whether the copyrightable elements of the infringing work are substantially similar to the copyrightable elements in the original work.

So what the heck does "substantial similarity" really mean? This is an especially good question as federal judges have had their own problems answering it.

Introducing the "audience" or "ordinary observer" test, which inquires whether an average lay observer would "recognize the alleged copy as having been appropriated from the copyrighted work." Some courts say this test should be conducted by comparing the two works with more attention to detail than a mere "generalized impression," but "still with no more attention than could be reasonably expected by a lay or ordinary observer." So it's a great start for the creator if a reasonable, average person has a spontaneous reaction when comparing the works and forms an impression that "copying" has taken place.

There's the "two-part test" where in determining substantial similarity, "The 'extrinsic' test considers whether two works share a similarity of ideas and expression based on external, objective criteria, and the 'intrinsic' test asks whether an 'ordinary, reasonable observer would find a substantial similarity of expression of the shared idea'." This is also called the "more discerning" test used by some courts. It can be applied where the original work may incorporate something from the public domain and still have many original, copyrightable elements. The courts try not to break up each of the competing works into so many different component parts as to lose the whole picture, sort of "not seeing the forest for the trees." Thus while courts will look to composite parts of the competing works, a side-by-side comparison of both works in their totality is preferred.

★

Where is the Public Domain?

The public domain is not a place. When a work has no copyright protections, it is considered part of the public domain and, as such, can be freely used by anyone.

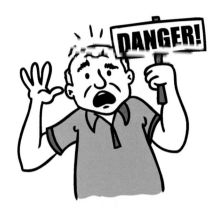

As defined by the Copyright Office:

> A work of authorship is in the "public domain" if it is no longer under copyright protection or if it failed to meet the requirements for copyright protection. Works in the public domain may be used freely without the permission of the former copyright owner.

Work(s) may be in the public domain because:

1 It was created before copyright laws ever existed. Textbook examples are both the Old and New Testament Bible(s).

2 A work that had copyright protection but that protection has expired, such as work created before 1923. All pre-1923 copyrights, for example, Herman Melville's *Moby Dick*, published in 1861, have expired. Run free Moby, run free big guy. But that's only the original novel. A new edition with footnotes and new illustrations may be a new copyright. And the movie starring Gregory Peck is under separate copyright protection.

3 It never had copyright protection or its protection was lost due to some technicality. A textbook published before March 1, 1989 that did not carry a copyright notice would most likely fall into public domain.

4 It was "prepared for" or dedicated to the public domain. For example a work created by fifty like-minded artists who wanted the joint work to be for the use and enjoyment of members of the public, any of whom are free to make copies or rip-offs if they are so inclined.

Other works may not be covered by copyright laws because they are:

1 Created by the U.S. government (there are some exceptions where contracts between government entities and others regarding the creation of the work may exist). All those pictures NASA takes of the galaxy or the Earth? They're yours to enjoy and use as you please. The very famous and often-used photo by Dorothea Lange titled "Migrant Mother" was originally shot for the government's WPA program in the 1930s and is in the public domain, so anyone can use it. You can download a file scanned from the original negative, make prints, sell them, and keep all the money you make.

2 Reprints of works already in the public domain. However, be careful because a license restricting their use could exist. Or there could be other issues like trademarks, which could restrict use. For example, the book *Peter Rabbit* by Beatrix Potter is in the public domain. The drawings of the characters are, however, still under trademark protection.

3 Ideas, facts, and common property. The most often-cited example is unadorned

phone books—even though few people alive have ever actually used a phone book made of real paper. Phone books and yellow pages now live in the land of obscurity with their companion, the rotary phone.

4 Federal laws, statutes, court decisions and orders, government regulations, administrative rulings, and the like. Any of which make dynamite bedtime reading, better than counting sheep.

5 Overwhelmingly composed of words, names, and phrases. But take caution: phrases, names, and slogans may very well have plenty of protection under trademark laws.

6 Most blank, routine forms.

7 Recipes, discoveries, procedures, and systems (but not the words that describe them). Again, be careful as these things may very well have patent and/or trademark protection.

If the work is not one of these works and was published after 1988, it is not in the public domain. Due to new laws extending copyright, no new work will enter the public domain until 2019. After a certain period(s) of

time, some works may "fall into" or "enter" the public domain. What time period applies to a specific work depends on the date that work was created. This is due to the various changes made in the Copyright Law over the decades.

Excuses—A Refuge for Scoundrels

"We are so glad you brought this to our attention" (Typical Infringer)

Excuses are like a . . . pick a body part or two, any part. Everyone has one or more. Some excuses are simple, innocuous, and often used to grease the wheels of business. We all have used them and heard them at least a time or two. Whenever Ed's office sends out a demand letter (see "Demand Letter" sidebar) to an entity infringing on a photographer's photo, an illustrator's work, or a company employing a model's image without permission, he is barraged with a variety of excuses. Some comical, some heartfelt, some arrogant, but most just plain typical.

While we were writing this book, Ed issued several dozens of such letters in two copyright cases and a modeling case, all within about a week. They were a rainstorm of infringements followed by another type of storm with the incoming excuses. We were struck with the predictable appearance of some very lame excuses by both infringers and attorneys alike. Ed went through some fifty odd reply letters and saw the very same excuses we have been seeing for decades.

As we've both stated many times, lawyers often tell their clients if anyone contacts or writes about an infringement they committed, they should simply ignore the letter, until and unless they get a lawyer's letter. Here is a list of top 11 excuses, and remember, they all came after receipt of a lawyer's letter.

1 *There was no copyright notice or photographer's name on the image.* This defense is from the school of "throw something up to the wall and see if it sticks." There has not been a requirement that there be a copyright notice or symbol since the Carter presidency. The defense is illogical. How many people engrave their name and address on their cars, televisions, and other

property? Imagine a thief stealing such an item and telling the cops, "Nobody's name was on the Mercedes! How could I know someone owned it?" If the "user" of the work in question didn't create it or obtain a license to use it, then the image was owned, created, and/or registered by someone else. A copyright notice is helpful to prevent theft and to prove willful infringement but it is not necessary. Although use of a notice is not required, as our mothers said about chicken soup, "It couldn't hurt." Furthermore, such notices are impractical or impossible to use especially when the image is used for advertising purposes.

2 *We are a small business.* There is no small business exception or defense under the Copyright Law. After stating the obvious we point out to the infringer (or their attorney) that our client is a one-person business whose own business is much smaller than that of the offender. Many of these "small businesses" have insurance coverage, making their own claims about financial stability totally irrelevant. Ed actually had a lawyer in a case try this excuse in front of a judge. Ed asked where exactly in the law a small business exception existed. The judge agreed with Ed.

In another case, where Jack was suing an infringer, the "small mom and pop" business was netting almost a million dollars a year.

3 *We haven't made a profit in X years.* We are frequently invited to review tax returns to buttress this statement. We don't go down these rabbit holes— whether or not a business makes a profit is most often of absolutely no concern to the aggrieved registrant. Many businesses operate for years without making a profit. See GM, Kodak, *The Washington Post*, *The LA Times*, etc. Lack of profit does not grant a company a pass to evade the Copyright Act. A business may also be run upon an accountant's advice to show little or no profit. None of this matters. We know of many "non-profits" where the executives make very large salaries. A "non-profit" in some cases is simply a tax designation, not necessarily a business philosophy. But since the term works well to get photographers to work pro bono, why not dress it up and run it out again for an infringement excuse? The same old, "see what sticks" approach.

4 *If you sue we will file for bankruptcy protection.* Fine. Copyright infringement

claims are not dischargeable in bankruptcy. Such a claim would be transferred to a "regular" Federal Court by the bankruptcy court, which lacks the power to adjudicate infringement claims. We welcome such filings. We have called this bluff at least 100 times and not once has the infringer elected to file for protection under the bankruptcy law as a result of our claim alone.

5 *The picture is all over the Internet/ everybody is using it.* Our usual reply is something like, "Yes we know. You are but one of the 23 infringers to whom we have written and may have to sue." If the image is "all over the net" that may be because many have licensed it for a fee and/or many have stolen it. The mere appearance on Google images does not mean that the image is in the public domain or free for the stealing. You should all be hearing your mother's voice in the background saying "So if everyone jumped off a bridge, you'd also go?" The excuse didn't work on your mother and it doesn't work in these cases.

6 *Thank goodness you contacted us.* We both LOVE this one, used often and usually with a straight face. It's slick, real slick. "We

had no idea who took the shot. We looked but couldn't trace the creator so we used it hoping we would be contacted. How much do we owe you?" Those who make this claim are, dare we say it, lying. This specious line crops up when the infringer runs the calculated risk of using an unlicensed image in the hopes that they will get away with it.

7 *We commissioned the shot years ago and used it again . . . sorry.* Said in an attempt to minimize the damages. The logic is that since the image was legally used previously, an unauthorized re-use by the same client and/or for the same product should be considered as a minor transgression requiring a modest "re-use" fee. This excuse does not take into account the provisions of subsequent licenses for the image. For example, you might not have granted an additional license to this former client even if they would have asked for one. It's like stealing a car from Hertz during Thanksgiving. Not only is stealing the car a felony, but also offering to pay a standard rental rate during a holiday weekend is about as dumb as it gets.

8 *We have a model release.* Congratulations but we represent the photographer, who also

has a copy of the model release, and has something called a "copyright registration." 99% of the time the model has no copyright interest in an image. The model cannot convey a license on behalf of the photographer. We've seen a lot of poorly written model releases that "give permission" by the model to copyright the image. Only with rare exceptions would permission be required by a subject in order for the photographer to copyright their image.

9 *Like your client is really going to sue over this*? Short answer is "Yes."

SAINTS IN THE COOKIE JAR

One thing we found very notable, almost every letter from an infringing party, no matter who they are, author, artist, lawyer, or corporation, contained some version of the following line early on, "We are glad you have brought this to our attention. We take matters regarding intellectual property very seriously." Yeah, right.

The line, and it is a line, is employed as a "softener" by the writer. The reader is supposed to believe that the recipient isn't really a thief or a bad guy but rather someone who is just like you and shares your ethics and morality. In real life, it is very rare that the infringer has any respect for intellectual property, unless of course it's their own property.

Once they got caught with their hand in the proverbial cookie jar, these thieves commence morphing into veritable saints. If they were, in fact, concerned with matters of copyright they would not be on the receiving end of a "gotcha" letter from some lawyer. Rather, they would have secured a license and paid a fee to use the photo from a photographer, model, or their agents as the case may be. But that, of course, would cost them money, so why bother? Nearly all infringers well know that the odds of getting away scot-free with the appropriation of an image are good, very good.

10 *We have taken it down. We trust this concludes the matter.* Ow, good try. But that's equivalent to plunging a knife into the photographer's chest and concluding after you pulled it out that all was okay. The courts seem to take the same view as we do that, in such cases of physical and image assault, the victim is still damaged after this "correction." Usage cessation may serve to reduce the amount of recoverable damages, but rarely relieves the infringer of liability.

11 *Our intern was responsible and he/she was let go.* Sure blame the kid who you "hired" but didn't pay. Interns take the blame for thousands of mistakes daily. We can't recall any intern receiving credit for anything. If the intern did, in fact, screw up, the employer is still responsible. If the intern was not properly trained, supervised, or taught how to perform his/her duties by the employer, such failure(s) may constitute negligence or gross negligence. In any event, the nature and extent of the infringement is unaffected by the fact that the alleged perpetrator is a dear departed intern. We generally express horror that such an important decision regarding the use of intellectual property would be left in the hands of an unpaid college student or unemployed "volunteer." We like to follow that up with a question to a well-paid

LIKE HEN'S TEETH

(*We know they exist, but we've never seen any.*)

The rarest reply, which would be typically the most effective one from the infringer's point of view, goes like this:

"It appears that there has been an infringement/unauthorized use. Our client is willing to pay a reasonable fee to avoid all the attorneys' fees, bad publicity, ill will, etc. So let's talk about a reasonable settlement number rather than spending money on lawyers, experts, and wasting our mutual clients' time."

That approach generally works. Ed has received some of these, but they are far and few between.

executive or editor like, "Well, if interns make decisions regarding licensing, what exactly do *you* get paid for"? Or "If the intern had tried to post a kiddie porn image, should we also assume that you had no way to prevent that photo from running either?" Judges have chuckled and agreed with those questions from Ed in court.

What is Copyrightable?

Now that we've talked about what copyright means to you, the next question is, "What *can* you copyright"? Well, you can copyright any of your photographs as long as they are "original expressions." In other words, not every photo you take is copyrightable. You can't, for example, claim that you own the rights to *any and every* close-up photo of two hands shaking. You can own the copyright to your specific and unique image of two hands shaking but you can't claim that all other shots of shaking hands are infringements of your photo merely because they happen to portray two hands shaking. For example, Jack's photo of Sarah Palin shaking Barack Obama's

hands in the White House would not be an infringement of Ed's photo of a Little League coach shaking the hands of a nine year old in Tokyo. Your copyright applies to your expression or rendition. Your specific unique photograph of a handshake itself can be copyrighted, but not the idea of two people shaking hands.

Ideas can not be copyrighted. Copyright can protect your particular artistic expression of that idea, but not the idea itself. Photographers can't claim ownership of an idea used to portray a subject or a situation. Simply put, the image of two hands shaking is generic; it's not considered original and unless your expression of that image is

NOT PROTECTABLE ELEMENTS

PROTECTABLE ELEMENTS

somehow unique or radically different from the thousands of others that exist, it simply will not be copyrightable.

So Jack can copyright this image of kids picking sides for a sandlot, pickup baseball game, but not for any image depicting the same idea. The photo is copyrightable, the idea or situation it portrays is not.

Jack's photo is copyrightable (and it is registered), but Jack or anyone else cannot claim to copyright the idea of picking sides for a baseball game. Ideas are not protected by copyright.

But here's where you could get confused: The Copyright Office will take your money on a copyright registration submission of a work even if it is not an original expression. It will most likely issue a registration to you, but such a registration could be challenged and would likely not hold up in a lawsuit. The Copyright Office is basically concerned with the paperwork and if that paperwork is in order. They are not concerned with deciding if a work is "copyrightable." That's for the courts.

As another example, let's say you photograph a beautiful lighthouse at sunset and behind the lighthouse is a photogenic cloud formation. You can't claim infringement against anyone who photographs that same lighthouse at the same time with another beautiful cloud formation behind it. If that person copies your photo, the actual, physical photo, then you can sue for infringement. On the other hand, if another photographer happened to photograph the same landmark from the same or similar angle that in and of itself does not give cause for a lawsuit.

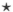

Protectable Elements

Let's take it a step further. Say you photographed that lighthouse at a unique angle, used a blue filter, and had a little girl in a pretty dress standing there holding two flowers. Along comes another photographer who shoots the same lighthouse at the same angle, uses a green filter, has a little girl in a different dress, and she's holding just one flower. In this case, you might have a successful claim for infringement. Lawyers use the term "colorable." In English, the term describes a set of events that could possibly turn into a successful lawsuit. "Colorable" is the term lawyers and judges use to describe a scenario that under applicable laws might be a winner.

We can't say for sure that you would win. (Avoid hiring any lawyer who guarantees that they know for a fact how a given case will turn out.) Outcomes in court can never be guaranteed by anybody but you would likely have a very good claim. Why? Because when you photographed the image, you included certain "protectable elements" that are covered by your copyright. Protectable

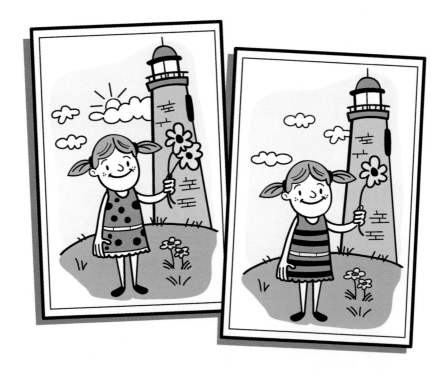

elements include posing, lighting, angle, background, perspective, shading, color and viewpoint.

Not all elements are protectable. Years ago photographer Penny Gentieu sued her stock agency, claiming infringement of her work because the agency sent out a request list to other photographers for images that duplicated her imagery. Specifically, that of shadowless babies photographed against a white background. The staging made the infants appear to be defying gravity and floating. Ms. Gentieu claimed that images produced by other photographers for the stock agency, per their request list, were derivative works.

The court ruled against her, saying that she could not lay claim to all images of babies against white backgrounds as an original expression. For her copyright to be infringed, those images would need to have been nearly exact duplicates of her images using protectable elements. Ordinary poses or angles that follow from the choice of subject matter—in this case, photos of just babies without any other elements—are not protectable, whereas contrived, unusual, or

rarely seen positions might be considered protectable and thus actionable. The same pose of a baby sleeping, but with the added element of a huge Great Dane on whom the baby is sleeping would be protectable. The use of the Great Dane as a "mattress" for the infant changes it from a generic image with an ordinary pose, to a specific artistic expression—a protectable image.

But with all that said, it always makes sense (within the guidelines of common sense— remember the two hands shaking) to take the position that all your images are unique. Maybe they are, and the prudent position is to register all of them. You can send a non-original image, one with elements that are not protectable, to the Copyright Office and they will likely take your money and issue a copyright registration complete with its own number. All that the examiners do is accept your check and ensure that all of the required information is filled in on the form. However, their acceptance of the check and the issuance of a registration number do not guarantee authenticity. Registration creates a legal presumption that the registrant is the true author of the work. If Joe steals Sally's image and, without Sally's knowledge, registers it in

PROTECTABLE WORK

What's the difference between a photographer and a plumber? No, not a leaky basement.

Say you agree that you will photograph auto dealer Bob Smith for an ad. You will do the headshot for use in the local PennySaver newspaper and Smith agrees to your fee of $500. You do the shoot; he does not pay you. The concept to those not familiar with intellectual property is that the payment by Bob Smith would be for the fair and reasonable value of the "services rendered." The misconception here is that what the photographer produced is the same as if he/she was a plumber, carpenter, or mechanic, and performed a service for an agreed-upon fee of $500. The error in that thinking is that what the photographer produced should be looked at as a creative or intellectual property that has been created.

As a photographer, you create and own intellectual property, namely the photograph, that can be copyrighted.

This places photographers in a category vastly different than a plumber, mechanic, or carpenter. In legal terms, they performed services, whereas you created property. Even though the plumber created a beautiful weld on a pipe, under the law they have not created a "protectable work." The law distinguishes such creations, photographs, paintings, books, movies, and so on, via the copyright law, as opposed to someone providing a common service. But copyright can be a toothless tiger if you don't follow the rules, which means, basically, registering your work. This distinction between providing a service or creating a property that is a "protectable work" means, in the case of non-paying auto dealer Bob Smith, you can recover not only the money owed for services rendered, but you can also collect statutory damages, damages not obtainable to service providers, such as plumbers, carpenters, or mechanics.

TOP TEN MYTHS OF COPYRIGHT, PLUS 1

It's OK to use someone else's image if . . .

1 I change x% of the work.
Nope. See derivatives

2 I don't charge anything.
Nope. Just because you didn't charge any money doesn't negate the fact you stole.

3 I'm using the photo for non-profit, educational purposes.
Nope. "Non-profit" or "Not for Profit" is a tax status, not always a business philosophy.

4 I include the creator's copyright notice.
Nope. All that does is let everyone know exactly from whom you stole.

5 I removed it from my website when the copyright holder objected.
Nope. The copyright holder is still damaged. It's like plunging a knife into the copyright holder's chest and then saying, "Whoops" and pulling out the knife. The damage is still done.

6 I asked permission and didn't get a response.
Nope. If I asked to "borrow" a Ferrari I saw on the street and didn't hear a reply, that doesn't mean I can take it for a joyride.

7 I can't find the copyright holder.
Nope. If you can't find the photographer, their estate (if they're dead), or even know who did the photo, the photo is an "orphan work" and can't be copied—unless an Orphan Works Bill passes Congress in the future (see Orphan Works sidebar on pages 35, 28–41). Then this becomes a slightly different answer. You would then need to do a "diligent search" for the copyright holder.

8 The image does not have the © symbol or say "copyright."
Nope. Not required since 1976. But if you do have it, you help defeat any claim of "innocent infringement."

9 It's posted on the Internet.
Nope. Just because one person ripped off a photo doesn't give everyone else permission to rip it off.

10 The image is in the public domain.
Usually nope, but not always. Actually, it's a trick question. The qualifier "always" trips it up. There may be other rights tied in, like trademark rights.

11 The big one, the urban-legend-sized myth that will not go away: If I place my work in a sealed envelope and mail it to myself, I'm protected.
Big nope. That just proves you mailed yourself something. A judge will laugh that out of court. If a lawyer recommends you do that, you probably need to find a new lawyer.

his name, she can challenge the authenticity of the filing and would likely succeed. A registration is not a guarantee. It would be physically impossible for the Copyright Office to determine whether each image seeking a registration was original. How could an employee compare each image to every image ever submitted over the last two hundred years? It is the responsibility of the victim to challenge the legitimacy of the registration. It is the examiner's job only to determine whether the application appears legitimate and that the item appears to be copyrightable, not to conduct an investigation upon each submission. Another example of what can't be copyrighted: If you photograph a cereal box or a perfume bottle on seamless paper, unless you find your own singular angle, lighting effect, perspective, or background, then you can't claim the work as original and unique, and thus protectable by copyright. There must be protectable elements.

A TOY STORY

In a case especially important for still-life and catalog photographers, the U.S. District Court for the Northern District of Illinois held that a photographer cannot obtain valid copyright for his own images if they are photos of already copyrighted products, in this case, toys.

The plaintiff Daniel Schrock was a Chicago-based professional photographer. Defendants comprised of numerous entities were (in effect) Learning Curve International, Inc., a toy distributor that owned the copyrights and other intellectual property to the famous Thomas & Friends toy train properties. From 1999 to 2003, the defendant engaged the services of Schrock to photograph product shots, including some of its Thomas & Friends toys. Schrock registered copyrights for a large number of these photographs in 2004.

Out of some 100 written invoices submitted by Schrock to his client(s), at least 72 included a "usage restriction," limiting the term of use to two years. After the expiration of the two-year restriction,

the defendants continued to use those product photographs over Schrock's objection and in contravention of the usage term set forth in the invoices. So Schrock sued for copyright infringement and the defendants moved for summary judgment claiming that Schrock had no right to copyright the images in the first place. The key issue was whether a photographer who shot copyrighted products could validly claim copyright ownership over his images.

Because the main subject of each image was the trademarked product, the court classified the images as "product photographs," or "depictions of Thomas and Friends toys." This is an important point, and differentiates Schrock's images from, say, a shot of a child playing with a Thomas the Tank Engine toy; such a shot may well be copyrightable, because the main subject of the image is not only the trademarked product. Schrock's images, however, simply portrayed the three-dimensional toy in two dimensions. He photographed the toys without people, on white seamless, thus not adding any copyrightable elements. Copyright law

states that such photographs "recast, transform . . . or adapt" the preexisting three-dimensional toy into another medium, thus creating a derivative work. Any and all IP registrations whether in the form of trademark(s), service mark(s), trade dress, patents, and/or copyrights were owned by the manufacturer and thus the photographer had not created anything original in this case.

Since the copyright law grants a copyright owner the exclusive right to prepare (or authorize) derivative works as part of its bundle of rights, a third party like photographer Schrock who seeks to copyright his derivative images must first have the permission of the original copyright holder of the underlying work. There was no evidence that Schrock was able to obtain the consent of the copyright owner (the defendant) in order to register these derivative works as his own with the Copyright Office. So, as a matter of law, the plaintiff did not hold a valid copyright over the photographs, and the district court dismissed his claims of copyright infringement.

WORK FOR HIRE (WFH)

There's another way of losing copyright without necessarily signing away the rights to individual images: Work for hire (WFH). Big businesses and many publishers are acutely aware of the value of copyright, and they routinely insert work for hire clauses and terminology into their paperwork. Simply put, a work for hire clause transfers your copyright to your client; all your ownership and control goes out the door. To our way of thinking, work for hire is one of the most evil phrases an independent or self-employed photographer can hear. If you're a full-time employee, work for hire is something that comes with the turf, but if you are not paid on a W2 basis, be wary of WFH clauses. Any time you hear that phrase, you should hear the old TV show *Lost In Space* robot warning "Danger! Danger!" Avoid WFH at all costs or you'll find yourself very much lost in space.

The circumstances and criteria under which a work is considered a "work

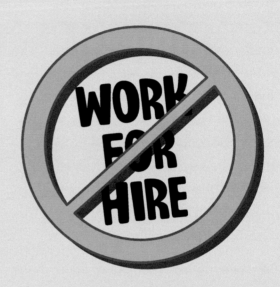

made for hire" are determined by the specific language contained in the United States Copyright Act of 1976:

Works Made for Hire (1) a work prepared by an employee within the scope of his or her employment; or (2) a work specially ordered or commissioned for use as a contribution to a collective work, as a part of a motion picture or other audiovisual work, as a translation, as a supplementary work, as a

compilation, as an instructional text, as a test, as answer material for a test, or as an atlas, if the parties expressly agree in a written instrument signed by them that the work shall be considered a work made for hire.

(17 U.S.C. sec 101)

So, a signed "writing" for a "non-employee" is required for the work to become a WFH. Once the work is covered by a valid WFH agreement, you have no copyright in the work. You may receive money, royalties, sales percentages, a creative fee, a fee, payment, and/or lots of other benefits—or absolutely nothing at all. The point is, a WFH takes away your copyright interest and ownership in the work and all say in its future use. It is the functional equivalent of an outright sale of the work—no different than selling a used lawn mower. Your rights are typically limited to waiving the work goodbye.

Orphan Works

Of course everyone should register their copyrights, but the fact that a photographer creates and owns their copyright the moment they trip the shutter makes for some sticky situations. For instance, if you wanted to use a work whose creator was unreachable or even dead, you can't until you obtain proper permission. So assuming you were not the photographer at your parents' wedding and have a lovely wedding photo that you want to copy and blow up for their 50th anniversary, you are out of luck without getting written permission from the original photographer. Any copying of that photo might simply be illegal. Even if you know for a fact that the studio is no longer in business or the photographer was the victim of a high-profile murder that inspired its own episode of *Law & Order or Elementary*, it still falls on your shoulders to acquire written permission. In the latter case, that would likely be from the estate of the photographer. If you run into a dead end, the work is "orphaned" and cannot be legally reproduced. This is also true if you have an old photo of yourself or a loved one and want to have it restored because of damage or fading due to age. The restorer cannot legally make a copy to work on.

HISTORICAL BRIEFS—1600S, PART 1

Prior to the existence of copyright law, people who wanted to protect their work had to be, well, let's say creative . . .

There are lots of examples in the history books: In 1623, Salomone Rossi, a Jewish musician in Renaissance Italy, wrote a collection of Jewish liturgical music called *The Songs of Solomon* and protected its copyright by putting a Rabbinical curse on anyone who dared pirate it. Rabbinical curses being both imaginative and specific, Rossi knew that if he saw someone with his head in the ground and his feet in the air, growing like an onion, that he'd found an infringer.

About the same time, the Shah Jahan, who commissioned the Taj Mahal, used less fanciful but more extreme methods. Deciding that he didn't want to ever see a reproduction of his beloved Taj, he ordered that as the workmen finished their task, one of their hands be cut off. Drastic, but you don't see a second Taj Mahal, do you?

HISTORICAL BRIEFS—1600S, PART 2

Gutenberg's Printing Press

Before technological advances in the 1600s, copyright was not a great concern; there simply wasn't that much to copy. Bibles were pretty much it, and if you wanted your Bible reproduced, then you went to your local St. Kinko's Monastery and asked the abbot to make a copy. Of course, it would take a few years—longer if the monk died (and you thought running out of toner was a problem).

Then Gutenberg changed everything. His printing press expanded reading lists beyond Bibles to include newspapers and (eventually) novels. In a very real sense, the new technology of moveable type was responsible for the novels of Charles Dickens. Interestingly, the same people who today argue the merits of film versus digital were around back then taking part in the pen-versus-press debate.

This quandary has led Congress to consider an "Orphan Works" bill. It is an attempt to open this logjam of unusable images so that, say, a documentary filmmaker like director Ken Burns can employ important images that are otherwise prohibited from use (unless they've fallen into the public domain). The same issue is of great concern to museums and universities. As of this writing there is no Orphan Works law in effect. One version did pass the Senate in a past session, with a great deal of support. It did not get to the House of Representatives that year, but most legal scholars are fairly certain some version will eventually get passed by both houses of Congress and will eventually become law.

Nevertheless, there has been much yelling, screaming, crying, and even some well-reasoned objections coming from the creative world against an Orphan Works bill. A lot of it is misinformation, wedded to hysteria, bouncing around and permeating the Internet. One photographer's website that dispenses legal advice tried to paint it as an invitation to infringe on copyrights. It posted that, if someone took an ad for a consumer company like Nike and cut off the bottom half inch that contained all the copy info and logo, then they could claim it as an orphan work and infringe the photo (steal it). That photographer, who is not a lawyer, used an example of a pet food ad done in Europe where all the copyright information was in the bottom half inch and could easily be cut off. If the photographer found the infringement, the author reasoned, the infringer could claim they looked but couldn't find the photographer. They saw a similar image in stock for $100 and that would, in effect, be the limit of damages to the infringer's wallet. This scenario was not only patently wrong, but it invited Ed's involvement. Those of you who know that, in our business, everyone knows practically everyone else will get a kick of this.

First, cutting out the logo did not make the work an orphan. If it ran as an ad, especially for a high-profile company like Nike, that image would never become an orphan work. Virtually impossible. The consumer ad and visible logo demonstrate that the infringer could not possibly have conducted a diligent search for ownership. All the versions of the bills that we've seen require that a provable, diligent search be conducted so an infringer can't hide behind an orphan status, and all applicable copyright laws remain in effect.

Second, the pet food that the website author used to illustrate his point was an ad shot by one of Ed's clients—Vincent Dixon. Vincent is a well-known photographer who does a lot of work in both the U.S. and Europe. Ed sent the website author a wonderful letter saying, in no uncertain terms, that their (ironic) use of ripping off a working photographer as an example of how nasty people could easily rip off poor photographers had to come down immediately. They complied and then tried to explain that the use of the image constituted "fair use" and was thus permissible. Another letter from Ed clearly explained why such a claim was, as the lawyers like to say, "utterly without foundation in law or fact." (English translation: nice try, but we ain't that stupid. See our explanation of legitimate "Fair Use" at the end of this chapter on pages 42–3.)

This is a great example of why Ed and Jack are leery of non-lawyers with websites dispensing

Perhaps it's time to turn to Pedigree light dog food

© Vincent Dixon

what masquerades as legal advice to photographers. It's like having Joe the Plumber giving out medical advice. And people listen because, hey, it's easily accessible on the Internet, and the author, just like the reader, is a photographer. When teaching persuasive speaking techniques, this phenomenon is called the "commonality of like experience." In essence, it's why a photographer would feel more sympathy for a photo studio going up in flames than, say, a plumber would. However, identifying, empathizing, or being simpatico with the writer does not make the writer an expert.

So, what do we think of an Orphan Works law? Well, nothing at this writing, as nothing has passed and it's hard to comment on something that does not yet exist. (We readily admit that such obvious logic is dismissed out of hand by both of our wives on a daily basis.) The Copyright Office is aware of the concerns of both sides of the issue. It is not in a position to advocate a lessening of copyright protection, but does see orphan works as a real problem that has to be dealt with. It has pointed this out via a presentation to Congress by Marybeth Peters, the former head registrar at the Copyright Office.

To get a good read on exactly where the problem stems from and the solutions proposed by the Copyright Office, we recommend reading Ms. Peters' testimony to the House Judiciary subcommittee on March 13, 2008; you can find it at www.copyright. gov/docs/regstat031308.html. It is enlightening reading, and since she was in charge of the Copyright Office at the time, we believe her testimony is more credible than the musings of photographers contained in any blog. Quoting Ms. Peters directly from www.copyright.gov/orphan referencing some of the criticism against the proposed bills:

> Some critics believe that the legislation is unfair because it will deprive copyright owners of injunctive relief, statutory damages, and actual damages. We don't necessarily agree. First, all of these remedies will remain available (to the extent they apply in the first place) if the copyright owner exists and is findable. Second, the legislation will not limit injunctive relief, except in instances where the user has invested significant new authorship and, in doing so, has relied in good faith on the absence of the owner. Third, statutory damages, which are

available only when a work has been timely registered, will usually not apply at all because the overwhelming majority of orphan works are not registered by owners but languishing in institutions and private collections. Fourth, one of the basic tenets of the legislation is that the available remedy will be proportionate to the nature of the infringement. Reasonable compensation, a standard derived from a leading case on copyright damages, will usually be within the range an owner could expect to recover in an ordinary infringement suit. And it should certainly reflect a reasonable license fee.

We believe that eventually some type of bill will emerge and when it does we will both have something to say about it. Neither of us believes that any such bill will spell the end of the world for creatives. As it stands now, if you do not register your work, with or without an Orphan Works law in place, you are severely restricted in your options to get satisfaction (i.e. money, attorneys' fees, and injunctions) in the event of infringement. The most important lesson still stands: register your work, no matter what.

Orphan works are not a problem confined to America. This is a global issue. All countries that are Berne Convention signatories have or will have something to say on the issue. Canada passed an Orphan Works bill years ago, and while Canadian copyright laws differ from U.S. laws, infringement anarchy (as predicted by some in the U.S.), has not come to pass. This does not mean, however, that we cannot, as our good friends in fictional South Park, Colorado say, "Blame Canada!" We just can't blame it in this instance.

BEWARE! WARNING!

While any works before 1923 do not have a copyright and are in the public domain, assuming that just because a work is old, it *must* be in the public domain, can get you into deep manure.

If you're at all uncertain, the failure to obtain a written license or permission to use or copy the work from the creator or owner can get you sued and broke. Remember, an owner need not be the creator. The work and the copyrights (and/or trademarks and/or

patents) could have been and routinely are sold, transferred or left to another person or company in a contract or will.

Years ago, many TV stations would run Frank Capra's movie *It's a Wonderful Life* over and over during the holiday season. Why so many times? Many believed the movie fell into the public domain because of a clerical error in renewing the copyright and the TV stations didn't have to pay royalties to show it. But it was argued successfully in court by the copyright owners that the movie was a derivative of the original short story, *The Greatest Gift.* And so the copyright, based on that, stands. It's still shown during the holidays, but not nearly as much as in the past because it's not in the public domain, as assumed. So be careful when assuming something is in the public domain.

What Qualifies as Fair Use?

Copyright law gives the creator the exclusive rights to reproduce, distribute, and publish their work and/or grant one or more of those rights—via a "license" or permission—to others such as publishers and filmmakers. Typically the creator receives a fee (money) from someone obtaining one or more of the rights the creator by law possesses. In a sense, the creator owns a monopoly on the work, but there are exceptions to this absolute control.

One exception is known as "Fair Use," and it is mistakenly asserted about as often as it is legitimately relied upon. The concept green-lights the efforts of a non-author to copy, publish, or distribute certain copyrighted works without the consent of the creator or registrant for purposes such as commentary, news reporting, education, or scholarship. Historically, copyright law has always been about a "balancing act" between the benefits to society and the rights of creators.

Fair Use is a category of works, which are in effect exempted from the regular rules of copyright. In plain English, the courts permit a work that fulfills the requirements set by the law to be classified as a Fair Use and thus it can be used without infringing upon the rights of the copyright holder (creator) under the Copyright Act. If the work is classified as a Fair Use it means that the persons using it need not pay a licensing fee to anyone nor pay

a judgment for losing a case in copyright infringement. Big bucks are frequently at stake.

Some claim that Fair Use simply legitimizes a special category of stealing. Others assert that Fair Use is sensible and allows for freer discourse. There are attorneys on each side and many who switch sides from case to case. The concept and term are frequently, in fact almost always, misunderstood by both attorneys who do not practice copyright law as well as by photographers. While most lawyers will admit their uncertainty when pressed, by and large photographers do not.

The courts have applied a four-part test to any work where a claim for a Fair Use exception to the Copyright Act is made. This test is not employed with the simplicity or precision of a mileage chart or a light meter.

Here are the four factors which the courts need to consider *on a case-by-case basis* to determine whether a specific use falls under this exception to the copyright law. As you read each factor you need to be patient and "wait for it" because no one factor on its own clinches anything.

1 *Purpose/character of use.* The court looks to whether the use is not for profit, educational, or commercial. Is the work "transformative" or merely a substitute for an (existing and presumably registered) original? A book or movie review that quotes original dialogue is likely to be determined "more fair" and transformative than a mere copy of the original used to simply avoid paying for a license to use the original.

2 *Nature of original work.* One cannot protect an idea or fact but only an expression of an idea. Simple sample: Ed can't protect (register) the idea of Lady Gaga in modern football gear running over Madonna holding a football, wearing an old fashioned leather helmet, merely by thinking it up. Jack *can* with his camera create an expression of the above, a photograph, and that expression can be registered. A painter *can* create with their brush an oil painting of the above and that expression – a painting – can be registered.

The more "facts" in the original, the greater the chance that the work seeking protection will qualify as Fair Use. A mere compilation of only facts and statistics might not qualify for copyright registration at all. Think of a

compendium of weather data for Las Vegas, Nevada. If the layout, organization, design, and so forth are so unique and original, then the "original" might qualify. However, if the "new" work is a photograph strikingly similar to the original – like those of, the famous, unique, iconic photos of say Richard Avedon – a claim of Fair Use is more likely to be classified, as we lawyers like to say, as *mucho lame.*

3 *How substantial, how much of the original was taken.* There is no percentage of taking, stealing, appropriating that marks the legal boundary line. It is not like a breathalyzer test where you are either under or over the limit. That such a percentage exists is a myth that simply will not die. Courts look to whether the "heart of the original work" was appropriated by the work seeking the Fair Use exception. The amount taken is indeed relevant, but it is not the Holy Grail of the Fair Use test as some people wrongly assume.

4 *The effect of the "new" use on the commercial market or upon the value of the original.* Does the new work serve to reduce the demand for the original in the commercial marketplace? Does the new work serve to devalue or dilute the price of the original in the commercial marketplace?

Unwritten Rules

Courts will also look at things like the behavior of the parties, the motive of the lawsuit (i.e. to squelch criticism or kill a competitive movie or book) or whether one party is simply attempting to outspend the other to force a party in the right to simply give up the good fight or risk bankruptcy. A successful claim is not dependent upon satisfying any one or more of the above factors.

Warning: These issues are always fact- and judge-sensitive.

Chapter 2

Copyright Registration

The scene: The 1800s, somewhere in the Old West. Our hero is standing tall, wearing white—white jeans, white chaps, white shirt, and, of course, a white 10-gallon hat. It's a windy day on Main Street; nothing but tumbleweeds playing across the road. The windows of the wooden buildings have curtains moving slightly, as cautious townsfolk peer out into the scene. At the other end of the street, there stands Black Bart: the meanest, orneriest copyright bandit west of the Pecos. Dressed in black leather, with a handlebar mustache and an evil curl on his lip, Bart sneers at our hero.

The sun is high in the sky, and the air hangs heavy. Our hero reaches for his gun, takes a bead, pulls the trigger, and . . . nothing. Nada. Just a loud click. Unloaded gun—whoops! The villain in black laughs, spins on his heels, and strolls out of town with the loot, yelling, "Maybe next time, sucker!"

Now let's re-shoot the scene. This time there are bullets in the gun, and Black Bart knows it. As soon as our hero makes a move for his weapon, the villain's hat blows away, his mustache falls off, and his lip quivers with fear. He turns the loot over to our hero and walks away in chains. Justice is served.

Copyright without registration is like a gun without bullets. The gun might look flashy and feel reassuring, but it's useless against a real thief. Since relatively few photographers register their work—perhaps only 5%, and that's being optimistic— odds are that you are not currently registering any or many of your

photographs. If you are among the five percent, then you've protected your work. You have image insurance, just as you have camera or business insurance.

Written Benefits

When you register your work, protections and remedies are available to you under the law, in addition to the copyright bundle of rights explained in Chapter 1. With registration, you have a very big shield that protects your work, and a very big club with which to pursue infringers. The additional rights you get by registering your work are as follows:

The ability to file a lawsuit. That's right, you cannot file a copyright infringement suit against anyone without a registration in hand. Registration is your "key to the courthouse." Copyright is a federal law and copyright cases must be heard in federal courts. You can file in state court, civil court, or any other legitimate court of law, but (unless you count Judge Judy as legit) any court other than a federal court cannot hear a copyright suit and will kick it out the door. Of course, the court clerks in those other courts will take your money for the filing, only to then have the judge inform you that they can't hear your suit.

Compensatory damages. To dissect the word "compensatory" in its root, it's the actual compensation for your work. This is essentially the value of the fees you would have earned had the infringer initially come to you in good faith and legitimately paid for a license of your image. The minimum compensatory damage would be the amount you would have charged had the infringer asked and fairly negotiated for use of the image with you. There are various factors in computing compensatory damages, but suffice it to say they are computed so as to award you, at least, the amount of money you have been deprived of by the theft of your image. You may also seek money damages if as a result of the infringement it is now more difficult or even impossible for you to ever license your original image (including similars) ever again.

Statutory damages. In an infringement case, you can decide to collect either compensatory or statutory damages, but not both. Timely registration gives the copyright holder's lawyer the option to select which form of damages to seek. Statutory damages are based on the court's discretion and may be substantially higher than compensatory in

some (probably most) cases. However, in other cases, especially when dealing with "big name" photographers and/or huge ad campaigns, the opposite may be true. The election or selection of which damages you want the jury to award can be made after the evidence has been heard and just before the jury leaves to deliberate. Bottom line, you are permitted to choose which form of damages will give you the most money.

Lawyers' fees. You gotta love this one. On top of the above damages, the court has the option of directing the losing party to pay for the prevailing party's lawyers' fees and expenses. The court will accept itemized invoices, paid bills, and similar backup material along with testimony from the winning attorney. If the defendant has been unreasonable in failing to settle the case or has otherwise wasted the court's time, such fee awards, while they must be "reasonable," may be quite generous. When they do award your lawyer fees, it's like hitting triple cherries on a slot machine. It feels right, and it feels good.

Injunction. This is an order from the court directing that the photos at issue cannot be used by the defendant in specific usage or not used at all. Such an order may also take the form of requiring the client to remove the advertising or product "from the stream of commerce" so long as the infringing continues. An injunction may also direct the removal of the image from the items on which it appears, as in "Pull those photomugs off the shelves!" Injunctions may be temporary or permanent. The threat and/or cost of having an injunction issued against an advertiser or client is intimidating and often persuades them to offer a settlement. So if your image appears on an Everstrong cereal box and that

is offered for sale at every Acme Supermarket location, think of what it means if an injunction forces a client to remove the gazillion boxes that are out there. Think of the cost of destroying all those boxes. Think of the leverage and the size of the stick this gives you in talking with the infringer about settling your case.

Some common reactions from photographers regarding registering images at the Copyright Office go something like this:

"I don't shoot no stinkin' celebrities."

"I don't hang with rock stars."

"I don't have a big city studio."

"I don't shoot fancy-schmantzy photos."

"I do shoot local people, everyday people, doing everyday things, in everyday places."

"I shoot for schools."

"I shoot weddings, Little League, and VFW events."

"So why do I have to bother with this legal stuff?"

"Why should I spend time and money registering my images?"

"I don't want to be a lawyer, I don't want to talk to a lawyer. My brother-in-law is a lawyer and he's a moron!"

Needless to say, none of the above are reasonable objections to registering your images. No matter the subject, and no matter your personal feelings about lawyers, it's always a smart move to register. As you'll see throughout this chapter, you never know which photos will suddenly become valuable.

★

LISA STEINBERG

In October of 1987, photographer Stuart Gross was on location in a New York City elementary school shooting a catalogue for his client, Scholastic Books. Stuart had obtained model releases for all of the children on the slight chance that one or more of the kids might be used in a shot.

He came upon a young girl who looked, well, sort of out of place. Unlike the other kids in her class, her hair was matted and her fingernails were dirty. Most importantly, Stuart noticed a "mouse" under the child's eye. He and his client questioned the young girl as to how she received the bruise. She was evasive. The child's teacher advised that Lisa received the bruise while fighting with her six-month-old brother.

With no intention whatsoever of using the child's bruised face and disheveled appearance, Stuart took several shots of her anyway. He was captivated by Lisa and photographed her on pure instinct.

A few days later on November 2, 1987, officers of the New York Police Department responded to an emergency call and found the young Lisa Steinberg comatose in the upscale, Fifth Avenue brownstone apartment of her adoptive parents. In addition to traumatic injuries that proved fatal, Lisa remained comatose and was put on life support. Lisa Steinberg was ultimately taken off life support and her adoptive parents, Joel Steinberg and his paramour, Hedda Nussbaum, were arrested in connection with her death. Later, her adoption by Mr. Steinberg (a lawyer) and Ms. Nussbaum (a children's book author) proved to be illegal.

The story immediately became public and was reported by virtually every local and national television network, newspaper chain, and news magazine in the country. It was even covered by the foreign press in Europe and elsewhere. Immediately, there was an instant and significant demand within the print and television news industry for photographic

images of Lisa Steinberg as she appeared at or before the time of her death. Everyone wanted to see what this little girl looked like. Precious few images of Lisa Steinberg were known to exist at the time of her death and only one old shot became available for licensing purposes through *Newsday*.

Stuart called us as soon as the story broke, and we went to the New York County District Attorney's Office with the critical evidence. Along with Stuart's

testimony, his photos helped serve as the basis for indicting Mr. Steinberg. These images were—at the time of the assault and still to this day—the only photographs ever existing or published which demonstrate that Lisa suffered physical abuse, was a victim of such abuse prior to the fatal assault, and that she carried her bruises "in the open" for others to see. Later, Stuart became a star witness for the prosecution at the trial of Joel Steinberg. The District

Attorney used the images as evidence and a fine relationship was developed between photographer and prosecutor.

Stuart also agreed to selectively—very selectively—license the images to specified media outlets that, he believed, would preserve the dignity of both the image and subject. In the days following the fatal assault, restrictive licenses were given to (only) the *New York Daily News* (front page), *ABC Television*, *Nightline*, *20/20*, and *WABC*. Stuart rejected numerous proposals made by media companies to license and/or sell these images. Plus, the licensing agreements that he did grant set forth specifically how the images could be printed and used. Monies were donated to a charity dealing with abused children in New York City. Turning down substantial sums of money, Stuart made the conscience decision not to exploit the images in certain media or for certain purposes.

Over the span of the ensuing 20 years, Stuart extended licenses for the use of the images very selectively, including *Life* magazine's *The Year in Pictures*

1987, where it ran as a two-page spread. Lisa Steinberg became the poster child for the formerly closeted issue of middle-class child abuse. Infringements of the registered shots occurred many times over the next two decades. Unauthorized media outlets sought to use the images on numerous occasions, including, but not limited to: the time of the arrests, during the trial, at the sentencing of Joel Steinberg, at the plea deal for Hedda Nussbaum, upon Steinberg's release from prison some 18 years later, and requests continue today even after Stuart's untimely death. There are no equivalent or similar images of Lisa Steinberg out there and there never will be.

Most offenders knowingly infringed and elected to run the risk of being sued. Stuart and Ed prosecuted each and every violation.

It has been many, many years since the photos were taken. Ronald Reagan was President and iPhones did not exist. Stuart passed away several years ago. Nevertheless his images continue to be

infringed from time to time and lawsuits have been brought on behalf of Stuart's wife and children.

Copyrights can and should be passed down via a will drafted by a competent estate lawyer. Photographs can be valuable assets. Stuart understood this and made the necessary arrangements.

While no one enjoys considering their own mortality, it is necessary to organize the body of your work so that it can generate income to your heirs after you have passed. All too frequently, photographers neglect to treat their own collection of images with the same care employed to create them in the first place. Photographers, like most people, are not exactly eager to pay a visit to a lawyer to draw up a will.

It is, however, simply smart to have a will prepared. It is good practice when planning your estate to appoint someone with expertise in the licensing and/or sale of images to represent your photos after you have gone to your eternal reward. Such a person typically earns a fee for such services and the heirs benefit by having the sale and/or licensing potential of your images maximized. Leaving that responsibility to someone who knows absolutely nothing about photography often serves to deprive your family of money it could be receiving for decades to come.

Most photographers who have had good relationships with their agents appoint their agent. A spouse who knows the business is frequently the very best choice. In 1987 no one could have possibly known that these images would be stolen many times over a period of nearly *three decades* generating a significant amount of money. That's why we love to say, "Ya' never know." Here is but another instance where you should *assume* that your images will have worth long after you are gone.

UNWRITTEN BENEFITS

These remedies and protections, standing alone or together with others, form a very, very big bludgeon when you tell a client or an infringer that your work is not only copyrighted but also registered. If you find your work has been infringed and it's not registered, most likely the best you can hope for is to get them to stop using your work. But if that work is registered, cha-ching—you know that there is a good chance money will be coming your way.

Along with these specific benefits of registration, there are also numerous "unwritten" benefits. One example of an unwritten benefit is that registration serves as real leverage to ensure you will be paid after shooting a job and delivering the images to a client. Having the images registered serves as a big stick if the client uses the photos before you've been paid. In cases like this, if all you have in your favor is your unregistered copyright, a client can tell you to take a hike; sadly, you will find out that you may not have many other economic options. But with your copyright and registration, you have the upper hand. The threat of a lawsuit for copyright infringement is far more powerful than lawsuits commonly termed "theft of service" or a suit for "services rendered." Receipt of a complaint against an infringer with the stamp of federal court for alleging copyright infringement is a very sobering experience. It's a serious and expensive matter regardless of the size of the infringer's business or finances. And that's what gives you the upper hand with infringing clients or clients who simply avoid paying you. Nowhere does it state that a federal copyright lawsuit is an intimidating factor in settling or forcing payment, but let us tell you: It definitely is extremely intimidating. Many infringers are brazen and pugnacious until their attorneys inform them of what a federal lawsuit entails, the size of the lawyer's retainer, and what it may cost them if they're found liable for infringement. The prospect of a federal suit will generally deflate the blustering airbags, and settlements are usually made, saving both the client and you the expense of going to court. A federal copyright suit cannot be ducked or ignored. As sometimes stated, it's now a "federal case."

So, How Do You Register?

Registration is so simple that it takes longer to describe than to actually do. Still, you shouldn't try to register all the images you've ever taken at one time. Chances are you'll get discouraged and probably avoid the project. Start with a smaller, current project. Then, when you can, go back and take another bite of your library of images. The important thing is to get the process started. Jack tries to register his images every three months and also whenever he shoots a big job. He doesn't always make it exactly on the three-month mark, but he makes the effort. And if he's busy that quarter then he'll register several times in that three-month period.

It's easier to register when the work is unpublished. With unpublished work, you need just one small JPEG of each image to send as the "deposit" to the Copyright Office. If the work later becomes published, you are fully protected. You cannot mix published work and unpublished work together in a registration. With published work, registration can be more complicated.

Registering a past collection of published works, a question we get all the time, is a bit more complicated and time consuming compared to how simple a collection of unpublished images is to register. We have therefore devoted a section to registering published collections.

Also, the additional protections you get from registration are there only if you register before an infringement. You can always register images even after an infringement, as you need the registration in order to file any copyright infringement suit, but you lose some of the additional benefits that a pre-infringement registration provides. You lose the right to pursue statutory damages and most likely attorneys fees, without prior registration. There is one exception of having a registration after the infringement registration date and being fully protected: For published work, and only published work, you have a three-month window after the first date of publication to register and still be protected even if an infringement has already occurred. Nothing seems to confuse people more than this exception. This three-month window exists only for published images, not unpublished images. So moving quickly when

you discover an infringement can be critical in your case.

So, if a photo is published on January 1st, and someone infringes it on February 1st, then as long as you register it as published by April 1st, you will be fully protected against the prior February 1st infringement. If you wait until April 2nd, then you are one day beyond the three-month window of protection. Just to emphasize and reiterate, this is only for published work, and it's a three-month window—not a 90-day window as sometimes described. The law is stated as three months, so January 1st to April 1st is three months, no matter how many days are in between or if it's a leap year. Just like your birthday is always the same date every year, no matter how many days in between (365 or 366).

Let's look at the same scenario, but this time the work is not published. You create the work on January 1st. It is infringed on February 1st. You register it February 2nd, a day after the infringement. You are not as protected. Sorry, but that's the way the law is written.

Basically (with the notable exception for published work), register today and you are protected for tomorrow, but you were not protected yesterday. You might want to read that all again slowly. Listening to Jack and Ed explain this material in their lectures is like listening to Abbott and Costello doing their "Who's on First?" routine. Trust us, your hair will stop hurting soon. It does eventually make sense.

As stated above, it's easier to register your unpublished work and be protected in advance. If you register a work as unpublished, you are still protected if it is published at a later date. But if you publish a work first and then register it later, it must be registered as a published work, which requires a few extra steps in the process as you can see below. A notable exception is if the work is published without your knowledge. In that case, the courts will respect your work as unpublished and its registration status as unpublished.

★

DEFINITION OF "PUBLISHED"

Published means "presented to the public" and not just printed in a magazine or book. Displaying a photo on a website so anyone can see it is publishing; putting it on your website with password protection is not publishing, as the photo is not presented to the public. The same principle applies to a bride's wedding album. When you give the bride her wedding album, that's publishing, as you have no control over who sees it. But, if you give a bride a book of proofs, that's not publishing, as the images are considered work in progress.

One famous photographer never sends out any photographs without a specific license attached— including snapshots sent to his mother! This protects him from accusations that the work was previously published. If you send a photo out without any control (a license for instance) then it can be sometimes considered published. Even if it's far-fetched, it opens a door for a lawyer to pursue. Better to have that door closed by registering the work before it leaves your hands.

So does posting it on a social site like Facebook render the image "published"? If you put the image on a *public* area of a website under your control (i.e. your own site or your social media site) where almost anyone can view it, then the image will most likely be considered "published."

Below is how the Copyright Office addresses this question. Note the second paragraph where the Copyright Office states it's up to you to make the determination of published or unpublished:

> *Publication*. Under copyright law, publication is the distribution of copies of a work—in this case, a photograph—to the public by sale or other transfer of ownership or by rental, lease, or lending. Offering to distribute copies to a group of people for purposes of further distribution or public display also constitutes publication. However, a public display of a photograph does not in itself constitute publication.

The definition of publication in the U.S. copyright law does not specifically address online transmission. The Copyright Office therefore asks applicants, who know the facts surrounding distribution of their works, to determine whether works are published.

Registering a Collection of Published Work

In order to register a collection of published images, you will need to jump through a bunch of hoops, compared to the ease of registering a collection of unpublished images. The first difference is that you need to contact the Copyright Office and ask to be put on their "pilot" program for registering published collections. You do that by contacting the Visual Arts Division at the Copyright Office at (202) 707–8202. It can take a while to get through, but once you do they are very helpful and nice, so be patient. They will then assign an inspector to you to instruct you and facilitate your first few registrations. The inspector is basically there to make sure you follow the exact specifications for this type of registration.

You will also be limited to registering no more than 250 images per application, and only if they are for one calendar year. When the inspector feels you have the process down and can do it properly on your own, they will cut you loose and you can exceed the 250 limit. At that point, you can register more than 250 per application. We don't know what the upper limit is after that, but even 250 published images is very respectable to us.

While the naming convention for unpublished work should be descriptive, the naming conventions for published works need to be very specific, including the number of images in the collection as part of the title. For example the title needs to be named like this: "Group Registration Photos, Hawaii, published Jan. 1, 2015 to Dec. 31, 2015: 250 photos." You need all that information.

After that, the title of the collection itself, you need to enter the contents titles, or in other words, title each image very specifically. You need to include the publication date in each title, at the end of the title. If the example above were the collection, the individual file names would be like this: "Diamond Head, Feb. 14, 2015; Pearl Harbor Mar. 2, 2015; Maui Wowie Drink, April 1, 2015" and so on. You enter all the image titles in a string, each separated by a semicolon. The title goes

© Sarah Silver. This is a collection of Sarah's published images that was registered as a published collection.

into the Contents Box, and you are limited to 1900 characters, including spaces. For 250 images, you will probably need more than 1900 characters. While the Contents Box has that 1900 character limit, you can have up to 40 Contents boxes. And there is a total limit of 75,000 characters per application. Got that? 1900 characters per box, 40-box limit, 75,000 characters total. Ah, but there's more.

It's best to write it all out in another program, and then cut and paste, rather than do it all on the Copyright website, as it will take a while to write out. But you cannot use MS Word or WordPerfect to prep the titles. There are formatting issues and unseen added elements that happen further down the line, so it's required to use a "dumb" word program, like Notepad, WordPad, or something similar.

You then fill out the rest of the registration application, just short of hitting the "submit" button. Before you can submit, you need to call your assigned inspector to go over your application.

Not too hard, but not as easy and quick as registering unpublished images.

The three elements you need to register images are:

1 The registration application filled out.

2 Payment for the application (Single image $35; Collection of images $55).

3 Samples of the images.

★

WHO KNEW? PART 1

Years ago a photographer in a small sleepy Southern town had a young high school graduate walk into his studio to get some standard portraits. He wanted a common package for family and friends, mostly a wallet size order, with maybe an 8 x 10 or two. No thought of any editorial or advertising usage entered anyone's head. Nothing special, nothing glamorous. In no one's wildest imagination would these images be seen by anyone other than family and friends.

Some years later, Jack got a call from the photographer, Ken Knight of Franklinton, LA. Seems that the young man he photographed up and married a local girl from the Bayou state. They got hitched in a fever at a marriage chapel in lovely Las Vegas, NV. A very common, oft-told tale except for the blushing bride's name—Britney, Britney Spears.

The photos of the wedding ceremony itself were subject to a big buck media exclusive. They were not, therefore, available to the general news media. Instantly there was an insatiable demand

© Ken Knight

for images of the new groom by the general worldwide media. Since the young lad was not in show business and had yet to do anything newsworthy, nobody had a photo of him.

The stock cupboard was bare and hysteria spread to stock agencies, networks, and media conglomerates throughout the land. They all wanted to see a photo of the guy Britney chose to marry. What did he look like? Suddenly

and quite magically, Ken's image was everywhere. But Ken wasn't getting paid for his photo and no one had asked for his permission to run it.

During their phone call, Jack asked Ken the first question that is always asked, "Is the image registered?"

The answer, as usual, was "No." Uh oh. "Better talk to Ed Greenberg, a lawyer, right away," advised Jack.

By chance, Ed was in Washington, DC on another photography case. Good timing and good luck for Ken, who sent the registration materials directly to Ed in DC. Ed then walked the registration through the Copyright Office and obtained an "expedited registration." Because of that registration, lawsuits were filed against various media companies—all of which were eventually resolved to "the mutual satisfaction of the parties." All we can say is that Ken is very happy he called Jack and had the image registered right away. Who knew?

HISTORICAL BRIEFS—1700S—THE STATUTE OF ANNE

In the 1700s, writers were taking advantage of increasing numbers of printing presses set up across Britain following the relaxation of government controls on printing in 1695. Along with these new writers came those who profited from their labors. No, not agents (they came later, in swarms, like locusts); but rather the booksellers (we would today call them publishers) who prospered and profited. In order to create a more diverse publishing market and to break up the monopolies enjoyed by a small group of London booksellers—so that the educated could get cheap editions of standard works, like Shakespeare—it became necessary to create rights for authors. The result was the original copyright law, passed in Britain in 1710, called the Statute of Anne, which "for the Encouragement of Learned Men to Compose and Write useful Books" gives authors "the sole Right and Liberty of Printing such Book and

Books for the term of One and twenty Years." The Statute of Anne is formally titled "An Act for the Encouragement of Learning," which is notable for Americans because, in 1787, the same idea was written into the United States Constitution, which uses the words "to promote the progress of science and useful arts."

WHO KNEW? PART 2

Jack photographs kids for large companies, typically licensing the images for national consumer usage. One day, Jack got an angry call from an art director asking why Jack licensed one of the kid's images, for which they held the license, to an online discount coffee website.

Who knew that this photo would be infringed by a website selling coffee? As Ed found out in deposing the owners of the website, they used it because the girl appeared "coffee colored."

"Who, me?" Jack responded—a phrase well known by every married man. "Never!" He might re-license an image, as is his right, after the licensed use is over. But Jack emphatically told the art director that he did not and would not license the image during the term of his client's license.

Jack's client had discovered the infringement purely by chance—an employee who was shopping via the Internet recognized Jack's image on the coffee website. Jack immediately advised his client that he would contact his lawyer to have the offending image taken down.

Jack sent Ed a copy of his copyright registration and Ed proceeded to write the dreaded "lawyer's letter," the kind no one wants to receive, with the registration attached. While Jack is an artist with the camera, Ed is just as much an artist in his own right at drafting those letters. That letter requested that the

image be taken down and a written account of the full nature and extent of the offending use be sent to us ASAP. Immediately upon receiving Ed's letter, the offender took down the image. Essentially their position was that since they had removed the infringing image, Jack's problem was solved. Sort of, "OK, you caught us and we took it down, so no harm and no foul. Why make a federal case out of it?"

Letting an infringer off without seeking damages would encourage that infringer and all future infringers to assume a catch-me-if-you-can attitude. They could simply continue to rip off images because there would be no deterrent to keep them from doing so. Under the copyright law, Jack had certain rights as the author of a registered work. Included among those rights is the ability to sue for money damages irrespective of whether or not any profits were generated. Jack likened the infringement of his work to being stabbed in the chest with a serrated knife. Simply saying, "Whoops, my bad" does not itself heal the wound. Nor would merely taking the

infringing image off the website be the end of this story.

The defendant represented itself as a small, mom-and-pop operation with no other employees. But their mom-and-pop operation was marketing name-brand products throughout the country, and apparently making close to a 7-figure business. Mom and pop were cookin' and not hurting. Recently in one of Ed's court cases the infringer's attorney told the Judge that his client was "a tiny company with only 15 full time employees". Ed responded, "Judge, let me introduce you to my client, Mr. (Photographer). You are looking at *all of his employees*." Whether a business is profitable or has profited from an infringement does not determine whether an infringement has occurred. In infringement cases, we prefer dealing with experienced Intellectual Property (IP) lawyers who understand the risks and rewards of litigation to both sides. Scare tactics or dares used by inexperienced lawyers typically backfire. Rather than resolve the matter without resort to litigation, this defendant in

offut clarod Jack to sue. So sue he did, in federal court in his hometown of New York City.

We want to make it clear that prosecuting a copyright infringement case is no walk in the park. Taking oral depositions is just one part of the process. Ed would depose the website owners, and their lawyer would depose Jack. Ed prepped Jack for his deposition. Let's just say that many of Ed's clients get really peeved at Ed after he preps them—a fact of which Ed is quite proud. The prep session basically involves getting grilled like a chicken on a summer barbecue and being bombarded by a hurricane of questions. If you are properly prepared when an opposing lawyer questions you, the experience can be like a walk in the park. Instead of looking like a deer in headlights, you now sound like Sir Lawrence Olivier. Don't worry, Jack has long forgiven Ed for that deposition prep he went through. Well . . . sort of.

After his prep, knowing Ed was going out to St. Louis to depose the infringing couple, Jack almost felt sorry for the offending couple whom Ed would be deposing. Almost, but not quite.

You see, the defendant's own website bore a copyright notice. Even though Jack's image had been misappropriated, mom and pop knew enough to register and protect their site. This opened the door at the deposition for questions all aimed at why this defendant would violate the rights of a creator while at the very same time seeking to preserve those very same rights for themselves! You can't make this stuff up.

With the amount of the monetary settlement that was paid, we are fairly sure they have not and will not be infringing anyone else's work. Good.

All of this was only possible because Jack had registered his image long before the infringement occurred. Without the registration, this lovely story with a happy, income-producing ending would likely have not ended well for Jack. Without a proper registration, you simply cannot file in court and get the remedies allowed by the law. Who knew? Luckily, Jack knew that.

Registration Walkthrough

We've talked about why you should register your photos until we're blue in the face (see photo). Now, we'll hold our breath until you do register your work (see same photo). Here's how to register.

This walkthrough will only cover the eCO (Electronic Copyright Office) system. There is a paper option, the old paper VA (Visual Arts) form, but the Copyright Office discourages the use of it. It does so by charging more, $85 for a paper filing, as opposed to $55 for electronic filing, and by taking a year or more to return the

Certificate of Registration

This Certificate issued under the seal of the Copyright Office in accordance with title 17, *United States Code*, attests that registration has been made for the work identified below. The information on this certificate has been made a part of the Copyright Office records.

Maria A. Pallante

Register of Copyrights, United States of America

Registration Number

VAu 1-174-775

Effective date of registration:

May 27, 2014

Title

Title of Work: 2014_2ndQT_CanonCIATour

Completion/Publication

Year of Completion: 2014

Author

Author: Jack Reznicki

Author Created: photograph(s)

Work made for hire: No

Citizen of: United States Domiciled in: United States

Copyright claimant

Copyright Claimant: Jack Reznicki

New York, NY, 10016, United States

Rights and Permissions

Name: Jack Reznicki

Email: jack@photonews.net Telephone: 212-

Address:

New York, NY 10016 United States

Certification

Name: Jack Reznicki

Date: May 27, 2014

Page 1 of 1

Here is a copy of the Certificate of Registration that the Copyright Office mails you. Note that there is an "effective date of registration" in the upper right, reflecting the date you finished registering. The certificate itself can take 3 to 4 months to arrive, but your copyright is protected from the stated effective date.

registration certificate to you, versus three or more months to get the certificate via electronic filing. We highly recommend sticking with electronic filing, unless there is a compelling reason to file by paper. Once you have completed your first online registration, the next time will be easier.

There are basically three steps to registering your work with the eCO system: filling out the application; paying for it via a direct link to the U.S. Treasury; and, finally, sending in your images by either uploading them digitally or mailing your images in. The great advantage of registering via eCO and then uploading your images is that your registration becomes effective immediately. If you mail in your images, your registration will not be effective until the Copyright Office receives them. That will delay the effective registration date.

The effective date is important, as that's the date your registration protection starts. If you are infringed before the date of the registration, even though you started the process, it's like not being registered at all. But if any infringement occurs after that date, then you're covered. It's important to note

that the effective date of registration is the day that the Copyright Office receives all the elements of your registration, regardless of how long it takes them to process your application, or how long it takes for you to receive the registration certificate. Getting the registration certificate could take two months, three months, or even a year. Again, the three required elements are: the application, the payment, and the images themselves (files, prints, contact sheets, or whatever).

The registration fee is $55. That's per application, NOT per photo. Jack's record for highest amount of images registered with one application was over 13,000 unpublished images, all for the one application fee.

To start registering your work, go to www.copyright.gov (Screen 1A). There is great info on this page, so do look around. But be very careful you do not go to the dot com, "copyright.com," website instead of the dot gov (.gov) website. The dot com used to be a commercial site offering to register your copyright for a fee, but it appears the Copyright Clearance Center (CCC) purchased that URL and it is now their site. The CCC is an organization that clears

Screen 1A

"content," meaning copyrighted material like photos, writings, and artwork, so publishers can use it. They take a small fee for reprint rights and nothing, or close to nothing, floats down to the photographers, authors, and artists. We are not fans of this site and suggest that you be diligent and make sure you are on the dot gov (copyright.gov) website.

Screen 1B

Once there, proceed to the "electronic Copyright Office," which will be shown as their acronym "eCO." To get there from the front page, go to where it says "How do I . . .?" and click on the "Register a Copyright" box (see red arrow on Screen 1A). On the right side of the next page (Screen 1B) you will see the current estimated times to get the registration certificate mailed back from the Copyright Office. Electronic submissions usually take 3 to 5 months, but sending in a paper form can take 7 to 13 months.

Click on the eCO symbol (see red arrow on Screen 1B) and that will take you to the eCO sign in page (Screen 2).

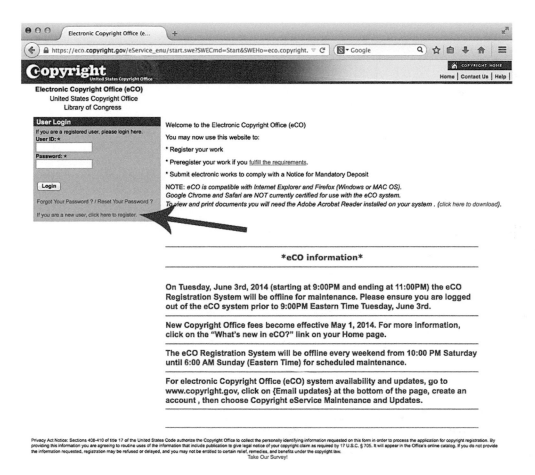

Screen 2

You can also avoid all of these preceding pages in the future by simply going directly to the log-in page of eCO by using the URL www.eco.copyright.gov.

If you are a first-time user, you need to create a Username and Password when you get to the sign in page (Screen 2 at arrow). This is the page we recommend you bookmark, so you can start here next time, and skip over all the previous screens. Your password must contain letters, numbers, and at least one "special" symbol, like "$" or "%" or "!"—so a password for Jack or Ed might be JackShoots $5000 or EdWillSue!x2. If you already created a username and password previously, just sign in.

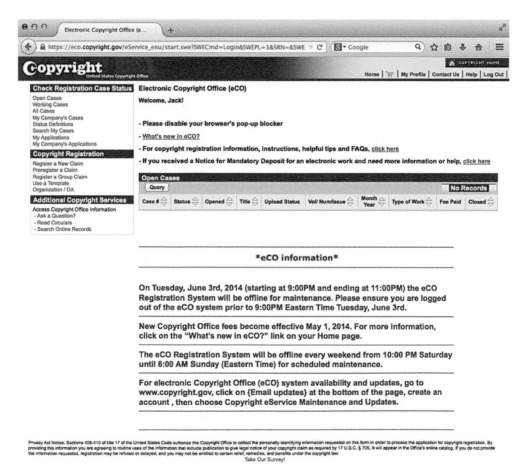

Screen 3

REGISTRATION STATUS

The description of the status of your cases according to the Copyright Office is as follows:

1 *Open:* These are cases currently being processed by the Copyright Office. "Open" means you can still upload images in that registration. The date of your most recent upload will be the effective date of the registration. The registration ends when you click on the *Upload Complete* button on the *Electronic Deposit Upload* screen (Screen 40) at the end of the registration process and the date you do that will be the effective date of registration. If I start a registration and upload most of my images on January 1st, and then leave the registration open and upload more images on January 22nd, the effective date of my registration is January 22nd, not January 1st when I started the uploads.

2 *Working:* These are cases that you have started registering and payment has not yet been submitted (i.e. you haven't placed the application in your Cart).

3 *In-Cart:* These cases are in your Cart, thus, they have not yet been submitted to the Copyright Office. You've completed the application for them and are either in the process of paying or waiting for confirmation from the Treasury that payment was made.

4 *Closed:* These cases have been completed by the Copyright Office. The application is done and your registration is either on its way or you already have it in hand. To view closed cases, click the All Cases link on the upper left of the eCO front page.

5 *Discarded:* These are cases that you want to remove from your case history. You can still view discarded cases by clicking on the "All Cases" link.

HELPFUL HINTS

MAC or PC, you can't use the Safari or Google Chrome browser on the Copyright Office registration website. You must use Firefox or Internet Explorer (IE). There are also some prompts you should read if you are on Firefox, which have to do with setting your preferences. It reads:

> Firefox 2.0 users must adjust the Tabs setting to 'New pages should be opened in: a new window.' The Tabs setting is under Tools/Options in Firefox for PCs; the Tabs setting is under Preferences in Firefox for MACs.

OK, so their instructions are a little behind in software versions, but the preferences are still the same for all the current versions of Firefox. It takes a while for government sites, which work under tight budgets, to update such stuff.

For all browsers, you should disable the pop-up blocker. Also disable any 3rd-party toolbars (e.g., Google or Yahoo Toolbar). And finally, set your security and privacy settings to Medium.

Do not use the forward and back buttons on your browser once you start your registration. This will cause the registration program to self-destruct. You need to navigate using the program's *Next* and *Back* buttons. There is also a *Save For Later* button, which will stop your registration at that point and save everything you've done so far. Then you have to start at the front page again and navigate back to where you were via the *Next* button. Quite kludgy, we admit.

After putting in your username and password, you will finally find yourself at the eCO front page (Screen 3). We like that they greet you here—in this example, "Welcome Jack!"

If you have any open or working registrations, called "cases," you will see them listed at the bottom.

★

Filling Out the Application

OK! You're signed in and have your browser preferences set, so you can finally start a registration. Under the Copyright Services heading, click on *Register a New Claim* (Screen 4, Arrow #1). After you've gone through the registration application process once, you can then save what you did as a "template." A template will save you a lot of time with future registrations. You may find the registering process to be cumbersome, clunky, and time-consuming, but after your

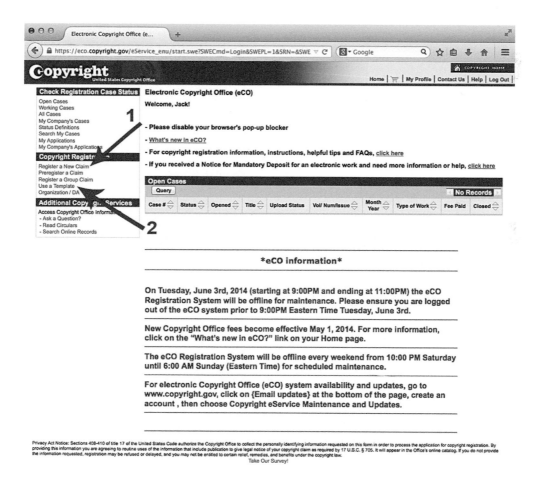

Screen 4

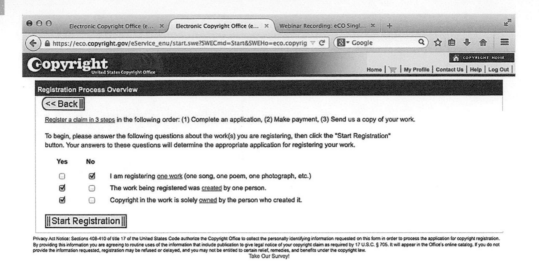

Screen 5

first time, especially if you utilize a template, it'll be a breeze. If you have previously created a template, then instead of clicking on *Register a New Claim*, you can click on *Use a Template*. (Screen 4, Arrow #2)

The first screen you will see will ask you three questions about your registration (Screen 5). This is to help streamline your application if you are registering only one photo, and you are the creator and owner of that photo. If you are registering more than one photo a collection as it's called, click on the *No* box. Since it costs the same $55 to register one photo or ten thousand photos, we suggest registering a collection, unless that one photo is very unique or unusually historical. So for multiple images on the registration, answer as we show here on Screen 5, namely *No* for the

first box, and *Yes* for the next two, if you are the sole creator and you are the only owner of the copyright.

Next, click on *Start Registration* at the bottom of the page.

The next screen you will see will be the *Type of Work* screen (Screen 6). At the bottom, where the red asterisk is located, you need to select *Work of the Visual Arts* (Screen 7) in the drop down menu, if you are registering photos. This option cannot be changed later because it affects the screens that follow, so make sure you choose wisely. (Note that any red-asterisked box must be filled out.)

Before you move on, note on this screen a shaded navigation box on the left, with the

Screen 6

Screen 7

11 steps of the application process. It will highlight with a red arrow which step you are currently working on, and will place a check mark in the right column when you are done with that page. As you continue, the completed pages will get checked off. This will tell you where you are in filling out the registration application. Some steps take several pages and some are simply skipped by clicking on the *Next* button. This navigation box will show up on every screen in this process.

OK, now you can click on the *Continue* button and continue to the *Titles* screen

(Screen 8). Note the navigation column on the left; the page you are currently on has a red arrow to the left of its name and a check to the right of the name of the previous page you completed.

Click on the *New* button to go to another screen with two pull down boxes next to two red asterisks (Screen 9).

The first asterisk says *Title Type.* The correct selection if you are registering a collection of unpublished photos will be: *Title of the work being registered.* So click on it to select it (Screen 10).

Screen 8

Screen 9

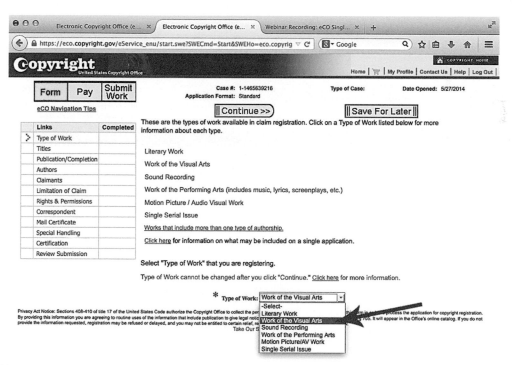

Screen 10

Next fill in your title of the collection you are registering in the box that says *Title of this work* (Screen 11) and click the *Save* button above.

If you are registering a collection of published photos, which will be explained later as it's a very different process, you would have selected *Contents Title* rather than *Title of the work being registered* and then you would enter each photo title in the next box. But since we are registering unpublished photos, you only need to enter just one title of your choosing for the collection. For some reason,

from the feedback we get, this titles box is confusing for many people, so we'll repeat this. You *do not* enter the title of each photo for a collection of unpublished photos, just one title for the entire collection. The collection can contain dozens, or hundreds, or thousands of images. One title. You can title your collection anything you want, but the Copyright Office likes it to be somewhat descriptive. Jack likes something descriptive, so he knows when he shot it and what it is. A typical title for him might be "2015_1stQT_ Paris." It's obviously done in 2015, in the 1st quarter of the year, and in Paris. It can be

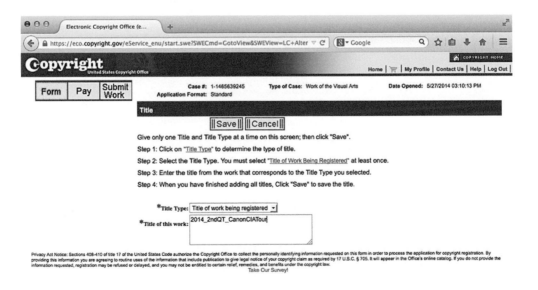

Screen 11

whatever you want, even your own shorthand abbreviation for a description. Technically you could call your collection Fred or Wilma and it will probably fly, so don't sweat the title.

But do note, and this is important, whatever you title your collection, use that name for the folder holding the images. You need to be consistent when you later upload your images. Having a different title name here and a different folder name for your images, could result in an examiner from the Copyright Office calling you to confirm the title and

folder names, as Jack found out the hard way. This will delay you getting your certificate.

When you are done, click on *Save* and you will go back to the front *Titles* page. Here you'll see your *Title of Work* and *Type* fields filled in (Screen 12). As you can see, this is Jack's registration for his second quarter, 2014, Canon In Action Tour images. Check it and make sure that your collection title is correct at this point or you'll have to wade through a lot of windows later if you have to correct it.

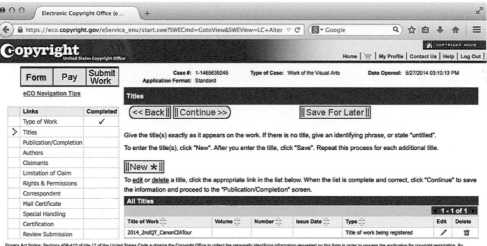

Screen 12

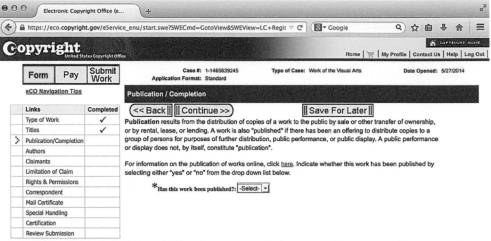

Screen 13

Screen 14

Click the *Continue* button, and now you're on the third page, called *Publication / Completion* (Screen 13). You will see a red asterisked box asking, *Has this work been published?* You have two choices: *Yes* or *No. No* means the work is unpublished and therefore, as explained earlier, easier to register. If you select *No*, you will be prompted to enter the *Year of Completion* (Year of Creation) (Screen 14). OK, easy enough. What year did you create the work? There is another box for putting the pre-registration number, but this rarely applies to photographers. It's for works being made in progress, like a motion picture where they want copyright protection before

the work is completed, which could span several years. If you are working on a long-term photojournalistic story, then you might want to contact the Copyright Office and inquire about pre-registration.

For most of your registrations you will probably register unpublished work, but if the work has been published and you select *Yes* on the initial page (Screen 13), you'll be prompted to enter the same *Year of Completion* (Year of Creation) box, in addition to the *Date of First Publication* (to be filled out in a MM/DD/YYYY format) and the *Nation of First Publication* (Screen 15).

Screen 15

Screen 16

Screen 17

The United States is the first choice in the drop-down menu, so you don't have to scroll all the way down—thoughtful of them, no?

If your photo was published in both the United States and another country on the same day, give "United States" as the nation of first publication. We're number one. There is also an *International Standard Number* box. Typically, this would be filled in if you are registering a book and have an ISBN number. For photographers, you will not have to fill that out.

Just so you don't get confused, you will not see Screen 15 unless you are registering published work.

Click the *Next* button and you will be at the *Authors* page (Screen 16). There is a *New** button and an *Add Me* button. The first time you're here, you must first click the *New** button to create your template. In subsequent registrations, you can simply click *Add Me* to bring up a screen with everything already filled out. It remembers you. But always double check, even if you use the *Add Me*.

You are now in the *Add Me* screen (Screen 17) and since you're the creator, or in the Copyright Office's language, the "author," fill in your name. Even if you have a photography business, we recommend that you do not register your images in your company name, but rather register them personally. Even though Jack is incorporated as Jack Reznicki Studio, Inc., all his images are registered to Jack personally. The reason is Jack wants to personally own all his images. If they were registered to the company, they are then an asset of the company, and if anything happens to the company, Jack could potentially lose the rights to his images. If you aren't sure which way to go, it is always better to consult with your accountant and attorney to determine whether you ought yo register in your own name or that of your business. Some partnership and shareholder agreements require that all intellectual property be registered in the name of the business.

Clicking *Save* will move to the second part of the *Authors* section (Screen 18). This is an easy one. You'll see the red asterisk with the words *Author Created*, and in the boxes under that, just check the box next to *Photograph(s)*.

Screen 18

Screen 19

Screen 20

Click *Save* again to return to the beginning of the *Authors* screen, which will now have all the necessary information filled in.

Continue brings you to the *Claimants* page (Screen 19). Unless you assigned, sold, or transferred the copyright, then you, as the creator/author of the work, are also the claimant. It's all you. You should be able to click on *Add Me*, but sometimes, the first time you register, you will need to create another profile template for yourself by clicking the *New** button, just like you did in the *Authors*

section. Enter all the required information (Screen 20), and click *Save* to return to the main *Claimants* screen. Then click *Continue*.

This brings up the *Limitation of Claim* page (Screen 21). Easy. Just hit the Next button. Why in the world do you want to put a limitation to your registration? Jack has never had any reason to. There's an explanation of what this is all about on the top of the screen if you're curious. Generally, just click the *Continue* button without filling in anything.

Screen 21

Screen 22

This is the *Rights and Permissions* page (Screen 22). "This is the person authorized to grant permission to use this material." Oh, look, another *Add Me* button. Unless you want someone else to have control over your images (and why would you?), either click on the *Add Me* button to add your information automatically or input your information manually, click *Save* and then click the *Continue* button. You should be getting the hang of it now.

Now you're at the *Correspondent* page (Screen 23). This is the person the Copyright Office will contact if it has questions about the application. Yup, another *Add Me*. Everything should fill in automatically. If not, just enter it manually. You will see a red asterisk next to name, email, and address—so filling those boxes in is mandatory.

Clicking *Continue* moves on to the *Mail Certificate* page (Screen 24). This is the name and address to which the registration certificate should be mailed. This is usually another *Add Me*, unless you have another address you want the certification mailed to.

Screen 23

Screen 24

Screen 25

Next up is the *Special Handling* section (Screen 25). This is the $760 page. Generally speaking, just click *Continue*. Nothing to fill out here. If you need special handling and fill out this page, it will cost you $760. The only reason you might want this is if you have an infringement and there is a court case pending. Remember, you can't file a case without the registration in hand, and this will expedite getting it into your hands. You should only consider utilizing this service under the direction of your lawyer.

Click *Continue* to move on to *Certification* (Screen 26). This is where they remind you that filling out any false information may constitute a criminal act. They even spell out the specific statute. You will be required to enter your name and check a red-asterisked box that certifies you are indeed the copyright owner. If you have any special comments about your claim for the inspector who will look at your application, there is a box at the bottom for comments. Jack has yet to leave a comment.

Screen 26

Screen 27

Click the *Continue* button, and you'll be presented with all your application information at the *Review Submission* page (Screen 27). This will be a summary of all the information you previously entered, all on one page. Do review it carefully, since after you leave this page, you won't be able to change anything. If you do want to change anything at this point, you need to go back, page by page, using the on-screen *Back* button. No skipping. Page by page. Inch by inch. Step by step.

Note there is a *Save Template* button at the top of this page. It's a good idea to save the template and name it. The template does save a lot of time, since you don't have to type everything in again.

If, after reviewing the summary, everything on your application looks correct, then click on the *Add to Cart* button at the top of the page (Screen 27).

★

Submitting Payment

Once your application is "in Cart" (Screen 28), then you can pay for it. To continue, click on the *Checkout* button at the top of the page. That will take you to the checkout page (Screen 29), or what I like to call the "So how do you want to pay for this?" page. You will see three buttons at the top: *Change Order*, *Pay – Deposit Acct*, and *Pay – Credit Card /ACH*. Your option is the pay by credit card, the *Pay – Credit Card /ACH* button since you're not changing your order, and Deposit Accounts are for those that register on a regular basis, like a newspaper, magazine, or movie studio. They have an account at the Treasury Department to pay directly from their bank account. Unless you register a lot of things regularly, this would be overkill.

Once your application is in the cart, you can't go back to change any of the information. The cart holds the application while you get transferred to the Treasury Department to pay your $55.00. When you check out there will be a warning page

Screen 28

Screen 29

Screen 30

(Screen 30) explaining that you are leaving the Copyright Office site and being transferred to the Treasury Department website, so they can more efficiently and quickly move the money out of your pocket directly into the government's. It seems that the most efficient arms of the government are the ones that relieve you of your money. They will ask you if you want to proceed. Click *OK*.

While you are going to the cart or to checkout, you may encounter an error message. Don't freak out. For some reason this used to come up a lot, and from what we can tell it doesn't mean much. But it can be frustrating if you don't know that the error message itself is usually just an error. It seems they fixed it at this point, but if you get stuck with an error message and can't go on or checkout, hit *Home* on the mini toolbar at the upper right of the page, and go through the screens until you get back to the checkout.

Screen 32

When you get to the payment page, you'll see that it's a standard online payment form (Screen 31). Enter in your credit card info in the bottom half of the screen that says *Pay Via Plastic Card* and click on the *Continue with Plastic Card Payment* button. You are now on the next screen asking if you want email verification (Screen 32). Always a good idea to get an email receipt. You can also enter another email address in the cc box if you want a copy sent to someone else, like your studio manager or accountant.

Do sign up for verification, just on the rare chance there is a problem getting your registration materials to the Copyright Office. You can't proceed with your registration until the Copyright Office gets payment confirmation from the Treasury Department. The Treasury site warns it could take a while to get the confirmation to the Copyright Office, but in our experience, it happens in seconds. To repeat: they are very efficient at getting your money. There will also be an authorization box, that is required, as you can tell by the red asterisk. Click the box and click on *Submit Payment* at the bottom to complete the transaction.

★

Sending in Your Images

Once you have paid and it's confirmed, you will see the *Payment Successful* notice at the top of the page (Screen 33). Click on *Continue* and proceed with the last third of the registration process: the image deposit (Screen 34).

If you previously marked that you will mail in the images—or, as they call it, the deposit—then you will print out a shipping slip to include with your images on CD, DVD, contact sheets, or whatever. That way when they get your images, they know to which application it corresponds. The button to print the shipping label is at the bottom of Screen 34. You have 30 days to send in the images if you are mailing them in.

Payment successful.

Click the "Continue" button to complete your registration.

1-O8NL8F

Form | **Pay** | **Submit Work**

Customer Information

Jack Reznicki

New York, NY

|| Continue >>

Submissions

Cases

1 - 1 of 1

	Case # ⌃⌄	Title ⌃⌄	Type of Work ⌃⌄	Total Fee Paid	Require Submission ⌃⌄
	1-1465639245	2014_2ndQT_CanonCIATour	Work of the Visual Arts	55.00	Y
Total Amount Due:				$55.00	

Payment Info

Amount Paid: $ 55.00

Account: XX5006

Paid By: JACK REZNICKI

Pay Date: 5/27/2014

Payment Type: Credit Card

Confirmation #: 242611

Take Our Survey!

Screen 33

Please review deposit copy requirements before proceeding. ("Deposit Copy" refers to the copy of the work being registered with the Copyright Office.)

You may either submit your deposit copy(ies) as (1) an electronic file(s) or (2) by mail. **Do not do both.**

(1) Electronic upload (see restrictions): Ensure that your browser's pop-up blocker is disabled.

• Click the "Upload Deposit" button in the table below and browse and select the electronic file(s) for the corresponding work. If there are multiple cases in the table, repeat these steps until the files for all cases have been submitted.

• When you are finished uploading files for a work, click the corresponding "Upload Complete" button to complete your submission.

Electronic Deposit Upload

	Step 1: Upload Deposit	Step 2: Upload Complete	Upload Status	Case #	Title	Volume	Number	Issue Date	Type of Work
>	Upload Deposit	Upload Complete	Not Complete	1-1465639245	2014_2ndQT_CanonCIATour				Work of the Visual Arts

(2) Send by mail:

• Click the "Create Shipping Slip" button in the table below; a Shipping Slip link will appear in the Attachments column.

• Click the Shipping Slip link and print out and attach the shipping slip(s) to your deposit copy(ies). For multiple cases, be sure to attach shipping slips to the corresponding copies.

• Mail the deposit copy(ies) within 30 days to the Copyright Office address at the bottom of the slip.

Click "Home" after uploading files(s) or printing shipping slip(s). You may verify the submission in the open Cases table on your eCO Home page.

Send by Mail

||| Create Shipping Slip ||| ◄ No Records ►

Attachment Name	File Type	Size	Date and Time	Comments

Screen 34

Screen 35

Screen 36

Still on Screen 34, in the middle of the page, you will see the *Upload Deposit* button. We think this is easier and we know it's the fastest method of registration. Click on *Upload Deposit* and you will go to the *Electronic Deposit Upload* window (Screen 35).

Click *Browse* to locate the files you want to upload, and then input a title in the *Brief Title* (or description of work in this file) box (Screen 36). You can put any title in this field;

its purpose is simply to label and distinguish your uploads. It's best to be consistent with your naming convention. Jack uses the same name for the brief title as the image folder, but adds a sequence number if he is uploading more than one file, which is usually the case. Important note: the folders you upload need to be zipped. See more information on that and on sizing your files in the Resizing Images for Upload sidebar.

Screen 37

Screen 38

When you click to upload, which is the *Submit Files to Copyright Office* button at the bottom, you will see Screen 37 pop up, warning you that once you submit the files, they cannot be returned or deleted, so double check you're uploading the correct files. Click *OK* to proceed.

You will now see a progress bar (Screen 38), giving an estimate of how long the upload will take. You can upload multiple files if needed.

But you are limited to a one-hour session to upload. If the upload is estimated to take longer, or if your file folder is too big, you will get a warning notice and it will not let you proceed. You will need to break up your images into smaller folders and then zip the folder. Jack once uploaded 12 folders of images. Now while you have a one-hour session limit, you can have as many one-hour sessions as you need. It's just limited to one hour at a time.

Screen 39

there is an *Upload Complete* button on the *Electronic Deposit Upload* screen (Screen 40) and you will see at the top of the screen next to *Case Summary*, the words *Upload Deposit is not allowed* in bold red. That closes the registration and no more images can be uploaded.

★

That's it! It seems like a lot the first time you do it, and will probably take some time to complete the first time around. But after that, you'll find that it really flies and you can do it all very quickly. Now all you have to do is wait to get your certificate in the mail. It's such a great and empowering feeling when it comes. This is really important. Keep a good and accurate record of the images uploaded and what registration certificate number applies to those images. Jack keeps a "Copyright" folder of all the files he uploaded. When he gets his paper registration form in the mail, he appends the registration number to the appropriate folder name on his computer so he can maintain a record of what file is with which application. It could prove extremely costly to have the Copyright Office retrieve

After the files upload you will see Screen 39 that confirms it was a successful upload. You will also get an email sent to you confirming the uploaded folder. You will have a choice at this point to upload more files, with the *Upload More Files* button, or the *Close Window* button. You can close this window and upload again at a later date, by going to the home page and clicking on that case number. But take note, the effective registration date will be the date you finish uploading your files. When you are done,

Screen 40

that information from their files. It's much easier, more efficient, and cheaper to maintain those records yourself. And carefully retain and file that paper certificate. It is always a good idea to retain paper copies of whatever records you have in digital form. Computers get lost, freeze, and break. Paper is forever.

Note about Templates

Be careful with templates, as they will use all the same info from a previous registration. When a template is created, the information is repeated automatically and there are some fields you will need to change. You have to be sure to eliminate the old title of your work and give it a new title; otherwise you may end up with the same title as your previous registration, which can create problems. Using a template will save you a lot of time, but carefully review each application before payment.

The following file types are accepted by the Copyright Office

.bmp (Bitmap Image)

.dwg (AutoCAD Drawing)

.dwf (Autodesk Design)

.fdr (Final Draft)

.gif or .giff (Graphics Interchange Format)

.jpg, .jpeg, or .jfif (Joint Photographic Experts Group)

.pdf (Portable Document Format)

.pic or .pict (Picture File)

.png (Portable Network Graphic)

.psd (Photoshop Document)

.pub (Microsoft Publisher)

.tga (Targa Graphic)

.tif or .tiff (Tagged Image File Format)

.wmf (Windows Metafile)

For photos, we feel that small JPEGs work just fine.

RESIZING IMAGES FOR UPLOAD

Jack runs a Photoshop action to resize and prep his files for registration:

- Open an image in Photoshop.

- Open the Action panel.

- Start an Action Folder by clicking on the *Create new set* icon at the bottom of the Action panel; it's the one that looks like a folder. Name your new set "Copyright."

- Click on the *Create new action* icon at the bottom of the panel; it looks like a page with one corner turned up. Name it "Copyright Resize and Save," or anything else that you'll remember.

- Go to *File>File Info*. Fill out as much as you want, but if nothing else, make sure you go to the dropdown menu that says "Copyright Status" and change it from the default "Unknown" (which we hate as a default) to "Copyrighted." This will add a small (c) icon to your file title when you view it in Photoshop. And also put your name where it says "Author." Click *OK*.

- Go to *Image>Image Size*. Make sure the *Resample Image* button toward the bottom of the dialog panel is unchecked. Set the *Resolution* to 72 pixels/inch (ppi). Click *OK*.

- Go to *File>Automate>Fit image*. Set the parameters to constrain the file at 700 pixels on both the width and the length. That will make the longest side of your file 700 pixels long, no matter if it's a horizontal or vertical file. Click *OK*.

- Go to *Filter>Sharpen>Smart Sharpen*. Set the *Amount* to anywhere from 25 to 60, depending on your taste. Click *OK*. We do this because downsizing a file throws out pixels and makes the file less sharp. Don't worry too much about this, as sharpening is an entire book by itself. Smart Sharpen is quick, easy, and does a great job for this function. This step is really not needed, but Jack likes his files looking as good as possible.

- Go to *File>Save As*. When the dialog box opens, create a new folder wherever you want. Jack puts his on his desktop. Save the file as a JPEG, and move the *Image Quality* slider to a compression level of 5 or 6. Click *OK*.

- Now this is a very important step that most people miss or just forget: At the bottom of the action panel you will see a red ball. That means the action function is still recording. Click on the square box to the left of the red-ball recording button. That will stop the action.

- Go to *File>Automate>Batch*. Make sure the Set and Action boxes are "Copyright" and "Copyright Resize and Save," respectively (or whatever you named them). At *Source* choose the folder holding your files waiting to be registered. Now check the *Suppress File Open Options Dialogs* and the *Suppress Color Profile Warnings*, as these will only slow you down or mess up your action. Since we didn't open the original file until after we started recording the action, you do not need to click on the *Override Action 'Open' Commands*. At the very bottom, make sure the *Errors* box is set for *Stop For Errors*. Click *OK*.

- One last and important item. You need to zip the folders before you upload them. That's never mentioned, but it seems that if I don't zip the folder, it wouldn't upload.

That's it. When it's done, you'll have a folder of properly sized files, ready to upload to the Copyright Office. And once you have an action, you can use it over and over. After the initial set up, it's a great tool and a real timesaver.

Chapter 3

Release Me

Ad agencies, clients, and others who use your images and who write your name on the "pay to the order of" line of their checks insist upon releases. Their insistence is cultivated by many well-paid lawyers who spend many billable hours protecting their clients (and their own jobs). They insist upon these releases for good reasons. When attorneys agree on anything there is probably something to it. There is no reason to ponder the musings, thoughts, or comments of bloggers and fellow photographers who are simply not lawyers. They come up with all sorts of reasons, explanations, and dances as to why you don't really need releases. They are not correct. You want to focus on taking pictures and making a living. The health of your business should not be dependent on urban legends and myths.

What Exactly Is a Release

No topic we discuss attracts more attention than that of the need to obtain written, signed model releases. Model releases are bilateral documents, meaning they actually protect both parties: the photographer and the subject. When asking about releases, photographers generally look for an all in one answer, or their need is motivated by the desire or need to employ the photographs in connection with the sale or promotion of any product, service, company or organization (whether a for profit enterprise or otherwise). In such scenarios model releases are required. Editorial and fine art uses are generally exempt. We use the term generally because every situation is very case dependant, fact dependant, and sometimes state dependant in the US, as the laws and statutes for releases can be different state to state.

The information in this chapter should clear the air and help explain exactly what is a photo release. We are providing templates for a variety of model releases in the back of this book. If you do use the templates, please read them carefully and have some of the blanks pre-printed, like where your name goes. Adding your logo or letterhead with contact information would also be helpful as having them look professional.

Don't confuse copyright and release issues, as photographers often do. Copyright does not give a photographer any rights to show an image without a model's consent. Want to put up on your website or blog a photo that you took of someone, even with their verbal permission and consent? Well, you need to have a written release if you want to be properly protected in that situation, as well. If you aren't protected, then you can be sued— and you will lose. It's really as simple as that.

★

Model Release Myths

Non-expert experts thrive on the Internet these days, perpetuating myths instead of facts. Photographers, prone to accept the un-vetted, anecdotal experiences of their non-lawyer comrades, vacuum these myths up, generating even more business for lawyers. Ed's wife says he should thank these non-experts for doling out advice—she wants a new car. What follows are some of the most common "factoids" we run across. For those that never heard the term, factoids are statements that may contain a germ of truth, which makes them appear credible, but are in fact not *facts*, and are therefore likely to be misleading and deceptive. Here are some of the factoids we've run across:

FACTOID *"Most model release disputes never go to court."*

This factoid is intended to give you peace of mind. It shouldn't. Let's dissect the phrase "go to court." If it means an actual trial to verdict, the statement is accurate. The reason why relatively few such cases are taken to verdict is that the law is so crystal clear that typically the only issue at play is not if there's been a violation, but who is going to pay and how much. Clear cases get settled; settled cases do not, for the most part, become part of the public record. Unlike most lawsuits and football games, the winners and losers in model release cases are fairly easy to predict and predictable results create settlements. Best estimates are that 95 percent of filed cases of any type (including divorce, personal injury, etc.) are settled or ended without a

trial. The overwhelming majority of claims or disputes are resolved without filing a lawsuit.

FACTOID *"The need for a model release may be dependent upon how much coordination goes into the shot."*

Not hardly. You are also told that whether public space is used for the photo may be a factor, as well as whether the subject is photographed in a controlled environment where access is restricted. In the state of New York and other jurisdictions these so-called factors have little to no relevance in court when determining liability. For example, a photographer happens to see and photograph Michael Jordan crossing Fifth Avenue in New York City in the midst of, say, 500 people. He takes the picture, and it's subsequently used to advertise or promote a product, service, or organization—without Michael Jordan's written consent. If Michael happens to have endorsement contracts (we think he probably does), he might sue the photographer for interference with a contractual relationship, in addition to bringing a legal action under the Civil Rights Law—as anyone can.

FACTOID *"Some form of payment or tangible benefit must be received by the person in the photo in order for a release to be valid."*

As the song goes, "It ain't necessarily so." In New York, for example, consideration is specifically not required. You do not have to give the model a print or even pay them a single dollar in order for the release to be in effect. You do need their signature on the release.

FACTOID *"You don't need a release if the person isn't a professional model."*

Wrong. Liability is not dependent upon the job description listed in the subject's tax return. Models who earn income from modeling will likely recover more money than civilians because they can probably demonstrate greater financial damages. But sometimes a civilian can collect far more than even a supermodel. An orthopedic surgeon who happens to be a team doctor for the New York Jets, and whose photo is employed without consent in an ad promoting a branded pain reliever, will likely recover far more money than virtually any professional model whose image was used without consent in the same type ad.

MORE ON "CONSIDERATION"

Freud is famously credited with saying, "Sometimes a cigar is just a cigar." We like to say, "Sometimes a model release is just a model release." In many states a model release need not be a contract. By definition, a contract must contain elements such as consideration (compensation), promises, duties, and obligations that must be met by the parties who typically sign their names to legally bind each other to such terms and conditions.

One of the biggest misconceptions we hear is the idea that a model release must be a contract. Even some lawyers— especially the ones who just live in a lawsuit-happy world—perceive that everything that is written and signed is a contract. It's like the old saying, "If you have a hammer, everything looks like a nail."

Many writings of legal significance are not "full-blown contracts," such as receipts, signed estimates, invoices and so on. Such documents affect legal rights of persons and companies, but do not rise to the level of being contracts.

Always remember that state laws vary. While there is no one-size-fits-all rule with releases, you are good to go in just about every state when you satisfy the New York requirement for a written, signed release.

We see that many releases begin with the words, "For valuable consideration . . ." If you have the words "for consideration," on your release, you might, after researching your state laws, consider revising your wording. Why? Because in some states, such wording opens a door that need not be opened. New York and many other states do not require that any compensation (consideration) be paid. Stating that you are providing the model with "valuable consideration" (such as a crisp one-dollar bill and/or a print) may give a lawyer an opening to argue that you did not provide "valuable consideration." That could invalidate your release.

Generally speaking, a well-constructed, precise model release, which bears the signature of the subject, need not refer to "consideration." There's no need to spend any dollars or provide any prints, unless you want to be generous of your own accord. Or if the state you work in requires it.

Case study

RUN ON THE BANK

A bank asks its employees to remain after closing if they want to be included in advertising materials to be distributed for the bank's promotion. It is made clear that they have no obligation to hang around, and no releases are signed. Some employees choose to remain and participate in a standard location shoot with a photographer, assistant, hair and makeup person, art director, and the all-important caterer. They pose, and the shoot takes several hours. Ads and promos come out. Some employees—having never signed anything expressing their consent—claim violations of NY law. They win.

Lesson: While the employees' behavior demonstrated consent, the statute specifically stated that written releases were required. A clearly written law trumps the impressions, assumptions, and beliefs of any photographer.

FACTOID *"Property releases aren't required by law."*

Trademark issues aside for the moment, maybe they are, and maybe they're not. But you shouldn't take the chance. Ed's been involved in more than a few cases where money changed hands due to the lack of a property release. Location releases may also serve to protect a photographer by establishing his legal right to be at a given place at a given time for the purpose of creating certain imagery. In any event, most major stock and ad agencies require them. Overkill? Maybe. But it doesn't matter. No property release, no money to you. Property release in hand, you get paid. Choose wisely grasshopper.

★

WHAT ARE THE ODDS?

Once upon a time in Africa, a young Kenyan woman was employed in a major restaurant in Nairobi. A high-end fashion photo crew shooting in Africa came into the restaurant prior to embarking on a weeklong location shoot. The photographer loved the young Kenyan's food and invited her along to cook for the crew during their shoot. Over the next few years she became well known in the photo industry and accompanied various international crews on photo shoots, and became what is known as a local "fixer" and a prop stylist, because she was familiar with local language, wardrobe, and customs.

Several years after her last shoot, she found herself newly married and living in New York City. One day she went to Bloomingdale's, where she saw her own image on an expensive fragrance label. She bought the fragrance, took it home, and proudly showed it to her husband— who happened to be a prominent employee of a large advertising agency. Her husband called an attorney—Ed. Ed wrote one of his famous demand letters and had it hand-delivered to the

photographer who had taken the image and licensed it without a proper model release.

The photographer had made a big mistake, and he knew it. He called Ed and confessed, "I'm a jerk, I know better."

"So why didn't you get a release?" Ed inquired.

His answer: "What were the odds of a Kenyan cook, in the middle of the African jungle, coming to New York, marrying someone in advertising, and then walking into the one and only store in the entire United States of America that sold the product?"

We have no idea what the odds were and frankly my dear, we don't give a damn. What we do know is that a very substantial settlement was paid to the young lady from Kenya.

It really doesn't matter what the odds are—with a signed release in hand, you're protected. Without a release, the odds shift and you may well find yourself putting everything you own at risk. "Signed" is the key word here.

A verbal okay to use a person's likeness in your photo is an invitation for problems in the future. Who said what, to whom, when, and where can always serve as fodder for lawsuits. It's easy to dispute an (alleged) oral agreement—ask anybody who is married or has a child; it quickly becomes a he said, she said situation. But it's hard to deny the contents of a written and signed release. So always get one.

Model Release: Fine Print

The specific requirements for model releases vary from state to state, so to be absolutely safe you should consult a lawyer on your particular state's statute. Note that some states have statutes containing very specific, unambiguous language that can be easily understood by anyone—New York is one example. Since most published works, magazines, and ads appear in the state of New York at one time or another, many clients require that your model release satisfy New York law. No matter where the image was taken, retouched, or printed, if the image is shown in NY, it needs to satisfy the crystal clear NY statutes. What matters is where it appears, not necessarily where the image was shot.

Generally speaking, you are required to obtain the written permission of a subject for his or her inclusion in any image used for advertising, promotional, or trade purposes—regardless of whether the photo is used by a for-profit or not-for-profit entity. In this respect, a photo employed in a Red Cross advertisement is no different than an ad to sell Dell computers. Images from wedding and portrait work should be released if you intend to use them on your website, in your blog, as a display in your studio, for self-promotion, or in a mailer.

Releases can protect you when a client utilizes photo in a manner agreed to by everyone, but "there were subsequent unauthorized uses." Example: a release was obtained at a shoot, the image ran in the manner agreed to by all, model was paid on time, and everyone was happy. Years later the image gets re-used by the original client or by the same ad agency for a new client or was simply ripped off and used by someone else for any number of commercial or unseemly purposes. Now the model is justifiably enraged—especially at the photographer who had absolutely nothing to do with this subsequent use. Assuming the photographer did not participate in this

second use, possession of a clear, signed model release from the original job will likely prevent the photographer from being sued.

Your model release should also cover the entry of the image into a photo exhibit, competition, or contest. You'll find most if not all legitimate competitions require you to provide a model release on demand. A release for such use need not have expansive "universal, do anything, anytime, anywhere" language in it. If you have a subject who is reluctant to sign such a release, you can use a release written for just one or a few defined uses. For example: "For use by Jane/Joe Photographer for 'Hottest Photographer' photo competition only." But we recommend getting as many rights as you can in your release because, hey, ya' never know when that image could make you some money. Limited use releases should be used when that is the only type of release you can get. Celebrity releases are typically limited use releases, with specific allowances and limitations so as to prevent the image from being licensed for advertising at the whim of the photographer. Celebrities like to get paid to endorse products or appear in ads on terms set by them. Understand that only the people

included in the picture can sign a release for themselves, with some exceptions like guardians signing for their children or authorized agents who can sign on behalf of their corporation. So for a wedding photograph, you must assume that neither the bride nor the groom, nor anyone else, can sign a release on behalf of Uncle Charlie or Aunt Sally.

Simply put, in every circumstance you are never wrong and always better off having a signed model release in your pocket. Releases, like copyright registrations, are cheap, excellent, and essential forms of business insurance.

Rights of Publicity and Privacy

The rights of a person in his or her portrait, image, likeness, or even voice are commonly termed "rights of publicity" or "rights of privacy." These rights are independent of any of the photographer's intellectual property rights, such as copyright. Copyright is just a photographer's right to his images and how

those images are shown and controlled. Subjects in your photos also have different and sometimes conflicting rights. In short, the person in your photo—whether a professional model or not—has rights too. Those rights may parallel those of the photographer or conflict with them. You may want to license an image to a particular client for particular purposes, but if the model does not grant the same rights by his or her consent, you cannot license your image for that purpose. The result being that you can't make a buck. You must strive to derive as many rights from the model/layperson as possible. Ideally both photographer and subject will find themselves on the same page, licensing identical rights to a paying client or customer.

Copyright does not give a photographer any rights to show an image without a model's consent. Want to put up wedding photos or a recent senior shoot on your website or blog? Well, you have to have a release to be properly protected. Depending on what state you're in, you may be sued and you may lose.

On pages 322 to 328 you'll find copies of model release forms you can customize and use in your daily business. While they differ

NEW YORK STATE OF MIND

Mark Twain said, "The trouble with the world is not that people know too little, but that they know so many things that ain't so." And so it is with the subject of model releases. There are so many myths, misconceptions, and falsehoods flying around concerning releases that straightforward, simple rules by which to work and live have become obscured. Remember: It takes less time to obtain a signed model release than it does to think about whether you need to obtain a signed model release.

Obtaining and retaining model releases will always, without exception, keep your business on an even keel. The problem is, there is no "one size fits all" model release law. Every state has a different law or statute regarding model releases and their requirements differ. For instance, Illinois law specifically requires "a writing." In legalese "a writing" may be a document that lacks many of the formalities of a full-blown contract. In contrast, under Florida law there are some exceptions to the need to have a written model release. Generally speaking, if your image appears in NY

State, NY law applies; if your image appears in Minnesota, Minnesota law applies; and so on. These state statutes are in effect to cover use in that particular state. Typically, if you shoot a wedding in state A, you only have to worry about state A's statutes. But if you subsequently run an ad in *Brides Magazine*—a publication that will appear in all 50 states—you have to have a release that covers you for all state statues.

That's actually very easy if you have a well-written and properly executed release. If an image is used in the state of New York, the New York Civil Rights Law Sections 50, 51 require (under criminal penalty in some cases) that if the photo, portrait, or likeness is to be used for trade or advertising purposes, a "writing" signed by the subject authorizing such use is required. That "writing" may take the form of a release, a modeling agency voucher, a contract, an agreement, or any other duly executed writing. The model release forms in the back of this book are all in accordance with New York requirements.

slightly in form according to the type of shoot, use, or payment, they serve the key purpose of obtaining the model's written consent to use his or her image for limited or unlimited purposes.

It's easy to see why stock agents, ad agencies, models, and their agents and clients specifically require a copy of all model releases—they permit intended use and prevent lawsuits. Images without accompanying releases are generally worthless for most commercial usages, with the notable editorial/fine art exceptions. Concern about proper model releases applies to all sorts of photography and all sorts of clients.

Commercial or Editorial Use?

Under New York law, a message is for "advertising purposes" if it solicits patronage of a particular product or service. A straightforward example of this would be the piece that promotes or "sells" a product. A less clear, but still valid example would be if the message promotes a service. For example,

if an advertisement explicitly solicits patronage of medical, residential, psychiatric, mental health, and addiction services for fees (including health insurance covered fees), the fact that it also serves a secondary public or beneficial purpose like advocating the treatment of drug addiction is not relevant to the fact that the piece is still an advertisement requiring a written model release.

Occasionally, because they neglected to get a model release, photographers (and even some clients) attempt to "create" an editorial use. This usually occurs after the user has been notified by the model's legal counsel that the image was used without consent. At this point, like Houdini, the photographer, ad agency, and/or client tries to escape. They will claim that the ad was not really an ad, and so it really does not require a written model

release. Amorphous terms such as "open letters," "public service announcements," or "issue advertising" are used to describe certain ads in an effort to skirt the laws requiring model releases.

Often the background facts concerning the creation of the ad are key. Say an ad agency licensed an image from a stock house for a fee, retouched that image, wrote advertising copy, prepared the advertisement, and had it inserted into countless publications and websites on behalf of the agency's paying clients—all of whom manufactured drugs, sold testing equipment, or treated diabetics. However, the claim that the resulting ad is not an ad but rather a newsworthy "public service announcement" or "open letter" not requiring a model release would be fallacious. That's because the primary purpose was to direct, steer, and cause viewers to pay money and/or attention to one or more of the advertisers for their commercial benefit. Even if someone seeing the ad was curious enough to get tested and obtained treatment, discovered he/she was a diabetic, etc., that's great, but it's still a byproduct and not the primary purpose of the ad.

To get protection under the newsworthiness or editorial use exception to the need for a written release, the image must bear a "real relationship" to the subject matter of the editorial in which it is used. The story cannot be an advertisement in disguise, or an "advertorial." An advertisement, even if it may have some secondary newsworthy value, is still an advertisement within the meaning of the law. Otherwise one could argue that any pre-existing advertisement for any item can be termed "newsworthy" if it, for example, contains a celebrity, advertises a "green" product, an electric car, a cure for a disease, and so on. If the primary purpose of an ad is to drive dollars and attention to those whose livelihoods are dependent thereon, it does not qualify as exempt from the requirements of the New York law.

Now, an ad may become "newsworthy" if, for example, litigation was commenced concerning its existence. Let's say that a billboard is put up in Times Square for a clothing company or a charity seeking donations. The user's profit or not-for-profit status is irrelevant to the issue of what is the ad's "primary purpose." In this case, the image is used primarily for commercial and

trade benefit and that is the key to the need for a model release. Can the model sue the clothing company or charity if the image was used on that billboard without a written model release? You betcha. Can a newspaper run a photo of the billboard in its story on the lawsuit without obtaining a model release from the model portrayed on the billboard? Sure. The newsworthy exception has a long and storied history and exists so that newspapers, magazines, and the like can cover news and stories of genuine public interest.

Most exceptions to the model release requirements of state laws are fairly obvious, in that an image accompanying an editorial magazine piece or news story of public interest does not generally require a release. Misuse of an image in such a publication could still lead to a claim in libel. Such claims arise when the image is used to falsely portray someone without consent. So, for example, a story on rampant heroin abuse by young mothers utilizes the image of an innocent public citizen/mom playing with her kids in the park. Without consent of the subject, if the photo falsely portrays the subject as a drug abuser, pedophile, etc., then the fact that it is used in a newsworthy article becomes largely

irrelevant. Mom has herself a great lawsuit for libel, defamation, and/or other similar claims and her lawyer can start shopping for a new car.

A classic example of the more typical scenario is that of Arrington v. N.Y. Times Co. That case involved an image of a young, African-American financial analyst in a business suit walking on a Manhattan street. The photo was utilized in an article in *The New York Times* entitled "The Black Middle Class: Making It." That image clearly bore a real relationship to the editorial content of the article since the image was of an actual young African-American financial analyst, and the article was about exactly that demographic. However, Brooks Brothers would need a written release if it wanted to use that image to sell suits. *The New York Times* did not need a written release or the permission of the subject.

St. Patrick's Day parade patrons dressed in traditional Irish garb, drinking Budweiser beer, utilized in a news story about the last of the Irish immigrants— no release needed. Use of that same image by Budweiser without a release? Verboten. The key is simply

whether the relationship between the news story and the alleged violative image is fairly obvious.

Note: While certain medical and pharmaceutical advertising can blur the lines between advertising and public service announcements, they don't have a monopoly on the practice. Charities of all kinds love raising and creating this false distinction to avoid paying both models and photographers their normal rates—or anything at all.

Sensitive-Issue Releases

When is a model release not a model release? A perfectly drafted and signed model release does not mean that you can use the photo for any and every purpose, without fear of being sued. Use of an image, even if model released, can still lead to civil suits, such as a libel suit. A criminal prosecution for dissemination of child pornography could result despite having a release. Such claims arise when the image is used to falsely portray someone without consent. If you intend to use the image to portray the subject

as say a prostitute, get her consent to be portrayed as such in writing. And that's only if the model is of legal age to give consent. Such a release is referred to in the industry as a "sensitive-issue" release—when it's used in the context of a "sensitive issue," or in a manner that disparages, sensationalizes, or puts someone in a bad light. Ads that depict drug use, teen pregnancy, alcoholism, depression, infidelity, sexual predators, etc., would all require specific model releases. If you photograph a nude or semi-nude person, we'd strongly advise that the release states that your subject is nude and that the subject acknowledges that he/she will appear and be viewed as such.

A lot of photographers have models and other subjects sign "universal" model releases, thinking that it gives the photographer every right under the sun, short of naming rights to their subjects' first-born children. You can easily get into trouble by thinking that such a broad release gives you broad rights. Sensitive issues require sensitive-issue releases. Basically this just means that the person signing the release understands the ways in which the image of them is to be used.

Similarly, a father of a child can not legally consent to permitting his seven year old to be filmed portraying a child prostitute, no matter how many releases he signs or how much money you may have paid him. In most states both dad and photographer would wind up sharing a prison cell. The question you should now be asking is "What about all the portrayals of child prostitutes I see on TV and in the movies?" Great question! For those type uses filmmakers generally have a court approve the terms and conditions of such a portrayal.

Ed had a case where he represented a model that worked on a stock photography shoot. During the shoot, all sorts of lifestyle photos were taken. The subjects were depicted having a family picnic, riding a bike, playing baseball, and even just posing for a family portrait of mom, dad, and two kids. You've seen pictures like these a hundred times. All of the models signed releases stating that the images would be used for stock photography. They knew the photos could be used in an ad for a bank, for a real estate company, and/or for many different end uses.

It so happened that the image appeared in a campaign about heroin use. The campaign represented the mom as both a heroin user and a child abuser. If her image had shown up in a bank ad, there wouldn't have been any problem, but because it appeared in an ad that represented her as a drug-abusing, child-abusing mom—well, that could hurt her modeling career. The standard stock agency release used specifically stated that no model "would be defamed" in the resulting images. Point, game, and match to model.

There was an ad on the side of a building containing a photo of a little girl that was originally shot for stock usage—the girl's mother signed a stock photography release for it. Her image dominated the ad which was an anti-abortion, pro-life ad with the very controversial headline: "The most dangerous place for an African American is in the womb." The ad caused a huge outcry and was taken down after a day. The mother went on TV and was upset that it had been used this way. When watching these interviews, we thought that any decent lawyer would explain to the mother that such usage was not covered by a general release. That ad would definitely need a sensitive-issue release, and if the

Portrait of Max Mantelmacher

mother had only signed a regular release, then she could have sued. We don't know for sure, but did hear that she started a suit, and we're guessing that there was some kind of settlement.

This photo of Jack's stepfather, Max Mantelmacher, just a portrait taken in a family room, has been used for medical stock photography in various pharmaceutical ads, such as one for depression. A "sensitive-issue" release was needed, and Jack made sure to get one signed because of the nature of the usage. It doesn't matter whether the person in a photo is a professional model or a relative, you still must be diligent. Make sure you're covered. Your best bet is to be upfront with your subjects and models and to be careful of the ways your images are being used.

If you find yourself shooting anything that might give you pause and make you think it could be an issue, then write into the release exactly what you're shooting or shooting for. Plain language is more than fine. This is not a time to be cute or obtuse in these releases, be specific. It does not have to be written in legalese. For instance, if you're shooting nudes, then put into the release that the photos being released are nude images. If the subject is going to be portrayed as a murderer, drug dealer, prostitute, or in any disparaging manner, it should be specifically stated. Despite common belief, portraying someone, a non-lawyer, in an ad as a lawyer is not considered a disparaging use, so no sensitive-issue release needed for that use.

★

Electronic Releases

One of the most intriguing questions we receive involves obtaining a video release: "My new camera shoots stills and video with sound. I know how important model releases are. As someone who photographs people on the street, I'd love a simpler and less obtrusive way to obtain consent rather than putting a formal model release in front of them to sign. What is the legal status of a video model release, which I think people would find less intimidating"?

Video releases do not appear to fulfill the New York State requirement of being a "written instrument," so the short answer is that they may not be valid in New York State. But they may be acceptable in other places. The question raises a bunch of very interesting issues.

These days, with the advent of the digital revolution—PDAs, iStuff, Smarty Phones, etc.—we get questions that we would never have been asked years ago. So, how about these new-fangled digital model releases that can be offered to subjects via an electronic device? First off, content is king. If the wording of the release is lousy, then the release, whether it's paper or "plastic", video, or digital, will also be lousy. So it's important to have a lawyer look at your releases to be sure they're worded appropriately for your needs.

For the sake of discussion, let's make an assumption that the form itself is well drafted. Are there any potential problems on the legal front? It might become an issue to provide copies that match the originals. It's possible that one side or the other could make accusations of digital manipulation.

Just what constitutes an "original" could be also be an issue of contention in court. If the subject has second thoughts about having agreed to the shot, could he/she reject the copy sent to them by the photographer via e-mail by saying that, "This isn't what I agreed to"? Sure.

Here is what questioning in court might be like in the case of an electronic release:

Lawyer: Please tell us what you do and who you are.

You: My name is So-and-so and I'm a
 professional photographer

Lawyer: So you're a professional
 photographer?

You (Proudly): Yup.

Lawyer: You know how to use Photoshop?

You: Oh yes. Every pro needs to know
 Photoshop these days.

Lawyer: Where did you learn Photoshop?

You: At a local community college and online.

Lawyer: I understand that you can move
 objects, people, backgrounds, and even
 switch the heads of your subjects to
 create a scene that never even took place.
 Am I right?

You (Still proudly): Yes, sir.

Lawyer: So, for you to move or remove a
 word, a comma, or just a letter on a
 digital release would be a piece of
 cake. You are, in fact, a professional
 manipulator of images.

You (Thinking "Uh oh . . .")

Once that line of thinking gets introduced in court, your release is on shaky ground. A simple piece of paper with a signature on it is generally conclusive. It's simply more difficult to alter or forge a paper document. If all you have with you is an electronic way to get a release, use it, it's better than nothing. But know that it's not as good as paper which beats plasma every time.

Tips for the Street

Here are two great release tips. The first is about getting people you do not know on the street to sign your release: Carry a pad of paper releases in a bound form. We're talking about simple, short releases, not the long ones that scare people. Save those for professional models. Each pad should have two copies of each release. You can use old-fashioned carbon paper; NCR (No Carbon Required) forms are great, too.

Here's an important thing—have already signed releases on your pad so that your subject is not the first one to sign in the pad of releases. The ones already signed can be friends and family, even if you didn't photograph them. The advantage is that your subject will see other signed releases already in the pad. They will be less reticent about signing something that scores of other people

have signed. People are inclined to act in the same manner as others have before them—a manifestation of herd mentality. The original release they sign stays in the pad for your records and you hand the copy to the subject. This method is simple, effective, and elegant.

Second tip: Make sure you have a large number, either pre-printed or written with a Sharpie type pen, on the release and then take a photo of the subject with the release. It's not easy days, weeks, or months later looking at a stack of releases with notes like "woman in yellow blouse" or "guy with red hat" and then trying to match photos with a signed release.

There is also a psychological advantage when someone signs a release and you photograph them holding a signed release. It has what's known as a "prophylactic" effect. This is discussed in more detail in the Stage or Pen Names sidebar on page 134. This means that the subject, knowing they signed a release, will possibly not try to contest it or say, "That's not my signature". It's not a guarantee by any means, but is another layer of protection.

A RELEASE IS FOREVER

We've gotten a lot of questions about the longevity of releases. Questions such as "I photographed a minor and one of the parents signed the release. The minor is now of age and the parents are divorced. Can they rescind the release?" The answer is no, they can't. The same question comes up regarding property releases, like a house that is sold years later. Same answer. If the legal owner at the time signed a release, the release is still valid after they sell the house. Like a diamond, once signed, releases are forever. A notable exception: a release that contains language specifically stating that it expires or terminates on a specific date. In real life such limited releases are rarely used.

★

FAMILY FEUD

Nobody fights like family. The ugliest, most hotly contested lawsuits concern divorces and wills. Ed has been professionally involved in the following scenario only about a dozen times. Same movie, same script; only the actors change.

A young hotshot male photographer shoots a young wannabe female model for "their portfolio." The relationship heats up; they move in together or even marry. His muse never signs any model release unless a paying client (few and far between in the early years) insists upon one. He cheats on her. She cheats on him. They fight, they break up, they reconcile, they divorce, and they split on less-than-amicable terms. One of those portfolio shots (sans release) turns up just when the model is looking for an excuse to break her ex's legs! The model has since become a big star (which she, of course, attributes to leaving him). She strides into Ed's office saying she wants his head on a platter and, oh yeah, money would be good too.

Lesson: 50% of all marriages end in divorce. There are no reliable statistics on disgruntled former lovers, friends, stalkers, and so on. People and relationships change. A simple signed release would have saved the photographer tons of grief and, oh yeah, money too.

Is it Really Fine Art?

If you intend to use non-released images in works of fine art and your subject (a professional model or a regular person) objects to this use, a court may closely—and we mean closely—scrutinize your fine art credentials. You may need to demonstrate that you've shown regularly in art galleries and museums, that your work has been "collected" by others, and that the work in question has been produced and sold in limited numbers.

You can't suddenly deem your work is "fine art" simply for the sole purpose of avoiding a lawsuit. Thus, you should obtain releases from the subjects of any wedding and/or portrait work you intend to display on your website, in your blog, in your studio, or elsewhere for self-promotion, or in a flier. Don't assume, in such cases, that you can call your image a work of "fine art" and avoid the need for a model release.

If, however, you are a recognized fine art photographer with a history of exhibits, shows, books, and so on, then there are exceptions to the need for a release. Your images must have been reproduced in very limited editions. An edition of ten or even of a few dozen is fine, whereas a printing of 1,000 would not qualify.

While copyright and releases are two different areas of the law, it's important to note that the Copyright Law defines a "work of visual art" in part as: "A painting, drawing, print or sculpture, existing in a single copy, in a limited edition of 200 copies or fewer that are signed and consecutively numbered by the author, or, in the case of a sculpture, in multiple cast, carved, or fabricated sculptures of 200 or fewer that are consecutively numbered by the author and bear the signature or other identifying mark of the author."

In summary, to claim that your work constitutes "fine art" it is best to keep the number of prints to something well under 200. Cranking out 500 posters and calling it "fine art" anyway just isn't likely to fly in any courtroom. Number your prints consecutively just like the copyright law says, keep the edition sizes as small as possible (ideally under 100), and sign each one.

FINE ART'S DAY IN COURT

There is an interesting ruling in the case of photographer Philip-Lorca diCorcia, who was sued by an Orthodox Jewish man whom he photographed as part of a street-portrait series in 2001. To capture the images for his series, diCorcia taped an "X" mark on the sidewalk in New York and rigged strobe lights to scaffolding. From 20 feet away, he photographed thousands of people walking down the sidewalk.

Included as a subject in his series and as a part of his *Heads* show at the Pace Wildenstein gallery, was an image titled "#13" of Rabbi Erno Nussenzweig. Nussenzweig objected to the use of his image and sued diCorcia, with the case going before a judge. At trial, diCorcia said that multiple prints of Nussenzweig's picture sold for about $20,000 each. In addition, the picture was published in *Heads*, a book that sold several thousand copies.

Nussenzweig objected that such use was against his religious beliefs and that he had signed no release. The judged ruled for diCorcia, basically because the photograph of Rabbi Nussenzweig was considered a work of fine art by a recognized artist, printed in a very limited edition, and exhibited in a widely recognized fine art gallery. We strongly caution all of you not to regard this as some loophole to drive through—unless you are truly working on fine art pieces.

Another case that was widely reported in the news involved fine art photographer Arne Svenson, who set up a camera in his Manhattan apartment, in the trendy Tribeca neighborhood. Armed with a 500mm bird-watching lens, he photographed his "neighbors" in a new high-rise building, The Zinc Building, across the street from his residence. The photos were all shot through the open (or unobstructed) floor–ceiling windows of his neighbor's loft apartments, without their knowledge. Think of Jimmy Stewart in Alfred Hitchcock's famous movie *Rear Window*, except without the murder mystery. The images, printed very large, were exhibited at the Julie Saul Gallery at a show he cleverly titled *The Neighbors*. Printed in limited editions of 5, the photographs sold reportedly for up to $7,500 each. You can easily find the images with a Google search.

The "neighbors" needless to say, were not happy, even though there were no faces shown in any of the images. An action was brought against Mr. Svenson by one set of the parents whose children had been photographed. No model releases were obtained or existed. The parents sought to bar the publication/sale of the photos, on a theory based on an outrageous breach of morality and privacy, and because it was children who were shown. They also requested that the images be delivered to them so that Mr. Svenson would not retain any copies.

Not surprisingly, Judge Eileen Rakower ruled in favor of Mr. Svenson and dismissed the suit. The judge relied in her decision to a great degree on the First Amendment rights of the artist to create. Additionally, in New York State a model release is not required to sell fine art images containing the portrait, image, or likeness of an individual. These images could not, however, be employed for the sale or promotion of goods, services, or an organization without the subjects' written consent. Fine art is excepted from this New York Law (NY Civ. Rts. Law Sec. 50, 51). To reiterate, this is a New York case decided under New York Law by a New York State Court judge. Assume those very same facts but the site of the events was say, Alabama, Texas, California, or Florida. The results could well have been very different. State laws control matters such as these. In some states some judges could hold that the photographer's creating images of especially children, in the sanctity of their own home without the knowledge or consent of the parents, constituted a crime and/or would subject the shooter to a civil lawsuit. Do not assume that the result in this case would be the same in your state. This case would likely have little to no weight in a litigation occurring in any other state or territory of the United States.

Nearly all model release cases are state sensitive and state laws vary. There is no "one size fits all" answer to these complicated situations where competing federal and state constitutional rights collide. So, while this is a great result for photographers, never assume that this gives you license to do something similar. One size does not fit all.

STAGE OR PEN NAMES

The general legal rule is that the use of a "stage" name or a "nom de plume" is valid and will serve to bind the signatory to any contract or agreement as long as such name is used in a consistent and non-fraudulent manner. Cary Grant was born Archibald Alexander Leach. Ralph Lauren was formally Ralph Lifshitz (we can only assume what happened in junior high school, but look at who got the last laugh). Twiggy was born Lesley Hornby. And Stefani Joanne Angelina Germanotta has been reduced down to Lady Gaga. Except for the deceased Mr. Grant, they can and likely do all sign using their "stage" name and are bound by the documents they sign. It is not incumbent upon a photographer to ascertain whether the subject has "formally" and legally changed his/her name by order of a court in the United States or elsewhere. It is good practice when shooting anybody to photocopy their driver's license, passport, or other form of ID when possible. The key question is whether that person signed that document. As recounted in numerous movies, an "X" can suffice for both illiterate mountain men as well as non-English speaking wealthy immigrants. A Notary Public can affix his/her seal to a mere mark so long as there is evidence of the identity of the "signor."

Here's a helpful release bonus tip offered at no charge to you. Jack will sometimes take a photo of the model holding the release. This doesn't by itself establish the proof of signature, but it serves as excellent evidence to prove the identity of the signor in the event of a dispute. The reason Jack does so, and why this step makes sense for most photographers, is that Jack numbers each release with a thick Sharpie felt pen. When he photographs the model holding the release, he knows which model goes with which release. In the pre-digital days, Jack would "take a Polaroid" (real pictures in just 60 seconds!) and attach it to the release to identify and match the model to a specific release. In this digital age, getting a shot of the model holding the release serves the very same purpose. Lawyers like to term these acts as "prophylactic," in that the model knows you took their photo holding the release. Such a photo may prevent the model from even considering seeing a lawyer to determine if there is a claim.

A "STAGED" NAME

Years ago Ed had a case where a multi-national company was using a very well-known supermodel's photo worldwide in every media imaginable. The company was at utter peace, claiming in good faith that they had received a signed release from their big shot ad agency. Upon receiving Ed's claim letter, the company's CEO immediately faxed a copy of the release to Ed. One look at the release and the model exclaimed, "Game, set, and match!" The release, she explained to her counsel, was a forgery. Cynical Mr. Greenberg insisted that his client prove she was speaking the truth.

The lovely model then provided Ed with numerous checks, contracts, her driver's license, other model releases, even her divorce papers all bearing her signature and most were notarized. The model's legal name was, say, "Alice Barri Jones." The name used by her and her agencies was always "Barri Jones." When she appeared in a movie her credit read "Barri Jones." But the model had never,

ever in her life signed any document "Barri Jones" but rather "A. Barri Jones" . . . always. It seems she hated her first name and never used it, preferring "Barri." Her first grade teacher told her she couldn't do that and had to at least use her first initial when signing her papers. She had done so ever since.

Her ad agency (for a big multi-national consumer company) screwed up big. It feared losing a giant account because it stole the image and thus didn't have a release. So someone back at HQ on Madison Ave., fearing the loss of his/her job or even body parts, simply created a release and signed it "Alice Barri Jones" in a sort of intentionally slipshod fashion. When copies of the model's real signatures were sent to the CEO he fired the ad agency and came to NYC to deliver a check to Ed's client because he claimed he "felt just awful and wanted to apologize in person." Ed thinks that if the model had not been in the *Sports Illustrated* Swimsuit Edition the check would have come by mail.

REVENGE PORN

"Revenge Porn" is the use of a person's image without consent for the purposes of embarrassing, humiliating, harassing, or demeaning someone and it is an important consideration for a photographer or publisher wanting to publish photos without model releases. This type of use, irrespective of any profit motive, has been criminalized in several states including California. Typically the subjects are naked, engaged in sexual or otherwise private and/or embarrassing acts. The postings are usually but not always motivated by sheer animus. The subjects of these photos have multiple avenues of legal recourse which include having the photographer/publisher of such images placed in cuffs. Search for "Hunter Moore," who was indicted on federal charges in January 2014 for running a site "dedicated" to such activities.

It may matter very little that, at the time the photos were created, the model was a willing participant in their creation. The various criminal statutes specifically address the purpose and intent behind the unauthorized publication of such photos. An adult could, of course, issue written consent to the use of embarrassing, nude, or compromising photos via a written, signed model release. Porn actors and models for XXX rated materials do just that every day. Since it is not at all likely that a former lover will permit herself/himself to be publicly humiliated by a former partner, a release which would specifically permit the use of such images on social media or elsewhere would be exceptionally rare.

So if you are in possession of questionable images, even if the subject willingly participated in their creation, and whether or not you have a written, signed model release, your use of such images on the web or elsewhere can now get you arrested. Thus, what seems like revenge by the goose can turn into legal revenge by the gander. Today's cliché, "When in doubt, don't."

RETIREMENT

You can just feel the heartbreak. A photographer with many clicks in a very long career is looking forward to retirement. The shooter receives a significant seven-figure offer for a small-but-notable portion of his collection to be employed in a sort of retro ad campaign by a new client. The photographer has not kept any of the model releases signed at the shoots—mistakenly assuming that since all of the shots were over ten years old, the statutes of limitations had long since run out. And the original client had thrown out all of its paperwork many years ago. No one knew or could recall the names of most of the models. The in-house people at the ad agency and in the photographer's studio who worked on the campaign ten-plus years earlier had all long since scattered to the winds. All of the models were supplied by model agencies, some of which no longer exist.

When the prospective purchaser consulted its legal counsel on the value of these shots, the corporate counsel requested the releases. When told neither the releases nor models could be

found, the attorney quite rightly killed the deal. The photographer was out seven figures and retirement is no longer on the horizon. The images now have value only as curiosities to be produced in photo magazines or perhaps a book (though even publishers are starting to require releases). No stock agency would touch them, nor would any advertiser. Their actual fair market value is now negligible.

Lesson: Never depend on anyone other than yourself to retain records. Not your agent, your lawyer, an ad agency, a model agency, and especially not the client. Keep model releases forever because businesses fold, people move, get fired, have poor memories, and even die. Dogs are dependable and reliable; people are not.

HISTORICAL BRIEFS—1886—BERNE THIS!

The Berne Convention is neither a fireman's gathering nor a meeting of the George and Gracie fan club. Rather, it was a political meeting in Berne, Switzerland in 1886 that spawned an international treaty governing how copyright laws are handled among nations. Prior to the treaty, literary and artistic works were not protected across national borders—a work created in the United Kingdom was protected by UK copyright laws, but could be freely copied and distributed in other countries. By creating several international standards of copyright law, the Berne Convention sought to resolve this dilemma and ensure equal application of copyright protection in all the signatory countries a full century ahead of the Internet.

But for over 100 years, the United States refused to sign it. There existed at the time a fundamental difference of opinion on copyright law between Berne Convention signatories and the Unites States— namely, the United States did not recognize any copyright protection until the work was registered. You had to actually file with the Copyright Office in order to be protected. You also had to have a copyright notice appear on your photograph, or else your copyright would be invalidated, you could lose protection, and your work could fall into the public domain.

Rewriting these core principles of U.S. Copyright law took some time. By 1978, copyright was automatic and registration was voluntary rather than mandatory. With the Berne Convention Implementation Act of 1988, the United States became an official signatory to the Berne Convention treaty. With this Act (which came into force on March 1, 1989), the necessity of having a copyright notice appear on your work in order to be protected under U.S. Copyright law was eliminated. Of course, make sure you read our chapter on registration, because as we thoroughly explain there, copyright without registration in the U.S. severely limits your legal options in the event of infringement.

How to Avoid Your Worst Nightmare

1 Use a written model release all the time; get it signed. You'll sleep better.

2 Always get releases from everyone in the photo. Spouses, girlfriends, significant others, employees, friends, and relatives. Everyone.

3 Other than for the exceptions mentioned earlier, every image is potentially valuable, so every image containing a person must be accompanied by a model release. Don't fall into the trap of thinking that work is not valuable, nor ever could be. You would be amazed at the number of average or so-so photos that have become extremely valuable because the person in the picture becomes famous or infamous, or because events change the context of the image. (See "Who knew?" on pages 60–61, 63–5.)

4 Leave no blanks in a release and make sure it's dated. Also make sure you obtain suitable identification from the model, like a driver's license or passport.

5 Provide a copy of the release to the model and then retain the original, if possible. If your savvy client requires the original, retain at least a signed copy.

6 Keep your signed release forever. You must retain the release so it can be given to your children and grandchildren. If anyone, even your accountant, tells you that you can throw out old model releases after a certain period of time, ignore the advice. There have been cases where the photo was taken three or four decades prior to the objectionable use.

7 If the subject in the photo is a minor, obtain a written representation and proof if possible that the adult signing on the child's behalf is legally authorized to do so. These days the odds are good that a child might be or become the product of a divorce; a parent in such circumstances might not have the authority to sign on the child's behalf. That right might be held exclusively by the other parent.

8 Oral consent is usually not worth the paper it's written on. There is nothing better than a written release.

9 "But she looked 18." We love that one. Sounds as dumb in this context as it does in any other context. Ask to see a driver's license. Make a photocopy and attach it to the release. As you know, minors cannot sign releases, right? Well actually they can sign them, they're just worthless.

Everyone's Got a Plan

That great philosopher and boxer, Mike Tyson, once famously stated that "Everyone's got a plan, until they get punched." In the following case, we see Getty Images trying to defend themselves against a model release issue, using a defense that photographers have been (wrongly) disseminating around the Internet, with the idea that the "end user" is responsible for having releases. Rather than theories of what would happen, here is a real case, argued in a real courtroom. These are the relevant facts and portions of a 2014 decision of Justice A. Singh in the case of Avril Nolan v. Getty Images (US), Inc., heard in the Supreme Court of NY in NY County. Look it up if you want the entire case to read.

Photographer Jena Cumbo sent her stock agent, Getty, a photo that included the image of Ms. Avril Nolan, a healthy 25 year old. The photographer did not obtain a signed, written model release from Ms. Nolan. The image was licensed by Getty for a (purported) public service advertisement placed by the NY State Division of Human Rights in a free, but widely distributed daily newspaper, *AM NY*. (The paper is a "freebie" that exists on advertising revenue. It is vigorously handed out to New York commuters as they enter and leave subway stations, placed in hotels, and offered at no charge in newspaper boxes on the streets.)

The caption in the ads featuring Ms. Nolan's image stated, "I am positive (+) and I have rights. People who are HIV positive are protected by the NY Human Rights Law. Do you know your rights? Contact the NY Division of Human Rights."

Unsurprisingly, after seeing the ad, Ms. Nolan sued Getty under the NY Civil Rights Law Sec. 50 & 51 that clearly requires a signed model release for use of an image for the purposes of advertising or trade. No sale of any products was involved nor were there any allegations that the end user "made a profit." And so the fun began . . .

Getty sought to have the case dismissed before trial *essentially* on three grounds:

1 It had First Amendment rights to license the image to the press.

2 It had no responsibility to check if this image (or others in its collection) were model released.

3 It was not the "end user" who actually published the offending image and, thus, was off the hook.

We were utterly unsurprised that the Court didn't buy what Getty was trying to sell. In plain English, Judge Singh held that:

1 Getty is not immune from liability simply because the image appeared in a newspaper.

2 If the use by the end user is not lawful, then Getty's sale of the license to their client *may not* be lawful.

3 The appearance of the image in Getty's catalog "for trade or advertising" may serve on a basis for the plaintiff's action (especially) when the use of the image creates a false impression about the subject.

4 There is no heightened constitutional protection for this commercial speech.

5 The NY Civil Rights Law does not explicitly define "trade" or "advertising" but it clearly was drafted to "protect the sentiments, thoughts, and feelings of individuals." (Ed has had similar cases where so-called PSAs were treated as "advertising" or "promotion".)

The case is going forward as we go to press, and Getty will need to convince a jury that it should not be held liable by coming up with some additional facts, so as to blame its client and/or photographer. They will also try to somehow prove that this use, which advocates and/or promotes the services of a government agency, does not qualify as "trade" or "commercial" purpose. We assume that the plaintiff's attorneys will invoke the concept of branding and that Getty helps brand itself with each image it accepts into its archives and elects to promote. We wouldn't bet on Getty's success in their efforts and statistically

speaking the case is likely to settle short of a full-blown trial.

The judge clearly was convinced that Ms. Nolan has pleaded enough facts and used the correct law to entitle her to go to a jury trial. Potentially, Ms. Nolan may recover exemplary damages as determined by a jury. Simply put, NY law allows a jury to set a financial award, which may far exceed the sum(s) a person would have agreed to accept to be in an ad, if indeed they would have agreed at all. Oft times, as here, the subject would not for any fee permit herself to be portrayed in a false or damaging light as, say, a murderer, pedophile, drug addict, child abuser, or merely as endorsing or promoting a product or service with which he/she may have issues. The jury may compute an amount to serve as a punishment of the offender and deter others from acting in a like manner.

Getty never bothered to ascertain whether there was a release before taking the image into its archives nor before licensing it. The contributor/photographer never obtained a release. A simple, single piece of paper bearing a signature would have prevented this mess from ever occurring. The attorney's fees will likely go into the hundreds of thousands of dollars. At the end of the day, a jury may award Ms. Nolan anything from zero to seven figures. The next time someone pooh-poohs the need for a model release, or claims since you're not the "end user" it's not needed, take a moment to think whether you can afford to run these types of financial risks in *real life*. A signed model release is your best plan to avoid getting punched.

Back To the Future

Clichés like "Dance with the person who brung ya'" or "If it ain't broke don't fix it" speak to the wisdom of doing that which has worked well in the past. We have all become eager participants in the digital age and the instant communications it affords us. We are now all tied 24/7 to a smart phone, laptop, and a host of other electronic devices that didn't exist until, say, 2010. We often forget that, in business, sometimes the old-fashioned way is still the better way. Here are some examples where good old-fashioned paper beats out our modern-day electronic conveniences:

Snail mail: Placing a bill, invoice, or confidential note in an old-fashioned paper envelope, affixing a stamp, and depositing it with the good folks at the U.S. Postal Service is preferable to sending an instantaneous and "free" email. While emails are routinely accessed by hackers, the NSA, your employees, and Lord knows who else, envelopes sent via the USPS (or FedEx) are rarely seen by persons other than the intended recipient. It is not unusual to have the names of email authors and recipients (together with subject lines) on view on several screens at a business. Opening someone else's mail is a federal offense, period. That ain't necessarily so when applied to someone viewing an email meant for you. While snail mail is slower to be sure, paper envelopes are far more secure. And that, friends, is the extent of Ed's ability to rhyme. Be thankful.

Faxes: They have all the benefits of snail mail, but in addition they are faster and you avoid the cost of stamps. We are constantly surprised at the number of business people who proudly boast that they have buried their fax machines. In an effort to appear as up to date as possible they have disposed of a

valuable and relatively secure method of instantly transmitting business documents. Many business restrict their employees' access to fax machines. Employees rely heavily on emails and have little use for faxes. Again, that fax machine is an excellent way to prevent a transmission from being seen by unauthorized sets of eyeballs.

Business records, model releases, invoices, heck, all of them: Paper documents are still regarded as superior to electronic documents for trial purposes. Anyone with a basic knowledge about Photoshop can put Barack Obama's head on Jimmy Fallon's body. Altering paper documents and/or forging signatures in ink are far more difficult tasks. Good old-fashioned document manipulation in the days before Photoshop was a true art. Now any 8 year old can manipulate both photos and writings like a pro. The less likely that evidence has been altered, the greater credibility it has.

Computers are fallible: They crash, burn, get stolen, or get really, really wet. Even after the devastation wrought by Katrina and Sandy we are amazed at how many people in various industries fail to maintain both a computer

back up and paper copies of important documents. Three decades of essential paperwork generated by a busy photo studio can easily fit in say 10–30 file boxes (depending on the type of photography business). You need to keep licenses, model/property releases, invoices, and copyright registrations forever. Both the space and the cost involved are minimal compared to the insurance and security it provides. Many photographers have found out that their photos, years later, can prove to be a gold mine if they have the paperwork or a bust if they don't.

Messenger services: Expensive to be sure but speed, security, and a dated, signed receipt are hard to beat when a dispute over who said what to whom, when, and where arises.

Bottom line—in business, paper is as good as gold!

The Busyness of Business

Hard economic times in an industry that has always been very competitive make it vitally important to know how to handle and understand clients with excuses, clients that are bullies, and, plainly, clients that are thieves. You especially have to understand them if you want to get paid, survive, and even—dare we say—thrive. A business problem may be easily solvable, very complex, or completely unsolvable. The difference between collecting your money without losing any sleep and losing all your money plus all your sleep can be summarized in one, neat word: Paperwork. Your paperwork is both your first and last line of defense in the battleground of business. Yet far too many photographers fear that, like Robert De Niro's character in the movie *Brazil*, they will be overwhelmed by it all and die by drowning in paperwork.

Handling the Paperwork

The brain is divided into two hemispheres: the right side, which is creative; and the left side, which is analytical. Artists tend to be right-brain dominant and accountants and lawyers are left-brain dominant. Jack = right, Ed = left. You get the idea. When running a business, you really need a blend of the two. The right brain creates the work and the left brain bills clients and collects your money. Just like gears perfectly meshed and working in tandem, artists need to have both their right and left brains working together.

Unfortunately, most artists suffer from what actor Strother Martin in the movie *Hud* once described, in a slow Southern drawl, as a "failure to communicate." Many an artist has trouble getting the left, analytical side of their brain to really kick in when it comes to paperwork. This is very evident when it comes to dealing with invoices—the vehicle a business uses to collect money. If this is really not your world, not your comfort zone, that's okay. Simple solution: Get help. Don't hesitate to consult someone with

bookkeeping, accounting, or managerial experience. There's no shame in getting good professional assistance. The best businesspeople are those who know what they don't know, and when to ask for help.

The indispensable element of every business transaction of any kind is some form of paperwork. Every industry has its own forms—a lease, a mortgage, a contract of sale, a rental agreement for a car, or a simple receipt at your favorite diner. For photographers, invoices are actually very simple forms; they will indicate the services provided, licenses granted, and terms of payment. Remember, you never want to "sell" your work; you only want to "license" your work. The difference is like renting a car from Hertz as opposed to buying a car at a Ford dealer.

Typical Scenario

A photographer comes to Ed's office saying his best client hasn't paid him in eight months, but they are promising him another big job soon. What should he do? Jack would say, that's not a "client," that's a deadbeat debtor who will put you out of business. Don't laugh. It's very common for photographers to carry such clients because they are scared of losing any work, even if that work puts them out of business. The threat of losing work from a non-paying "client" has always scared creative types.

But Ed, being a lawyer, deals with it all the time. He asks the photographer to send him all the paperwork. Ed receives a spreadsheet that shows how many days were worked, where the work took place, and what the fees and expenses were. That gives Ed a picture of what's been done and maybe a sense of what's owed. Ed's office now calls the photographer and asks for the invoices. The photographer answers, "That is the invoice—the spreadsheet." We kid you not. A spreadsheet is not and never will be an invoice. Ed suddenly understands why this photographer

never got paid, and also why he drives a Yugo. The client's accounting department never got an invoice to pay, just a confusing spreadsheet. Even if they intended to pay, they had a perfect excuse not to. There was no name to make the checks payable to, nor could the bookkeeper easily figure out how much to pay.

If you want to facilitate payment of your invoice, you need to appreciate what your client's accounting department faces—hundreds of invoices every month including rent, floor cleaning, exterminators, payroll, printers, taxes, and even some photographers. Your invoice needs to be as clear and informative as possible.

On page 150 is an example of a simple invoice. Adjust and fine-tune it as you want, but please don't get too creative with it. Fight your creative urges when it comes to routine paperwork—save your creativity for the camera. This is not the time to let your right brain take over too much. Please utilize the services of your local attorney to customize it to conform to your state laws as well as approve any tweaks you want to add to the form.

HISTORICAL BRIEFS—1998

Like all laws, copyright is open to interpretation by a judge and jury—or worse, by a legislator looking for votes. Artists who think that owning and controlling their work is an enduring, God-given right are, in fact, quite wrong. The public good, the public domain, and the "Commons of the Mind" are what Congress and the courts have in mind when they play with copyright law. God-given? Hardly. Big business, lobbyists, and large campaign contributions have been known to affect politicians' views on copyright.

For instance, in 1998, with the new millennium approaching, the multi-billion dollar Walt Disney Corporation found itself about to lose its copyright on Mickey Mouse (and many other protected works from the early 20th century). Not about to lose its lucrative hold on its beloved cartoons, Disney began a huge lobbying effort to change copyright legislation and extend its copyright. Congressman Sonny Bono was only too happy to oblige— himself an artist with a vested interest in maintaining his own copyrights for as long as possible. The resulting Sonny Bono Copyright Term Extension Act (aka the Mickey Mouse Act) extended copyright protection for the lifetime of the artist plus 70 years, or 95 years for corporate works for hire. Powerful persuaders were Sonny and the Mouse.

Invoice Basics

1 Make your header legible and understandable, including who you are, where you are, and how to get a hold of you. This is for the person in accounting who has life-and-death control over when you will get paid. No one in the accounting department cares that you're the next big thing with a camera. All they care about is: who are you, how much money you want and for what, and if they do have to pay you, how to get in touch with you if necessary—period. We can't say that enough. This is one of the big mistakes we see on invoices. We've seen unreadable logos instead of names and not even an address as to where to send the check. Skip the fancy logos, and keep it simple.

2 Always date your invoice, and always have a unique invoice number that you generate. Get a PO from the client if at all possible, indicate the PO number on your invoice, and, for goodness sake, always state what client you are shooting the photo for—which quite often is not the ad agency that gave you the job.

3 Again, simple stuff. Who gets the bill? Who are you sending the bill to and what company is paying you? Should be easy, but many photographers mess this up by addressing it to just the art director they worked with rather than the ad agency. We put the appropriate person's phone number right on the invoice as a convenience, so we don't need to hunt it down when we have to call and ask, "Where's my check?" It saves you lots of time.

4 This section is the most important part of the invoice (well, maybe after the total). This is basically the license you are granting. It explains who is getting the license and what the image is—exactly and specifically. Never be vague here and say only "For photographs" or "For photography." Always, always have a complete and understandable description of the photograph or photographs. The use should also clearly state how the photo is being used, in what media, what geographic area, and even what it may not be used for, like "no TV," "No billboards," and Jack's favorite, "NO third party usage." The period of use should also state the date usage starts and the date usage ends.

The Copyright Zone Guys ① **INVOICE**

26 East Whowantstoknow Lane New York, NY 10000 Phone: 212.555.0190 Fax: 212.555.0191	**DATE:** December 32, 2020 **INVOICE #** 121232 **PO:** 42-67-18-HUTT ② **FOR:** *Copyright Brand Sunscreen Lotion Ad for SPF 40 product line only*

Bill To:
Joseph Schmoe ③
Schmoe Schlarry & Shirley Intergalactical Media Group
222 Stooge Blvd.
Hollywood, CA 90001
Phone: 1.800.Goodluck

DESCRIPTION	AMOUNT
CLIENT/JOB: Shirley Youkid Suntan Lotion **PRODUCT:** Copyright Brand Sunscreen Lotion- SPF 40 product line only. **DESCRIPTION:** Photograph of Jack and Ed holding up Copyright symbol **USE:** Print ads & billboards south of the Andomedia Nebula and Utah only. **PERIOD OF USE:** One year from 01/15/2020 terminating on 01/14/2021 ④	
CHARGES	
Fees: Creative fee for shooting and usage as stated above	50000.00
Labor: Hair stylist for Jack's hair and beard	1000.00
Hair stylist for Ed	1.00
Assistant for pre-light, prep and shoot ⑤	650.00
Props: Foam rubber circle "C" symbol	
Materials: Seamless, tape, etc.	100.00
Digital Capture and processing	750.00
Four Lark books so we could suck up to the publisher	36.99
Catering: For us to pig out with crew	847.29
Misc: Any items or services in connection with this shoot not itemized above	632.36
SubTotal	54017.64
Advance from invoice 201201 ⑥	-25000.00
NYS Sales Tax	

⑦ Please make checks payable to: The Copyright Zone Guys, LLP **TOTAL DUE** $29,017.64
 E.I.N #: 11-111112

TERMS: Full payment is due upon receipt of this invoice. Final billing reflects
actual, not estimated expenses, plus applicable taxes. All fees and charges on
this invoice are for the service(s) and/or licensing described above. ⑧
Fees for licensing of additional available rights will be quoted upon request.
Interest at the rate of 1.5% per month shall be due on all sums not paid within
30 days of this invoice.

by: _____ Date:_____ by: _____ Date:_____ ⑨
 The Copyright Zone Guys, LLP Client

RIGHTS LICENSED ONLY UPON FULL PAYMENT OF TOTAL BILLING ⑩

5 This details the itemized expenses—not just "A photo." We find the more information you can give the client, the clearer you denote what they are paying for, and the more likely you'll get paid in a timely manner. On the invoice, it's usually broad categories and totals. For complicated or larger jobs, you should add an additional page or pages, showing a more detailed breakdown of what was spent.

6 A subtotal makes reading the invoice easier for the people paying you, especially if you have advances to deduct and sales tax to add. Use a separate invoice for advances, so you have two different invoice numbers. This will make life much simpler if there is a problem and you have to call their accounting department. It also makes your life easier. As far as sales tax, consult with your accountant as to when to collect sales tax. You never "charge" sales tax, as it's not your money—you are simply collecting it to turn over to the proper authorities. Trust no one's opinion on sales tax other than your accountant. If your client says they don't pay sales tax, get the proper exempt paperwork from them. If the paperwork does not come by the time you're doing the invoice, then charge sales tax and tell them they can deduct it when you get the paperwork. Do this in writing. Collecting sales tax is your legal responsibility. Having paperwork if there is an issue can be critical.

7 If the clearly written and legible name at the top of your invoice is not whom the check should be made out to, then make sure you let them know how to write the check. If your logo says John Smith but the checks need to be made out to John Smith Photography, Inc., then say so. Accountants are not mind readers. The EIN (Employer Identification Number) is meant to save the accounting department the bother of hunting you down to ask for it. We find this saves a lot of time. Providing the accounts payable person with all the information they will need to process your payment reduces the odds that your invoice will end up growing mold in a pile on their desk or at the bottom of the "later" pile.

8 In nearly all states, commercial parties can set interest rates on unpaid sums at rates higher than those permitted in consumer transactions. If this rate is not written in your agreement, then you may be entitled to no more than the so-called "legal interest" rate in

your state. Check with your local attorney to determine what the maximum rate your state's law allows. This increased rate of interest adds up to substantial bucks rather quickly. Such sums may accomplish one or more goals:

- Hasten payment to you so your client can avoid the interest charges.

- Act as a factor for you to negotiate the payment of an overdue balance. For example say your client owes you $5,000 plus $440 in interest, you now have the flexibility to say things like, "I will forgive the $440 if I receive your check for $5,000 *today.*"

- If you are owed substantial fees for even a few months, the interest charges recoverable in court may well equal or exceed the amounts you have paid to your attorneys and accountants in pursuing the deadbeat.

- You can always agree to reduce or eliminate all or a portion of the interest due you BUT if you do not have the commercial rate of interest on your paperwork (i.e., 1.5 or 2% per month) then most state laws limit you to recovering interest at an *annual* rate of 9% or less.

9 This part is easy to explain. Make sure you sign your own invoice, and make sure to get your client's signature.

10 This can be one of the most important lines in your invoice. It states in clear bold letters that the client cannot use the images until you are paid in full. There are optional and dare we say, rather pushy "reminders" that can be added to your invoices to the effect that copyright infringement can be very costly. Either or both tend to expedite timely payment and serve to lessen the risk of theft.

License Terms and Explanations

There are other important things that must be in your invoice. Remember that your invoice will serve as the license for your work. You need to clearly spell out the use for which you are licensing the images, and for what period of time. "What for" can be broad or specific, but in either case the wording needs to be clear. When Jack licenses a broad usage, like

PR (Public Relations) use, he will also list what is *not* included: no billboard, no TV, and so on.

The terms and explanation can be quite simple with some jobs; with others, it can be more complicated:

Simple #1: Consumer magazines (only) commencing on 2/1/15 terminating on 1/31/16

Simple #2: *Newsweek* magazine, 1/1/15 issue, North East Regional insertion only

Complex #1: North American Consumer Magazines of not more than 1 million paid circulation only

The period of use (aka the license term) must also be clear. If it's a fixed time, when does it start? When does it terminate? For exactly how long does it last? Two months, one year, no time limit?

And what other restrictions are there? Geographical limitations, if any, are also important. "North America," "New York State only," "Milwaukee only," "East of the Mississippi only," "Worldwide," or even "Intergalactic." Whatever has been negotiated

must be written. The more usage for the client, the more you should be charging.

For business portraits you might want to include the line, "No third party usage." This means that if that Acme Company banker or real estate broker whom you photographed quits or gets fired, they can't take your photo and use it if they get hired by a competitor of the Acme Company or any other company, even in a different field. Your license is restricted for PR usage by the Acme Company only.

Then there is one line that you have to include. This is a must. You must, must, must include the line: "Rights licensed only upon full payment of total billing." That single line, coupled with the retention of your copyright, can make all the difference in whether or not you get paid. Your client's failure to pay you may now constitute copyright infringement. (Read Chapter 2 to understand fully what this means.) If your client seeks protection under the Bankruptcy law, that line will make a huge difference in making sure you are at the front of the line when the Bankruptcy Judge looks at who will be paid.

Also, remember to fill in *all* the blanks of any invoice, model release, or other paperwork you use. Do not leave anything blank. If there is a blank where a name or product name should be, fill in that name. If there is a blank for a date, don't do it later, fill it in now.

If you have an agent or rep, you should do all the paperwork and the checks should be made out to you, the copyright holder. Provide a photocopy of the check to your agent/rep when you get paid. If for some reason you don't prepare the invoice (though we highly recommend that you do it), then make sure you get a photocopy of the invoice and, most importantly, a photocopy of the check. A key element here is that you, the photographer, are the creditor—the one due the money— not your agent.

Jack had one high-profile photographer friend complain about how slow the ad agencies were to pay, but he had a good rep (agent) who always rattled the trees and got him a check when he really needed it.

Jack asked the photographer,

"How long does it take to get paid usually?"
"Six to eight months."

"Who bills?"
"The rep."
"Who gets the checks?"
"The rep."
"Do you see a copy of the check?"
"No."
"OK," Jack said. "Next time, ask to see a copy of the check from the ad agency as a check and balance system."

Jack knew the answer to all this. Skipping the gory details and excuses from the rep, suffice it to say the photographer and rep no longer do business together.

Despite what reps want photographers to believe, the rep works for the photographer— not the other way around. Photographers should always have the check sent to themselves and then pay the agent, not vice versa. Not doing that opens up a snake pit of potential problems. If the check goes to the agent/rep, then the photographer has to wait for that check to clear the agent/rep's bank account and then wait again for it to clear their own bank account. There's a lot more on reps and agents in Chapter 6.

ADDITIONAL WARNINGS

There are additional warnings that you *might* want to consider including in your invoice. Below are two such clauses, which may help deter the infringement of your work. Either one serves as some powerful evidence to be employed by your attorney in the event your client becomes an infringer. Some photographers may find either or both clauses too off-putting to clients but both are fairly effective in keeping thieves at bay. Another view is that a legitimate client, whose mind is free of any thought of larceny, won't be concerned about being warned of the consequences of an act it has no intention of committing. If you have that uneasy feeling in your stomach (and it's usually a very good barometer) that the client you are working with might be a problem further down the line, you might want to include either one of these warnings.

The first one, which you can use on the front of your invoice, can read:

Federal Law USC Title 17, The Copyright Act, may make the

infringer(s) of a registered image subject to the payment of damages of up to $150,000 per infringement together with the payment of the photographer's legal fees.

Your second option is to go to www.fbi.gov/about-us/investigate/white_collar/ipr/anti-piracy where you can download the FBI Anti-Piracy

The unauthorized reproduction or distribution of a copyrighted work is illegal. Criminal copyright infringement, including infringement without monetary gain, is investigated by the FBI and is punishable by fines and federal imprisonment.

Warning Seal. This is the version photographers can use and it is very similar to the one the big movie studios employ. We have included three paragraphs which accompany the seal on the site and they are well worth reading. The wording directly under the seal here must accompany the seal when used.

Now we certainly understand that some of you will think that the seal emblazoned on your invoice is well frankly, a bit threatening. On the other hand most clients looking at an "official" warning from the FBI are both far less likely to be stealing your work in the first place and more likely to be deeply troubled when your lawyer advises them they have violated your copyright in spite of the impossible to miss seal and written warning.

<div align="center">★</div>

NUMBERING INVOICES

Make sure you have a unique number on each invoice. It doesn't matter what that number is, as long as you have a number that doesn't repeat in your organizational system. Some people like to start with a three- or four-digit number like 100 or 1000, and then just continue numbering: 100, 101, 102, and so on. Other people like to use the date, but they sometimes mess up and use the common Month/Day/Year configuration. That's all well and good for the first year of business, but after that, you'll find your system totally out of chronological order because it's sorting by the month instead of the year.

So make sure you use the Year/Month/Day method instead. That way, an invoice written on the 4th of July, 2016 will have an invoice number of 20160704. Note the double digits for the month and day, even if it's a single-digit month. January through September should be 01 through 09, as should the first nine days of each month. You can

also drop the year down to two digits, unless you think your business will last until the next millennium. Doing it that way, dropping the first two digits of the year, means that an invoice written on November 11th in 2011 would have an invoice number of 111111. The 12th of December, 2012 would yield an invoice date of 121212. We love those repeating numbers, but that's it for this millennium.

PRICING—THE BLACK ART OF PHOTOGRAPHY

The hardest part of being a professional photographer isn't taking a photograph or deciding which lens to use, how to light, what directions to give the subject, or what props to pick. Nope. The hardest part is figuring out what to charge. There is no set answer, because there are so many factors to weigh in pricing your photography. Your overhead and experience are two big factors; how difficult the job will be to photograph is usually a smaller factor. Talent, not technical expertise, will always win out. So how do you put a price on your talent?

Pricing Commercial Assignments

Commercial photography is a business-to-business affair, unlike the retail transaction of a wedding or portrait studio, which is business to consumer. In those cases, the general public can come in and look at a price list. A consumer is paying for known services

and products for their personal use. What matters in commercial photography is determining the appropriate licensing fee for an image, based on the client's intended usage and period of use. Placing an image in a national consumer magazine like *Time* is very different than running it in a half-page ad for a trade magazine like *Supermarkets Today*. A consumer publication may be seen by millions of viewers while a trade use may be seen by just a few thousand people. A license to use the very same photograph can cost either $500 or $5,000, depending on the nature and extent of the usage.

For example, in the late 1990s, Jack licensed an image to a small-circulation trade magazine for $500 for a single issue. It was a fair price for that usage,

at that time. A few weeks later Jack got a call from an assistant at a major TV network. Someone had seen Jack's photo in a photographer's trade magazine and decided they absolutely had to have it for an ad that was on a tight deadline.

Jack was offered $2,000 on the spot—for the same photo that had earned a mere $500 only weeks earlier. You'd think that Jack would have jumped on this higher price, right? Not so fast. This is where it gets interesting, and complicated.

"What's the usage?" Jack asked.

"In *TV Guide*!" the assistant proudly replied.

Jack's ears perked up. *TV Guide* was one of the highest-circulation magazines in the country, meaning they charged more money for ad space than most any other magazine. After a couple follow-up questions, Jack figured that the TV network was probably paying a six-figure sum for the ad space alone. At that point, Jack said "No" to the $2,000 offer. Clearly, there was a large enough budget for this ad that Jack deserved a higher

price. He quoted $5,000 dollars for the usage, which was a usual amount in those days for that kind of usage.

"But the most we ever paid anyone is $2,500!" exclaimed the excitable assistant.

Suddenly, as if by magic, there was more money in the pot that wasn't there before—as is often the case. Nevertheless, the fact that other photographers had settled too low wasn't Jack's problem.

There's a lesson here: Don't fall into the trap of a "take-it-or-leave-it" offer. Be willing to walk away and mean it. Jack wouldn't have been able to look himself in the mirror, knowing he had undersold himself when the network was spending hundreds of thousands of dollars just for the ad space. Trust us, you'll never feel terrible about walking away from a bad deal. You might feel bad, but never terrible. And sometimes you even feel downright exuberant to have held your ground.

But it doesn't end there. About a month later, someone else called asking to

license the same image for another national ad. Jack quoted his $5,000, and the client accepted. Done deal. Now, understand that if Jack had taken the original $2,500 deal, he likely wouldn't have been able to license it again during that same period to someone else. For one thing, it's just not ethical; but more importantly, it would have seriously risked Jack's business reputation. You really don't want the same image in two national magazines for two different products at the same time (don't laugh—it's happened many times).

So let's review the crib notes version of what happened with Jack's licensing. $500 was a fair price for that client and that use. Then $2,500 wasn't fair, and then $5,000 was very fair, all for the same image.

Makes your head spin, doesn't it? You have to know your value in the marketplace. You also have to be flexible, of course, but always know what is your floor—what is the price you need to make a living.

★

DELEBS

Can you imagine someone making more money deceased than alive? And not only more, but more than most living, breathing people earn. Intellectual property laws—the "right of publicity" laws to be exact—make that possible. Proceeds from the licensing of rights to dead celebrities (called "delebs" in the trade) equal almost a billion dollars a year. Some of the top earning delebs are: John Wayne, James Dean, Marilyn Monroe, and the King Kong and the Godzilla of delebs: Elvis and Albert Einstein. OK, Elvis we get, but Albert Einstein? Yes, they trademarked him and if you want to use "Einstein" commercially, you need to get a license. The armies of lawyers looking after the intellectual property, which includes the "right of publicity" of these dead celebrities, are very aggressive in protecting those rights, and in turn their lucrative legal fees. The rights to using these images or likenesses in most cases are earning even more than these people

© StarPix Celebrity Images / New York Post
A photo of the late, great, and iconic Robin Williams. Some photos may fade away, but images like these in your files live on profitably long after their subjects pass away.

of the use of the images of baseball players on trading cards. The photos were then poached by competing card companies and the legal battles commenced. Over the ensuing decades, state laws were created establishing various levels of a right to publicity. These laws essentially made the right of publicity akin to a property right which could be passed to one's heirs by a will or sold like real estate.

An often confusing hodgepodge of inconsistent state laws establishing a right to privacy for the dead emerged by virtue of state, not federal, statutes. The result is that at this writing there are 13 states with laws which permit the control of one's image post mortem. Uses requiring permission *generally* track the same uses that require a model release from a living subject. Note that the ability to use the *image* of a dead celebrity is not the same as the ability to use or reproduce a *work* created by that celebrity, i.e., a book or movie, which is likely protected by its own copyright.

California's statute is fairly broad while New York does not recognize a right to

made during their living and breathing days. Can you say "happy estates"?

The first recognition by the courts of a right to publicity for the *living* occurred in the 1950s. The principal case arose out

publicity for the deceased. Some state laws apply if the deceased was a resident of that state while others make residency irrelevant. Do not seek a "one size fits all" answer, as one does not exist.

No state's law is as expansive as Indiana's. Who woulda' thunk that? The fact is that Indiana is home to companies which represent the estates of several delebs, particularly CMG Worldwide. CMG has represented the estates of Marilyn Monroe, Malcom X, Duke Ellington, and James Dean. Corporations have lobbied politicians to pass such laws to preserve the value of their businesses. Indiana bestowed on their hometown constituent/businesses the ability to market their "names" by imposing a very broad right of publicity.

The expansion in this field of law has been driven by (mostly) companies who seek to profit on the name, portrait, and images of both iconic and only moderately recognizable faces of the entertainment culture of yesteryear.

Heirs to such estates benefit financially and living celebrities can now sell the rights to their image at a higher price given this ability to produce income after death. Nevertheless, it is the companies which deal in the image and personae of the likes of Elvis and other show biz icons who have been behind the creation of these statutes. Opposition to these laws has generally been weak with the public having little to no interest in such matters.

Due to Photoshop and other emerging digital technologies such as holograms, the ability to use a celeb's image is becoming a technological breeze. The legalities of such use on the other hand, already require the assistance of legal counsel to navigate. Do not try this on your own. Grabbing a photo of Steve McQueen or Frank Sinatra to mask into one of your images can lead to a living mountain of trouble.

★

Comparative and Competitive Bidding

The previous story concerned an image that Jack had already taken, but plenty of other jobs start when an art buyer or art director calls you with an assignment. In this case, the first thing you want to find out is whether it is a competitive bid or a comparative bid. A competitive bid is just that—the client has competing photographers estimate and bid for the job, based on provided layout and specs. Like jobs for the federal government, the lowest bid usually gets the job.

A comparative bid is different, in that the lowest estimate may not get the job. Art directors may use a comparative bid to see what a project will cost or to see how different photographers will approach the same project. You should always provide a good, realistic estimate in such cases, mainly because you never know what they're looking for.

Negotiating Points to Ponder

When an art director calls you for a job whoopee! First and foremost, before you get too excited about the project, get that person's name and phone number. Have them spell their name if you're not sure. Then get the names of the agency, design firm, company, whatever.

Next, find out how they found you. Your promos? An ad in a photographer's catalog? Your website? A recommendation from another art director? That is valuable information as to what is working well for you. At this point, don't try to sell yourself even more, as photographers tend to do. Just listen and try to figure out what they really want. Pay attention. Ask them about the shot they have in mind. How do they see the image? Can they send you a JPEG or PDF of the ad? Are you the only photographer they're talking to or is this a competitive bid? A comparative bid? What is their schedule? Is there a specific deadline? Clarify as much as you can, but don't say anything definite concerning your idea for the shot until you get a "whole picture" of what's involved.

Then, of course, you have to find out the specific usage. Without that you can't give an estimate of what you will charge. Trade ad or national ad? North America or Worldwide? Billboards, POS (point of sale), or brochures? And also how long? Six months? Two years? Unlimited?

If you can get them to give you a price upfront, all the better. Sometimes that can become a game of Go Fish, where the first person to say a price loses . . .

— "What's the budget you have in mind?"

— "Well, we don't know. What do you think it will cost?"

— "What kind of production values are you looking for? Big production with lots of props, or something simpler?"

—"Well, do you have a ballpark for the high end and the low end?"

—"Well, we can do it several ways. But before we make the calls to models, model makers, hair, and makeup, we can get more accurate numbers for you to pass on to your client if we know the scope. We wouldn't want to find pitfalls later and have to raise the price."

You get the idea. The last sentence is especially good, as it puts the onus on the art director to give you an idea as to what they want. Since Jack photographs people— usually models—he likes to shift the discussion to the fact that he can't get the model prices for the estimate until he gets the exact usage, as that will directly affect the model pricing. Whatever you do, never give a ballpark number. In fact, you shouldn't quote any price right away. The best thing to do is hang up the phone and really give it some thought—even if they gave you a price upfront. $100,000 might sound fantastic at first, but if you crunch the numbers and find out that it would cost $98,000 to produce, then you might be better off flipping hamburgers for the amount of time and work involved. Besides, they hardly ever give you the real budget at first. Who would? If you can meet their initial budget, great; but if not, be truthful with your numbers. You'd be amazed at how often they can find the extra money. Another reason to carefully think out a project is that it's not always just the bottom line, but rather how you present your estimate. Compare these two estimates:

Generic Photog, Inc.

Estimate

100 Lostinda Woods
Notaclue, NY, 000001 (555) 555-555

SOLD TO:
Name: Big Shot Art Buyer
Address: 1 Mad Ave.
 New York, NY 10000

ESTIMATE NUMBER 536524
ESTIMATE DATE 12/32/2016
OUR ORDER NO. 105

QUANTITY	DESCRIPTION	UNIT PRICE	AMOUNT
	Product	15,000.00	$15,000.00
	Product	60,000.00	60,000.00

SUBTOTAL	75,000.00	
TAX	0.00	
FREIGHT		
	$75,000.00	

THANK YOU FOR YOUR BUSINESS!

Simple short invoice which is vague and missing a lot of important elements and can cause huge headaches later.

Real Together Photog., LLC

Estimate

100 West Whowantstoknow Lane
New York, NY 10000 (555) 555-555

SENT TO:	Big Shot Art Buyer			
	Big Bucks Ad Agency, Inc.		INVOICE NUMBER	1000002
			INVOICE DATE	December 32, 2016
ADDRESS:	1 Mad Avenue			
	New York, NY 10000			
	(212) 555-1234			

Description: Two day shoot on location in park with two models, including location van, two models, and crew. Special large Chinese symbol in wood to be created by model maker.
Product: Tattoo Miracle Removal Cream
Usage: Consumer Magazines and client's main page on website, only.
Period of Use: One year, starting February 1, 2017, ending January 31, 2018

	DESCRIPTION	AMOUNT
Fees:	Photography fee	$15,000.00
	Producer	6,000.00
Casting:	Casting fee and casting crew	5,000.00
Models:	2 models for two days*	17,450.00
Crew:	Assistants for lighting:	800.00
	Assistants on set	2,400.00
	Stylist	5,500.00
	Baby Wrangler	1,250.00
	Hair and Makeup	2,400.00
Props:	Wardrobe	1,500.00
	Misc. props on set	800.00
	Special prop from model maker	9,525.00
Equipment:	Equipment rental	8,250.00
Digital:	Digital prep and process	2,500.00
Trans:	Transportation - Location van and cabs	3,000.00
	Shipping (Fedex, messengers)	500.00
Misc:	Catering	1,250.00

*Note: Model fees will be billed directly to ad agency by model agents	SUBTOTAL	$83,125.00
	ADVANCE	
	TAX	
	TOTAL	**$83,125.00**

TERMS: Final billing will reflect actual, not estimated expenses, plus applicable taxes.
All fees and charges on invoice are for the service(s) and/or licensing described above.
Interest at the rate of 1.5% per month shall be due on all sums not paid within 30 days.
Sums on this estimate are applicable for 30 days.

RIGHTS LICENSED ONLY UPON FULL PAYMENT OF TOTAL BILLING

SUBJECT TO TERMS AND CONDITIONS ON REVERSE

Long complex invoice that is detailed and incorporates the same information as the invoice sample on page 150.

Now, if you were an art director and had to decide between these two estimates, and your own job depended on you making sensible, secure decisions for your clients, which photographer would you feel more comfortable with and confident in? In order to protect your job and provide the client with a good product, you'll be more inclined to go with the more detailed estimate because it shows where the money is going and what the photographer is thinking.

Helpful Hints: Pricing Software

Faced with the challenging and confusing array of pricing elements, how does a photographer determine a licensing fee that is a win/win for both parties in the negotiation? Today we have software. The most extensive and comprehensive pricing software available is fotoQuote. Their prices are also based on feedback from photographers actively using their program, so it's kept up to date and realistic in today's marketplace. FotoQuote gives you a range of prices for a particular usage and also considers production value,

signed model releases, and other factors. This can be especially helpful when an art director calls you for the twelfth time, requesting a new estimate based on new circumstances or a new usage request. Warning! Do not be a prisoner to the so-called pricing boundaries set by any pricing software. What you charge is ultimately determined by you and you alone. And many of Ed's clients—including Jack—elect to distinguish themselves from their competitors by charging more than they do. Remember, many clients equate price with quality. High price = High quality. Low price, well you get the idea. Logical or not, it's real life and you may want to consider setting yourself apart from the rest this way.

A Great Phone Call

One of Jack's best assignments in recent years was a bid for a pharmaceutical ad of kids. His agent found out later that, initially, the client had had a "choice" photographer already picked and Jack was the second choice. But Jack ended up getting the job. How? A five-minute phone call.

Jack called the art director, as he usually does, to speak creatively about the job. The art director was a quiet person and let Jack go on

and on about how he envisioned images for the ad. "Bright images, well lit, but still with a direction to the light. A simple set, a sense of place, not just seamless paper. Yadda, yadda yadda." The art director didn't say much, and at first Jack figured he hadn't connected with him and didn't expect to get the job.

However, it turns out that when the "choice" photographer called the art director, he basically said, "So . . . what do you want?" He didn't have a vision to share, and he didn't make the art director confident at all. So Jack ended up getting the job, even though price didn't come into play at all. What mattered was that Jack had real input and a better idea of how to produce the job.

Retail Pricing

So far we've talked about pricing for only commercial work—basically business-to-business situations. There also exists a vast universe of "retail" photography or as it's aptly called in Europe, "social photography." This encompasses weddings, portraits, school graduations, sports teams, and any situation when a photographer is selling (whoops) licensing their work directly to the public.

A good source for wedding and portrait pricing information is through Professional Photographers of America (PPA). They have a benchmark survey that they have compiled over many years and continually update. This survey is only available to PPA members, and if you're a professional photographer working in the arena of retail photography, it makes a lot of sense to join—not just for the survey, but also to be covered by their unique indemnity insurance.

PPA's website (www.ppa.com) explains the benchmark survey as follows:

> By definition, a benchmark is "a standard by which something can be measured or judged." Professional Photographers of America's Benchmark Survey is a financial snapshot of the photography industry. Its findings will allow studio owners to compare their financial operations to other studios of similar sales level or years in business as well as assess their productivity against overall industry averages and "best-performance" studios. It also validates the industry standards for financial management and accounting.

The PPA Benchmark Survey is also localized, so you are comparing New York apples to New York apples and California oranges to California oranges. This is great, as retail pricing can be extremely region-sensitive. Their pricing survey can even be limited to individual cities, not just large state areas.

If you are doing retail type work, make sure you know what business licenses you need, what taxes you need to pay, and various other financial considerations. When you have a retail photo business, it's vital that you learn how to evaluate all your true costs. Too many photographers jump into this type of work, assuming that what they charge for their photography is what they make. "Wow, a thousand dollars for photographing a wedding on the weekend! That's more than I make at my 'real' 40-hour-a-week job!" Thinking that all that money goes directly into your pocket will get you an express ticket to the poor house. You have to take into account all sorts of hidden and true costs. You may quickly discover that the 6-hour wedding shoot is just the tip of your time involvement. There is also the time spent working out a shot list with the bride, prepping your equipment, getting to and from the event,

editing (where many photographers find out just how few hours there are in a day), meeting with the bride again, designing and laying out the wedding book, dealing with the printer, and so on. And that's not to mention the task of dealing with a "Bridezilla." Even normal, well-adjusted, good-humored brides will still take up a lot of your time. Having a Bridezilla on your case is like spending time in another dimension.

Chapter 7 of this book contains a template for a wedding contract and lot of information behind the various clauses in the contract. Going over that information will give you a better idea as to what you need to consider and what can be involved in photographing a wedding.

So, pricing retail photography—or any photography, for that matter—is not just about coming up with a price that sounds good. You have to evaluate your true overhead expenses, capital expenses, general expenses, and cost of sales; and you also need to decide whether you are doing cost-based, competitive-based, or demand-based pricing of your photography. Some of that will depend on where your studio is located—in a

storefront or out of your home? What are the buying patterns in your community? Some parts of the country have a rich tradition of having an annual family portrait done with very large prints, and in some areas a family portrait is a rare occurrence. Wedding traditions in one part of the country are strange customs in another. If you want to have long-term success in a retail-type business, you need as much information about your clientele as possible.

While a lot of this book is about best practices, an area we can't cover is understanding your specific community. We can write and advise about your rights, but in a small, tight-knit community your reputation may be more important than winning a battle. Winning a battle can sometimes cost you the war. On the other hand, rolling over when trouble appears and "showing your belly", as the saying goes,

usually means that people in your small community will walk all over you and have you for lunch. It can sometimes be a balancing act of being firm and professional verses being soft and a pushover. We know of one photographer who had a great case against major news organizations. This photographer stopped pursuing a large group of infringers because of what someone was writing in a small, local PennySaver type newspaper. The statement that they would never use that photographer's services scared that photographer. The fact is in most of these cases, the person saying that would never use a well-priced photographer. They would never be that photographer's client under any circumstance, regardless of what they were writing or whining about. The take away is know your clients, know your community, know when to hold 'em, know when to fold 'em.

★

Terms & Conditions

As there are two sides to every story and two sides to every coin, there always should be two sides to every invoice. The back of the invoice, contained on that one page—in very small type if need be—is what is known as the terms and conditions (T&C). Those are your terms and your conditions. Anybody who sells you something has their own terms. It could be your local diner that says, "No shirt, no shoes, no service" or "No checks or credit cards." Those are the diner's terms and conditions. When you buy software, you are not actually buying it, but rather being issued a license. Opening the package seal or clicking on Agreed when you download the software is binding you to the software maker's terms and conditions.

So why wouldn't you as a photographer have terms and conditions of your own? You're the one providing the service, and like any other business, you provide the paperwork. Below is an annotated T&C that you can use as a basis for your own T&C. It should all fit on an 8½ × 11 piece of paper, so it can be on the backside of your invoice. You may have to reduce the type to 6-point type to fit, and double column helps.

★

THE RIGHT TO REPRODUCE OR USE ANY IMAGE IS SUBJECT TO EACH AND EVERY ONE OF THE FOLLOWING TERMS AND CONDITIONS

1. DEFINITIONS: This Agreement is by and between _____ PHOTOGRAPHY, INC. ("Licensor") and the "Client" named on the front of this Agreement. "Image(s)" means the visual and/or other forms of film, prints, slides, chromes and any other visual materials in any format including digital information supplied by Licensor to Client. Licensor is the sole creator of the Image(s). "Service(s)" means the photography and/or related digital or other related services described on the front of this Agreement that Client is specifically commissioning Licensor to perform pursuant to this Agreement. "Transmit" or "Transmission" means distribution by any device or process whereby an Image or copy of same, is fixed beyond the place from which it was sent. "Copyright Management Information" or "Metadata" means the name and other image identifying information of Licensor and/or terms and conditions for uses of the Images, and such other information that Licensor may provide.

2. FEES, CHARGES AND ADVANCES: Client and Client's representatives are jointly and severally responsible for full payment of all fees, charges, expenses and advances. The rights licensed, fees, charges and advances set forth in this Agreement apply only to the original specification of the Services. Additional fees and charges shall be paid by Client for any subsequent changes, additions or variations requested by Client. All advance payments are due in full prior to production.

3. POSTPONEMENTS AND CANCELLATIONS: If Client postpones or cancels any photography "shoot date" or other Service, in whole or in part, without first obtaining Licensor's written consent, Client shall pay Licensor 50% of Licensor's quoted fees. If Client postpones or cancels with less than two business days' prior written notice to Licensor, Client shall pay 100% of Licensor's quoted fees. Client shall in any event pay all expenses and charges incurred in connection with any postponed or cancelled shoot date or other Service.

4. Licensor shall not be in default of this Agreement by reason of its delay in the performance of or failure to perform, in whole or in part, any of its obligations hereunder, if such delay or failure results from occurrences beyond its reasonable control and without its fault or negligence. Client will pay 100% of Licensor's daily weather delay fee (as set forth on the front of this Agreement) for any delays due to weather conditions or any acts or occurrences beyond Licensor's reasonable control, plus all charges incurred.

5. CLIENT APPROVAL: Client is responsible for having its authorized representative present during all "shooting" and other appropriate phases of the Service(s) to approve Licensor's interpretation of the Service(s). If no representative is present, Licensor's interpretation shall be deemed as "accepted." Client shall be bound by all approvals and job changes made by Client's representatives.

6. OVERTIME: In the event any Services extend beyond eight consecutive hours in one day, Client agrees to and shall timely pay overtime for crew members and assistants at the rate of 1-1/2 times their hourly rates or fees, and if the Services extend beyond 12 hours in one day, Client agrees to and shall pay overtime for crew members and assistants at the rate of double their regularly hourly rates or fees.

7. LIMITATION OF LIABILITY AND INDEMNITY: Even if Client's exclusive remedy fails of its essential purpose, Licensor's entire liability shall in no event exceed the license fee paid to Licensor. UNDER NO CIRCUMSTANCES SHALL LICENSOR BE LIABLE FOR GENERAL, CONSEQUENTIAL, INCIDENTAL OR SPECIAL DAMAGES ARISING FROM THIS AGREEMENT, THE IMAGE(S) OR ANY ACTS OR OMISSIONS OF LICENSOR. Client shall indemnify, defend and hold Licensor and Licensor's representatives harmless from any and all claims, liabilities, damages and expenses of any nature whatsoever, including actual attorneys' fees, costs of investigation and court costs arising from or relating to Client's direct or indirect distribution, display or other use of any Image.

8. RIGHTS LICENSED: The licensed rights are transferred only upon: (a) Client's acceptance of all terms contained in this Agreement, (b) Licensor's actual receipt of full payment, and (c) the use of proper copyright notice and other Copyright Management Information requested or used by Licensor in connection with the Image(s). Licensor is willing to license the Image(s) to Client only upon the condition that Client accepts all of the terms of this Agreement. Unless otherwise specifically stated on the front of this Agreement, all licenses are non-exclusive; the duration of any license is one year from the date of Licensor's invoice and is for English language use in the United States of America only. Licensor reserves all rights in the Image(s) of every kind and nature, including, without limitation, copyright, electronic publishing and use rights, in any and all media, now existing and as yet unknown, throughout the world, that are not specifically licensed or transferred by this Agreement. No license is valid unless signed by Licensor. This Agreement may not be assigned or transferred without the prior written consent of Licensor and provided that the assignee or transferee agrees in writing to be bound by all of the terms, conditions, and obligations of this Agreement. Any voluntary assignment or assignments by operation of law of any rights or obligations of Client shall be deemed a default under this Agreement allowing Licensor to exercise all remedies including, without limitation, terminating this Agreement, the right to all net worth or financial information of any assignee and the fullest extent of adequate assurances of future performance. Upon request by Licensor, Client shall provide Licensor with a full and complete disclosure of any and all uses of each Image and provide Licensor with three (3) copies, without charge, of each and every use of each Image.

9. RETURN OF ANALOG IMAGE(S): Client assumes all risk for all Image(s) supplied by Licensor to Client, from the time of Client's receipt, to the time of the safe return receipt of the Image(s) to the possession and control of Licensor. If no return date appears on the front of this Agreement or on any related delivery memo, Client shall return all Image(s) in undamaged, unaltered and unretouched condition not later than 90 days after the date of delivery unless otherwise agreed in writing. Client acknowledges that the failure to return any image(s) to Licensor within the agreed upon time period(s) will cause economic damage to Licensor. Client agrees to pay the sum of $___ per week per image as and for a "holding fee." Such fee reflects Licensor's costs and expenses attendant to its inability to license, offer for license, maintain its picture archive and/or grant exclusivity to any prospective licensee with respect to any such images improperly retained. Client acknowledges that such calculation is fair and reasonable and bears a rational relationship to the inconvenience, damages, lost income, costs and expenses incurred by Licensor as a result of such failure. In the event an image is not returned to Licensor within _____ days of delivery to Client, such images shall be deemed "lost" and Client shall pay to Licensor damages in accordance with paragraph "6" herein. Notwithstanding, Licensor may assert a claim for lost or unreturned images at any time subsequent to the agreed upon return date(s).

10. LOSS OR DAMAGE: IN CASE OF LOSS OR DAMAGE OF ANY ORIGINAL IMAGE(S), CLIENT AND LICENSOR AGREE THAT THE REASONABLE VALUE OF EACH ORIGINAL IMAGE IS AS SET FORTH ON THE FRONT PAGE OF THIS AGREEMENT. Once original Image(s) are lost or damaged the parties acknowledge it is extremely difficult, costly, impracticable and possibly impossible to fix their exact individual value in a court of law. Accordingly, Licensor and Client agree that the reasonable liquidated value of each original Image is in such amounts as are set forth on the front of this Agreement. Client agrees to pay Licensor such enumerated amount(s) for each lost or damaged original Image (irrespective of the total number of images lost or damaged) and Licensor agrees to limit Licensor's claim to that amount without regard to any claimed actual value of such Image. An Image shall be considered an original if no high reproduction quality duplicate of that Image exists. Client specifically agrees that the amount(s) set forth on the front of this Agreement is reasonable, reasonably related to the value of the image(s). Both parties have duly considered or have had ample opportunity to assess the number of images covered by this agreement as well as their content, subject matter, historical or newsworthy significance, reputation of the Licensor, cost of creation, any existing model and/or property releases, market cost of comparable images (if any) and other business considerations to be considered including but not limited to the ability or lack thereof too recreate any such lost image and whether the subject images can, in fact, be recreated. The parties agree that the damage provisions agreed upon herein is not/are not punitive and that the establishment of such clause and amount is in the mutually beneficial economic interest of both the Client and Licensor in the event of loss or damage to any/all images. Client's agreement to these terms serves as a material inducement to licensor to deliver to Client the requested analog images.

11. DELETION OF DIGITAL IMAGE(S): For all images supplied in digital format, Client agrees to delete all such images from its internal files, FTP servers/sites and backup or storage media within 90 days after their delivery date unless a longer retention period is agreed to in writing. In the event client loses, fails to timely locate or renders a digital image unusable, Client agrees to pay Licensor all fees and expenses charged by Licensor to re-transmit or otherwise redeliver such image(s).

12. PAYMENT AND COLLECTION TERMS: Invoices from Licensor are payable upon receipt by Client. Client agrees to pay a late payment fee equal to 1.5% per month on any unpaid amount or balance. Such late fee(s) shall commence to run thirty (30) days after the issuance of this invoice. Such late fee(s) shall in no event exceed the lawful maximum permitted in the State of _____ with respect to commercial transactions of this type. In any action to enforce the terms of this Agreement, the prevailing party shall be entitled to recover their actual attorneys' fees, court costs and all other non-reimbursable litigation expenses such as expert witness fees and investigation expenses. The parties hereto consent to the jurisdiction of the courts of the State of _____, County of _____. The parties agree that any dispute arising out of this agreement shall be governed by the laws of the State of _____.

13. TAX: Client shall pay and hold Licensor harmless on account of any sales, use, or other taxes or governmental charges of any kind, however denominated, imposed by any government, including any subsequent assessments, in connection with this Agreement, the Image(s), the Service(s) or any income earned or payments received by Licensor hereunder. To the extent that Licensor may be required to withhold or pay such taxes, Client shall promptly thereafter furnish Licensor with funds in the full amount of all the sums withheld or paid.

14. RELEASES: No model, property, trademark or other such release exists for any image(s) unless licensor submits to client a separate release signed by a third-party, model or property owner.

15. ELECTRONIC RIGHTS: No electronic usage rights of any kind are licensed or granted hereunder unless as specifically set forth on the front of this Agreement. Licensor specifically reserves all rights not specifically conveyed to Client hereunder. Such rights reserved include but are not limited to all rights of publication, distribution, display or transmission in electronic and digital media of any kind, now existing and yet unknown. Usage rights for any kind of revision of a collective work including any later collective work in the same series are expressly reserved by the Licensor.

16. MODIFICATIONS, GOVERNING LAW AND MISCELLANEOUS: This Agreement sets forth the entire understanding and agreement between Licensor and Client regarding the Service(s) and/or the Image(s). This Agreement supersedes any and all prior representations and agreements regarding the Service(s) and/or the Image(s), whether written or verbal. Neither Licensor nor Client shall be bound by any purchase order, term, condition, representation, warranty or provision other than as specifically stated in this Agreement. No waiver or modification may be made to any term or condition contained in this Agreement unless in writing and signed by Licensor. Waiver of any one provision of this Agreement shall not be deemed to be a waiver of any other provision of this Agreement. Any objections to the terms of this Agreement must be made in writing and delivered to Licensor within ten days of the receipt of this Agreement by Client or Client's representative, or this Agreement shall not be binding. Notwithstanding anything to the contrary, no Image(s) may be used in any manner without Licensor's prior written consent and Client's holding of any Image(s) constitutes Client's complete acceptance of this Agreement. The formation, interpretation and performance of this Agreement shall be governed by the laws of the state of _____, excluding the conflict of laws rules of _____ (Same State).

17. COPYRIGHT/ENFORCEMENT OF EXCLUSIVE LICENSE: The sole right to pursue and/or defend any and all claims sounding in infringement of Licensor's copyright(s), trademark and/or intellectual property rights in the image(s), free from any claims by Client or any other person, whether or not the rights granted to Client are exclusive or non-exclusive shall be deemed retained by Licensor. If Licensor is determined not to possess such rights Client agrees to execute and deliver to Licensor such documents as Licensor reasonably requests to carry out the purpose of this clause so as to allow licensor the right to pursue and/or defend any and all claims sounding in infringement of its copyright(s), trademark and/or intellectual property rights in the image(s). Nothing contained herein shall be construed as limiting or waiving the Client's right to enforce, defend or protect any copyright, trademark or intellectual property owned by it.

18. Client agrees whenever commercially reasonable to include the photo credit: © _____ or _____ PHOTOGRAPHY, INC. in conjunction with all uses of Licensor's image(s).

19. Client acknowledges that it has received and executed this two-sided Agreement and has been provided a copy of same.

_____ _____ _____ _____
Photographer/Licensor Date Client/Licensee Date

The Terms and Conditions (T&C) should fit on a single 8½ x 11 sheet of paper printed onto the back of your invoice. All the blanks that are on the page, like your name and the state and county in paragraph 12, should be preprinted.

THE RIGHT TO REPRODUCE OR USE ANY IMAGE IS SUBJECT TO EACH AND EVERY ONE OF THE FOLLOWING TERMS AND CONDITIONS

1. DEFINITIONS: This Agreement is by and between _____ PHOTOGRAPHY, INC. ("Licensor") and the "Client" named on the front of this Agreement. "Image(s)" means the visual and/or other forms of film, prints, slides, chromes and any other visual materials in any format including digital information supplied by Licensor to Client. Licensor is the sole creator of the Image(s). "Service(s)" means the photography and/or related digital or other related services described on the front of this Agreement that Client is specifically commissioning Licensor to perform pursuant to this Agreement. "Transmit" or "Transmission" means distribution by any device or process whereby an Image or copy of same, is fixed beyond the place from which it was sent. "Copyright Management Information" or "Metadata" means the name and other image identifying information of Licensor and/or terms and conditions for uses of the Images, and such other information that Licensor may provide.

Defining terms in an agreement between the parties helps to eliminate any claims of misunderstanding or "I didn't think you meant XYZ I thought you meant ABC." The agreement is, as they say in Court, "dispositive." If the parties have agreed in writing as to what means what, the Court will not seek to re-interpret or change those mutually agreed upon definitions if the contract is clear and readable—dictionary definitions not withstanding.

2. FEES, CHARGES AND ADVANCES: Client and Client's representatives are jointly and severally responsible for full payment of all fees, charges, expenses and advances. The rights licensed, fees, charges and advances set forth in this Agreement apply only to the original specification of the Services. Additional fees and charges shall be paid by Client for any subsequent changes, additions or variations requested by Client. All advance payments are due in full prior to production.

The client has agreed to make full payment. This clause acknowledges that the license granted is only as stated in the agreement.

3. POSTPONEMENTS AND CANCELLATIONS: If Client postpones or cancels any photography "shoot date" or other Service, in whole or in part, without first obtaining Licensor's written consent, Client shall pay Licensor 50% of Licensor's quoted fees. If Client postpones or cancels with less than two business days' prior written notice to Licensor, Client shall pay 100% of Licensor's quoted fees. Client shall in any event pay all expenses and charges incurred in connection with any postponed or cancelled shoot date or other Service.

This clause ensures that a client who decides at the last minute to "go in another direction" (by hiring someone cheaper than you) would still be on the hook to pay you. The onus for the cancellation is on the client, who must pay for your inconvenience and time. Also see Force Majeure, below.

4. FORCE MAJEURE. Licensor shall not be in default of this Agreement by reason of its delay in the performance of or failure to perform, in whole or in part, any of its obligations hereunder, if such delay or failure results from occurrences beyond its reasonable control and without its fault or negligence. Client will pay 100% of Licensor's daily weather delay fee (as set forth on the front of this Agreement) for any delays due to weather conditions or any acts or occurrences beyond Licensor's reasonable control, plus all charges incurred.

Without clauses like 3 and 4, you would not be entitled to any cancellation or kill fees without a lawsuit, if at all. This paragraph is extremely important if you are shooting on location or affected by factors outside of your control—the weather, client's employees, airline cancellations, or events postponed by the officiant.

5. CLIENT APPROVAL: Client is responsible for having its authorized representative present during all "shooting" and other appropriate phases of the Service(s) to approve Licensor's interpretation of the Service(s). If no representative is present, Licensor's interpretation shall be deemed as "accepted." Client shall be bound by all approvals and job changes made by Client's representatives.

The client may have an authorized person present during the shoot to approve imagery; or if they elect not to have such a person present, your imagery gets emailed to the client while the shoot is taking place. In either scenario you want the client to indicate its approval of images by initialing or signing copies of the images

or emails referencing the imagery. This eliminates the possibility of a client making a claim (asserted to avoid payment) that the images "missed the concept entirely" or "are not what we wanted." This clause protects you in the event you are unable to transmit images to a client who has no representative present.

6. OVERTIME: In the event any Services extend beyond eight consecutive hours in one day, Client agrees to and shall timely pay overtime for crew members and assistants at the rate of 1–1/2 times their hourly rates or fees, and if the Services extend beyond 12 hours in one day, Client agrees to and shall pay overtime for crew members and assistants at the rate of double their regularly hourly rates or fees.

Without this clause you are not entitled to any such payments from your client. State labor laws may vary, but your assistant conceivably could have a claim against you for overtime pay. This covers crew members only. If you as the photographer are seeking overtime compensation, you must specifically include your terms in the agreement.

7. LIMITATION OF LIABILITY AND INDEMNITY: Even if Client's exclusive remedy fails of its essential purpose, Licensor's entire liability shall in no event exceed the license fee paid to Licensor. UNDER NO CIRCUMSTANCES SHALL LICENSOR BE LIABLE FOR GENERAL, CONSEQUENTIAL, INCIDENTAL OR SPECIAL DAMAGES ARISING FROM THIS AGREEMENT, THE IMAGE(S) OR ANY ACTS OR OMISSIONS OF LICENSOR. Client shall

indemnify, defend and hold Licensor and Licensor's representatives harmless from any and all claims, liabilities, damages and expenses of any nature whatsoever, including actual attorneys' fees, costs of investigation and court costs arising from or relating to Client's direct or indirect distribution, display or other use of any Image.

You as the Licensor are limiting the nature of the financial damages for which you could be held liable. When a contract is breached, the recognized remedy for an owner is recovery of damages that result directly from the breach, such as the cost to complete the work in accordance with the contract, the value of the lost or damaged work, etc. Consequential damages (also sometimes referred to as indirect or "special" damages) include things like loss of profit or revenue. These type of damages could mean instant bankruptcy for a creator. The cost to re-shoot a tabletop shot pales in comparison to the loss of operating revenue or profits that a client may claim or even prove resulted from your error. In short, you can't afford to be on the hook. This clause demonstrates the client has agreed not to put you on that hook.

8. RIGHTS LICENSED: The licensed rights are transferred only upon: (a) Client's acceptance of all terms contained in this Agreement, (b) Licensor's actual receipt of full payment, and (c) the use of proper copyright notice and other Copyright Management Information requested or used by Licensor in connection with the Image(s). Licensor is willing to license the Image(s) to Client only upon the condition that Client accepts all of the terms of this Agreement. Unless otherwise specifically stated on the front of this Agreement, all licenses are non-exclusive; the duration of any license is one year from the date of Licensor's invoice and is for English language use in the United States of America only. Licensor reserves all rights in the Image(s)

of every kind and nature, including, without limitation, copyright, electronic publishing and use rights, in any and all media, now existing and as yet unknown, throughout the world, that are not specifically licensed or transferred by this Agreement.

No license is valid unless signed by Licensor. This Agreement may not be assigned or transferred without the prior written consent of Licensor and provided that the assignee or transferee agrees in writing to be bound by all of the terms, conditions and obligations of this Agreement. Any voluntary assignment or assignments by operation of law of any rights or obligations of Client shall be deemed a default under this Agreement allowing Licensor to exercise all remedies including, without limitation, terminating this Agreement, the right to all net worth or financial information of any assignee and the fullest extent of adequate assurances of future performance. Upon request by Licensor, Client shall provide Licensor with a full and complete disclosure of any and all uses of each Image and provide Licensor with three (3) copies, without charge, of each and every use of each Image.

This critical clause states that you are licensing that which the agreement specifically sets forth ONLY. If your client wants an "exclusive" they must pay for it, and your agreement should state this. If your client wants packaging rights, the agreement MUST say "packaging" and you may charge accordingly. This reinforces your right to get paid in full, prior to the client using the images.

The last sentence assures you that copies of any and all uses (authorized or not) will be available to you. If the client is suddenly unable to produce copies of unauthorized uses, this sentence enables a court to in effect give your testimony heightened credibility and, in some situations, the ability to penalize the non-paying or infringing client. Note the simple sentence in the clause that reads, "No license is

valid unless signed by Licensor." So make sure you sign your invoices. We urge you not to edit this clause without the assistance of an attorney. Leave it just the way it is.

Note: If you shoot or ever deliver analog images, include paragraphs 9 and 10 below. See the comment below paragraph 7. If all your work is digital and you never, ever deal with analog images you can omit both paragraphs.

9. RETURN OF ANALOG IMAGE(S): Client assumes all risk for all Image(s) supplied by Licensor to Client, from the time of Client's receipt, to the time of the safe return receipt of the Image(s) to the possession and control of Licensor. If no return date appears on the front of this Agreement or on any related delivery memo, Client shall return all Image(s) in undamaged, unaltered and unretouched condition not later than 90 days after the date of delivery unless otherwise agreed in writing. Client acknowledges that the failure to return any image(s) to Licensor within the agreed upon time period(s) will cause economic damage to Licensor. Client agrees to pay the sum of $____ per week per image as and for a "holding fee." Such fee reflects licensor's costs and expenses attendant to its inability to license, offer for license, maintain its picture archive and or grant exclusivity to any prospective licensee with respect to any such images improperly retained. Client acknowledges that such calculation is fair and reasonable and bears a rational relationship to the inconvenience, damages, lost income, costs and expenses incurred by Licensor as a result of such failure. In the event an image is not returned to Licensor within _____days of delivery to Client, such images shall be deemed "lost" and Client shall pay to Licensor damages in accordance with paragraph "6" herein. Notwithstanding, Licensor may assert a claim for lost or unreturned images at any time subsequent to the agreed upon return date(s).

10. LOSS OR DAMAGE: IN CASE OF LOSS OR DAMAGE OF ANY ORIGINAL IMAGE(S), CLIENT AND LICENSOR AGREE THAT THE REASONABLE VALUE OF EACH ORIGINAL IMAGE IS AS SET FORTH ON THE FRONT PAGE OF THIS AGREEMENT. Once original Image(s) are lost or damaged the parties acknowledge it is extremely difficult, costly, impracticable and possibly impossible to fix their exact individual value in a court of law. Accordingly, Licensor and Client agree that the reasonable liquidated value of each original Image is in such amounts as are set forth on the front of this Agreement. Client agrees to pay Licensor such enumerated amount(s) for each lost or damaged original Image (irrespective of the total number of images lost or damaged) and Licensor agrees to limit Licensor's claim to that amount without regard to any claimed actual value of such Image. An Image shall be considered an original if no high reproduction quality duplicate of that Image exists. Client specifically agrees that the amount(s) set forth on the front of this Agreement is reasonable, reasonably related to the value of the image(s). Both parties have duly considered or have had ample opportunity to assess the number of images covered by this agreement as well as their content, subject matter, historical or newsworthy significance, reputation of the Licensor, cost of creation, any existing model and/or property releases, market cost of comparable images (if any) and other business considerations to be considered including but not limited to the ability or lack thereof too recreate any such lost image and whether the subject images can, in fact, be recreated.

The parties agree that the damage provisions agreed upon herein is not/are not punitive and that the establishment of such clause and amount is in the mutually beneficial economic interest of both the Client and Licensor in the event of loss or damage to any/all images. Client's agreement to these terms serves as a material inducement to licensor to deliver to Client the requested analog images.

If you are dealing with only digital images, you can omit this paragraph and paragraph 9. If you are delivering slides or prints, anything physical, to a client, a gallery, an exhibition, museum, and so on, then you should definitely have these two paragraphs in your terms and conditions.

Court decisions in cases involving the valuation of lost, missing, or damaged analog film have been wildly inconsistent. So-called "standard provisions" assessing each and every image in a given delivery at $1,500 or $2,500 have typically been struck down. Some decisions have incentivized stock agencies or clients in possession of analog imagery to have that imagery "go missing." We strongly advise that each image or group of images in a delivery be valued by the parties on the front of any delivery memo or invoice in such manner as to demonstrate to a court or jury that both parties thought about the value of the works, the subjects in the images, whether they can be re-shot, whether there are usable digital versions in existence, and agreed upon rational amounts per image if lost so as to avoid the cost and expense of lawyers and litigation. Varying amounts reflect that you have negotiated and mutually agreed with your client on these values.

For example, the front of an invoice or delivery memo might read: Subject Shoot Date Description/Image ID# Replacement Location value. There is so much to delivery memos and we think it's such an important subject that we have a sidebar about this topic titled Image Trek (or Tracking) that follows after this section.

11. DELETION OF DIGITAL IMAGE(S): For all images supplied in digital format, Client agrees to delete all such images from its internal files, FTP servers/sites and backup or storage media within 90 days after their delivery date unless a longer retention period is agreed to in writing. In the event client loses, fails to timely locate or renders a digital image unusable, Client agrees to pay Licensor all fees and expenses charged by Licensor to re-transmit or otherwise redeliver such image(s).

Believe it or not, clients—especially newspapers—retain your images. They have been known to use them without the creator's permission when there is a deadline, when the photographer is long dead, or in an attempt to make a free use of the image. This paragraph puts the infringer in a box. It means that they either illegally retained your image for unauthorized use or appropriated it from someone else. It is a wonderfully effective clause for you to have in an infringement lawsuit.

12. PAYMENT AND COLLECTION TERMS: Invoices from Licensor are payable upon receipt by Client. Client agrees to pay a late payment fee equal to 1.5% per month on any unpaid amount or balance. Such late fee(s) shall commence to run thirty (30) days after the issuance of this invoice. Such late fee(s) shall in no event exceed the lawful maximum permitted in the State of _____ with respect to commercial transactions of this type. In any action to enforce the terms of this Agreement, the prevailing party shall be entitled to recover their actual attorneys' fees, court costs and all other non-reimbursable litigation expenses such as expert witness fees and investigation expenses. The parties hereto consent to the jurisdiction of the courts of the State of _____, County of _____. The parties agree that any dispute arising out of this agreement shall be governed by the laws of the State of _____.

In nearly all states, commercial parties can set interest rates on unpaid sums at rates higher than are permitted in consumer transactions. If such rate is not written into your agreement, you may be entitled to no more than the so-called "legal interest" rate, which in New York is now 9%. This clause more than doubles the interest due you by law on unpaid sums. Check with your local attorney to determine what maximum rate your state's law allows. Insert your local state and county (pre-printed on your forms) so that if there is to be litigation or even the threat of litigation, you can make the client come to you and spend the money connected with travel, hiring local counsel, and participating in a lawsuit thousands of miles from corporate headquarters. And, oh yes, sometimes there is a home court advantage. Do you really want to have to search out a lawyer in some city or state far from home? Simply put, it's cheaper and more effective to fight on your home turf.

13. TAX: Client shall pay and hold Licensor harmless on account of any sales, use, or other taxes or governmental charges of any kind, however denominated, imposed by any government, including any subsequent assessments, in connection with this Agreement, the Image(s), the Service(s) or any income earned or payments received by Licensor hereunder. To the extent that Licensor may be required to withhold or pay such taxes, Client shall promptly thereafter furnish Licensor with funds in the full amount of all the sums withheld or paid.

Show this clause to your accountant. They'll thank us for it. In short, the client is taking responsibility for those things out of your control. Discuss with your accountant the appropriate procedure for you to use when and if your client claims any exemption from any taxes of any kind. You may, for example, be required to receive and retain certain tax forms from the client.

14. RELEASES: No model, property, trademark or other such release exists for any image(s) unless licensor submits to client a separate release signed by a third-party, model or property owner.

If releases are not part of the job, then there is no inference that they were provided by you or should have been provided by you. Copies of all releases used by you should be in the physical possession of you, your client, any ad agency, and any models. It's never a bad idea to have your client and model acknowledge receipt via email or fax of any/all releases.

15. ELECTRONIC RIGHTS: No electronic usage rights of any kind are licensed or granted hereunder unless as specifically set forth on the front of this Agreement. Licensor specifically reserves all rights not specifically conveyed to Client hereunder. Such rights reserved include but are not limited to all rights of publication, distribution, display or transmission in electronic and digital media of any kind, now existing and yet unknown. Usage rights for any kind of revision of a collective work including any later collective work in the same series are expressly reserved by the Licensor.

Again, only rights specifically licensed by you are granted. If the invoice does not enumerate the usage then no such usage has been conveyed.

16. MODIFICATIONS, GOVERNING LAW AND MISCELLANEOUS: This Agreement sets forth the entire understanding and agreement between Licensor and Client regarding the Service(s) and/or the Image(s). This Agreement supersedes any and all prior representations and agreements regarding the Service(s) and/or the Image(s), whether written or verbal. Neither Licensor nor Client shall be bound by any purchase order, term, condition, representation, warranty or provision other than as specifically stated in this Agreement. No waiver or modification may be made to any term or condition contained in this Agreement unless in writing and signed by Licensor. Waiver of any one provision of this Agreement shall not be deemed to be a waiver of any other provision of this Agreement. Any objections to the terms of this Agreement must be made in writing and delivered to Licensor within ten days of the receipt of this Agreement by Client or Client's representative, or this Agreement shall not be binding. Notwithstanding anything to the contrary, no Image(s) may be used in any manner without Licensor's prior written consent and Client's holding of any Image(s) constitutes Client's complete acceptance of this Agreement. The formation, interpretation and performance of this Agreement shall be governed by the laws of the state of _____, excluding the conflict of laws rules of _____(Same State).

All paragraph captions in this Agreement are for reference only, and shall not be considered in construing this Agreement. This Agreement shall be construed in accordance with its terms and shall not be construed more favorably for or more strongly against Licensor or Client. Simply put, this clause makes your invoice the controlling legal document.

17. COPYRIGHT/ENFORCEMENT OF EXCLUSIVE LICENSE: The sole right to pursue and/or defend any and all claims sounding in infringement of Licensor's copyright(s), trademark and/or intellectual property rights in the image(s), free from any claims by Client or any other person, whether or not the rights granted to Client are exclusive or non-exclusive shall be deemed retained by Licensor. If Licensor is determined not to possess such rights Client agrees to execute and deliver to Licensor such documents as Licensor reasonably requests to carry out the purpose of this clause so as to allow licensor the right to pursue and/or defend any and all claims sounding in infringement of its copyright(s), trademark and/or intellectual property rights in the image(s). Nothing contained herein shall be construed as limiting or waiving the Client's right to enforce, defend or protect any copyright, trademark or intellectual property owned by it.

This clause preserves your right to pursue any copyright claims even if you have granted your client exclusivity. A grant of exclusivity without language like the above could have the effect of giving your client the sole right to pursue an infringement of your copyright. That burden is frequently of no concern to your client, who may care only if the infringement directly affects sales of its product—with no regard for your reputation. A lack of this clause could effectively prevent you from starting a copyright infringement action.

18. Client agrees whenever commercially reasonable to include the photo credit: (c)
_____ or _____ PHOTOGRAPHY, INC. In conjunction with all uses of Licensor's image(s).

Our experience is that photo credits are an extremely valuable marketing tool and assist greatly in the policing of copyrights. Some clients have no interest in giving you the credit or the free advertising. Clearly this is a negotiable clause.

19. Client acknowledges that it has received and executed this two-sided Agreement and has been provided a copy of same.

Many, many photographers fail to fax or email BOTH sides of their agreements to clients. In the event of a dispute, photographers re-print their then current terms and conditions off their computer, which, of course, was never sent to the client or part of the original transaction. Keep paper copies with signatures of all transactions. The fact that you back up your computer is irrelevant. This clause prevents your client from claiming that it never received the terms and conditions at the time of the transaction even though the terms on the back may be referenced on the front of the invoice.

Photographer/Licensor Date *Client/Licensee Title* *Date*

Signature lines are there to be used! Names should be signed on the lines provided. As the licensor, make sure you sign the agreement prior to sending it on to the client.

IMAGE TREK (OR TRACKING): THE ART OF DELIVERY MEMOS

There was a time long, long ago when computers were the size of cars and could be operated only by a select number of NASA scientists. Tablets were something you took when you were sick and a screen was not something you watched but rather kept the mosquitoes out. There were no digital cameras and photographs whether film, negatives, transparencies, prints or slides were physical objects that could and often did get damaged or lost.

Photographers, stock agents, publishers and model agencies used delivery forms made of paper to track the delivery of all those images back then. Delivery memos have become virtually extinct in the digital world except for photographers and illustrators who create, print or sell fine art prints.

If valuable or even irreplaceable imagery is being transported or sold, then using a delivery memo is a must. You want to describe the images and try to set an agreed upon value in the event of loss or damage. Attention to some detail must

be paid — usually having the recipient sign and return your delivery memo indicating actual delivery has been made.

So what should a delivery memo or invoice for the sale of images include? To demonstrate, let's use the example of the upcoming tour of rock musician Bryce Sprungsteen. You are going to be shooting images on an exclusive basis for all sorts of uses ranging from merchandising, posters, fine art prints, editorial, promotional and the cover of the tour CD.

The following should be in the body of your delivery memo, including all the information about who the client is and who is receiving this valuable collection of slides, negatives, or prints; make special note if the recipient is someone other than your client. It doesn't have to be anything fancy or have fancy language. The important thing is to have all the pertinent information there in writing.

Remember, this is not an invoice or bill from you — it's a delivery memo that

accompanies the physical images sent. Unless you are one of the 247 people in the U.S. that has not ordered something online from Amazon, the Home Shopping Network, or something similar, a delivery memo is like the one you get with anything you order that gets delivered to you. Your delivery memos will set forth the value(s) set by you as opposed to the prices you already paid to Amazon:

The value(s) listed on the delivery memo is *not* the amount(s) you are charging the client to license your images. That would be on your invoice. These are simply the value(s) you have placed on the images. As you can see, not all images are priced the same. Shots that any Joe or Jane can capture, like the ones listed in #5 are only rationally valued at $25 each. The singular and unique shot, which was

1. (1) Photo of Bryce Sprungsteen (BS) at Madison Square Garden shaking hands with Mayor Bloomberg at world tour kickoff. Shoot Date: 1/1/15, Value: $2,000

2. (1) Photo of BS singing with surprise guest Millie Cyprus at New Orleans Superdome. Shoot date: 1/22/15, Value: $5,000

3. (1) Photo of BS deplaning at Heathrow Airport for UK leg of tour. Shoot date: 2/15/15 $750

4. (1) Photo of BS's hair catching fire on stage from pyrotechnics at Wembley Stadium. Shoot date: 2/17/15. Value: $25,0000

5. (40) Photos of audience members attending BS concert at the Acropolis. Shoot date 2/28/15 value $25 each

captured because of the photographer's exclusive backstage access, of Bryce's hair catching fire in #4, has a much higher valuation at $25,000.

And if these are all digital files, you can list the media sent (hard drive, flash

drive, CD, DVD, etc.) and the cost of not the images, as they can be easily reproduced, but the cost (with a healthy markup) for your time and expense to replicate what they lost.

Last, but Not Least: Insurance

One area that many photographers overlook in business is insurance. The topic of "Insurance" covers a lot of territory, from the obvious to the not so obvious. One use of insurance, which is usually common and affordable, is the coverage for loss or damage to your camera and other equipment. There's also liability insurance which covers you for personal injuries or damage to someone else's property. This is required by most landlords if you rent a studio and is a "must have" if you own the space you work in. If you shoot on location, having liability coverage is a typical requirement of clients and should be considered by you to be indispensable even if your client(s) overlook the issue.

Insurance provides not only payment for any covered losses but also will provide you with an attorney "at no extra charge." The premiums that you pay for car, home, or premises insurance include whatever fees the attorneys employed by the insurance companies would charge to defend you against any claims. Coverage for those attorneys' fees is often more significant than coverage for the actual claimed amount of the financial loss.

Insurance that will provide you an "income" in the event you are unable to conduct business is known as "overhead" coverage also known as business interruption insurance. This can be the result of flood, catastrophe, road closings, or a buffet of other reasons, such as you suddenly cannot function due to an accident or injury. In its most basic form, you add up your monthly fixed overhead expenses such as rent, utilities, service contracts for equipment, insurance premiums, and so on. These are typically the expenses you incur to keep your studio running whether or not you are doing any billable work. In the event of, say, a hurricane, flood, or fire, you would receive a monthly payment from the insurance company in an amount previously determined by you to satisfy those expenses.

Hurricane Katrina is a great example of a natural disaster that wiped out uninsured businesses while those with insurance (who were still suffering greatly) were able to get

back on their feet. It didn't matter if you were a small photo studio or a large corporation like Harrah's Casino in New Orleans, overhead insurance would have saved your bacon. This type of insurance premium for overhead coverage is of course scaled for the size of your business. When Katrina's aftermath devastated New Orleans and forced Harrah's Casino to shut down, Harrah's was able to pay all of its employees their full salaries, as well as other on-going debts, because its insurance coverage paid sums equal to the gaming revenue Harrah's was typically bringing in pre-hurricane. A small or even medium-sized photo studio wouldn't need that kind of coverage. You can decide with an insurance agent what comfort level you need the policy to cover. You might be happy with just your rent/mortgage being covered, or you may want your complete overhead, including your salary, employee salary, and any bills that you would pay on a monthly basis. And like Harrah's, you can even collect what your monthly revenue would have been, based on past average monthly income. That would be important after a natural disaster, because your client base, along with your physical business, might be wiped out. What's the point of having your

studio or business operational if your clients are not there? Well, that's why we have insurance.

Not as well known, but an important policy for photographers to have, is a form of business insurance called Professional Liability Insurance (PLI), also sometimes called Errors and Omissions (E&O) Insurance. Simply put, this is a type of insurance that covers losses resulting from the negligence of an owner, officer, director or employee of your company. Virtually all businesses of any size, especially those that sell products or provide services to the public, maintain such policies.

These policies, PLI and E&O, protect you and your business for things that sometimes just happen. Like your hard drive crashes, which in the old days was the equivalent of the lab screwing up the processing of your film. Even in this age of Cloud storage and cheap hard drive space, there is a large percentage of insurance claims for hard drive failures with important images, like someone's wedding shoot. Or, it can cover you for business losses, such as lost income, resulting from things like a flood—as opposed to merely getting $500 to

buy a new computer to replace a $500 computer which was destroyed by water. It does not cover you for just any and every screw up. Rather, it is like malpractice insurance for a doctor. It does cover you in case a client sues you for negligence, even if it's a meritless case. We know one portrait photographer who was sued for an outrageous amount of money, more than he could ever afford to pay, because his print order from his lab came in after Christmas instead of just before Christmas. Guess what, the client couple were both lawyers. What a shock. So what happened? We don't know other than his insurance took over and he didn't have to bother with it or pay anything. If he hadn't had PLI, well, he'd be asking if you wanted fries with that rather than continuing as he has in a successful portrait studio.

Your clients will also have Liability and/or Errors and Omissions insurance. This is also good for you if they carry such a policy in that frequently these policies will cover losses resulting from negligent copyright infringement, a breach of a license, or "errors or omissions." In short, this means that even if an infringer truthfully claims that they "have no money," operates as a "one person business," "will file for bankruptcy," or "will fold if sued," yet if they have insurance coverage, you can still get paid via settlement or litigation. In such event, the well-heeled insurance company will issue any payments due you and not the infringer whose financial resources will, in effect, be irrelevant.

People (and lawyers) who choose not to pursue a valid legal claim based on the belief that the other side has "no money", without knowing whether there is an insurance policy which would cover such claim, are often leaving lots of money "on the table." Determining the nature and extent of any coverage an infringer may have is a task best left to a competent trial lawyer.

This form of coverage may be a bit much to have when you first start out, but something you should certainly look into. Many locations, equipment rental houses, rental studios, and so on, want to know whether you have, or flat out require you to have, liability insurance in order to work with them. They will ask you for what is known as a Certificate of Insurance, naming them as an "additional insured." Jack's agent provides such

Certificates of Insurance at no cost while other agents charge for this service. Either way, for commercial jobs, even though his agent doesn't charge, Jack bills his clients a nominal fee for the time he spends getting a certificate.

One way to economically supplement an E&O type insurance is through the photographer's trade association, the PPA (Professional Photographers of America). The PPA has what they call an "Indemnity Trust" that covers wedding photographers who are PPA members for such errors and omissions. Technically it's not an E&O policy, but in reality, it basically serves a similar purpose.

The cost of this coverage is included in the PPA membership dues. One of the directors told Jack that they wind up paying money for about 2 weddings a year where the photographer's alarm clock failed to go off and the photographer was very late or missed the wedding entirely. If you are a commercial photographer, you can be covered by the Trust for an additional $25 or so over and above your regular dues. If you're a wedding or retail portrait shooter, we certainly recommend it.

Currently, the PPA also offers its members free equipment insurance that covers up to $15,000 in losses. This is adequate if you are starting out, but may be insufficient for your needs if you are more established. If you take it, it is free, but they will try to get you to increase that limit for payment of additional fees. As in most things, you will benefit by shopping around and comparing such policies with those offered by traditional insurance companies and agents. Remember, if you have a minimal amount of aging equipment, $15,000 may be sufficient coverage for now but it may be woefully inadequate by this time next year. If you have a claim, you may find that having a local insurance agent covering your equipment is better for you in the long run.

Worker's Compensation Insurance, or "Worker's Comp," is fairly inexpensive to have but can be extremely expensive not to have. Generally speaking, Worker's Comp will pay employees money if they have been hurt or harmed in the workplace as a result of job-related activities. In most instances, the worker cannot sue his/her employer but can receive financial compensation via Worker's Comp. Employers' premiums go into the pool

of money that is used as the source of any payments made to injured workers. Each business is "rated" and their premiums are based on the number of workers and how dangerous is the work being performed. A commercial fishing boat or meat packing plant pays premiums at higher rates than, say, an accounting office or a photography studio, where the incidences of physical injuries are fewer and far less catastrophic.

State laws vary greatly and you need to consult with an accountant or an attorney versed in the laws of your state. It is prudent to assume that you are required by state law to have this coverage unless you are advised by an expert that you do not need it. Most states provide a pool by which you can buy this coverage directly or indirectly through a state agency. Any competent business insurance agent can set you up so you will be in compliance with your state's laws.

Failure to maintain such a policy may result in heavy financial penalties and fines (or worse) being levied against you as the employer by the state. With the sophistication of government databases and the connectivity between state agencies, a Worker's Comp

audit or check can be triggered by something that has nothing to do with Worker's Comp. One of Ed's corporate clients was subjected to an audit going back five years because a former part-time worker quit his job and then applied for unemployment insurance benefits as if he were a full-time employee who had been fired. The company correctly fought the claim and the worker was denied benefits. Great, but while the hearing was held at the New York State Labor Department and was focused just on unemployment, the hearing generated a "notice" to the New York State Worker's Compensation Board. It was sort of like someone talking from one office cubicle to another cubicle, "Hey, Worker's Comp, we didn't get anything with this, but maybe there's something here for you." So the Worker's Compensation Board commenced a "random" and a very expensive audit resulting in a bill for "under payment" of worker's comp premiums.

Jack's studio employees have made Worker's Comp claims just twice over several decades. Once was when an assistant had a heavy packing case (luckily empty) fall on his head. While it did not appear to be a serious injury, there was some bleeding so Jack wisely sent

him to the hospital just to be safe. What happens in an instance like this, when someone shows up at an emergency room, the first question they ask is, "Were you working when this happened?" The hospital (or urgent care) wants to know who will be paying the bill. If the answer is "yes", then "Bingo!", it automatically goes down as a Worker's Comp insurance case for their billing purposes and for the state's records, no matter if you have a policy or not. All employees get covered by Worker's Comp.

If your Worker's Comp policy is in order, no problem at all, you're covered. If you don't have it, they come after you, the employer, with very large medical bills, fines, and penalties.

You should really get a reputable insurance agent to help you with any and all forms of insurance that you must and should have. Look for a person who understands the nature and size of your business so your needs can be met. If you're a new and growing photography business (meaning not yet making a lot of money) your policies should be different from say a well established photo business with five full-time employees and ten

part-timers. Look for an agent who is not looking to sell you things you don't need. There are many questions that an insurance agent familiar with the photography business can answer for you without breaking a sweat.

Let's take camera insurance, for example. Do you want to insure that 5-year-old camera for its current, actual depreciated value or for "replacement value"—the cost of buying a new one? Do you need coverage for international assignments? If you will be renting equipment, what insurance should you carry? Ask the agent about the cost of an "umbrella policy" which can economically serve to cover any loss above the limits of any/all of your various insurance policies. Agents who are reluctant to offer or discuss an umbrella policy suggesting you increase the coverage limits on your other policies ought to be avoided. Such an agent is trying to make bigger commissions at the expense of your wallet.

Jack rents a lot of props and has other props sent to him by clients. He shoots in studios located in Manhattan and many other places. Often he is shooting on location in a foreign country. Whether he is in a studio or on

location outdoors, in a private home or at a business, if something breaks, if an assistant knocks over an antique vase, he wants to know that he's covered. Let's say, a model slips and breaks her leg. Both Jack and his client need to know that there is insurance coverage to compensate that model for that injury.

Let's re-visit something here because as we like to say, "Ya' never know." If you carry a big overhead, like Jack did when he had a very large studio, you should consider getting the Overhead Insurance or Business Interruption insurance discussed above. That would cover Jack's rent, payroll, insurance payments, lost income and anything else covered in what is considered overhead in case you are incapacitated by illness or accident. You don't use this if you get the flu, but rather something a bit catastrophic. You can link this with a disability policy which pays you income at a pre-determined amount in the event you become disabled.

Most policies have waiting periods of say 30, 45, or 90 days before payments kick in. You can pick other time windows, but understand, the shorter the time before payments kick in, the higher the premiums will be. Premiums may be based on your gross income. There are other forms of insurance such as renter's insurance if your business is in a rental office or studio, or specialized auto insurance, for those of you who often use cars (including rental vehicles). You want to make sure that you, your assistants and anybody else operating the vehicle on your behalf are covered in the event of an accident. Your regular car insurance may not cover an accident if your vehicle is being used regularly for business purposes. It is best to get an agent and go over what you really need and put your entire house in order. It may not be as expensive as you think and the piece of mind knowing you're covered is priceless.

Always consult with your insurance broker to determine what forms of insurance are appropriate, available and affordable for your business.

Pricing and Negotiating

When someone asks me, "What do you charge for a photograph?" I respond by saying, "What does a car cost?" Are we talking about a new car or a used one, a four-, six-, or eight-cylinder engine? Is it a luxury auto or an economy model? And, do you want to buy, lease, or rent? The client can't say, "I'll have a portrait from Column A, a product shot from Column B, and, oh yes, I almost forgot, can I see the dessert menu?"

Just as a four-ounce drink can cost 20 cents if it's from a two-liter bottle of soda, six dollars if ordered as a cocktail in a nightclub, or well over a hundred dollars if it is from a bottle of vintage Grand Cru Bordeaux, the cost of a photograph can vary widely. How much clients pay for a photograph depends on what they want, need, and are willing to spend. A portrait for the high school yearbook and one of a CEO of a multi-national corporation for its annual report have about as much in common as a Big Mac at McDonald's and a chopped steak at the Four Seasons. They're both burgers, but overhead, materials, along with how, where and by whom they are consumed, distinguish them.

Formulating a Price

While there is no standard price for an image, there are standard questions that need answering before you can offer an intelligent price or estimate. First, you must know how the photograph will be used and for how long usage rights can be negotiated. Jack, as a commercial photographer, doesn't sell photographs; he "licenses" usage rights. If a client wants to buy a photograph outright, to own it and do as they please with the photo, Jack is going to charge a lot more than if they want to use it for a fixed period of time in a defined market. Is the photograph going to be used for an editorial publication, a consumer ad, a trade ad, a free-standing insert in the Sunday paper, a billboard, or a poster? How long does the client want to use it? A month, a year, two years, or forever? Does the client want regional, national, or international rights? And of course just who is the client? Are we talking about Betty's Chicken, whose sole location is over on Elm Street? Or is it KFC nationally or even worldwide?

Then, production values enter the picture, so to speak. Is there flexibility? Does a set have to be constructed? Is the setup at a nearby location, an exotic location, or in a studio? Is it a prestige client who wants the best of the best in props and styling? Or is it a small, local company that has a limited budget and you have to cut corners for a limited budget? After I compile all of the usage information, the lavishness or simplicity of the production, I can work on giving the client a price.

Photographers gain experience at pricing the same way people learn about sex. They talk with their peers, listen to a lot of tall tales and outright lies, make a bunch of mistakes on their own, and gradually they learn. While some photographers learn faster than others,

almost all exaggerate the story of their learning experience.

In the dark days of the last century, before we had personal computers and software to help us price, we had agents and networking. But it still isn't unusual to get a phone call from a friend wanting to bounce a price for a particular usage off of you. It gets tricky if you are both estimating the same job. That happens more often than you think, as many photographers know each other, work in the same area of photography (especially in the same community) and find themselves bidding a lot against each other. Price fixing in such situations is highly illegal and one needs to be very, very careful when conferring on jobs with your competition.

Remember that someone calling you today for a favor might be someone you need a favor from tomorrow. You're not obliged to give out information that can be harmful to your business, but you also don't want to be so standoffish that you have no friends. Like many things in life, talking with your competitor, even if they are friends, is a delicate balancing act.

Jack relates a situation he faced:

I had a good friend call me to go over a job where everyone knew I was the first choice. My friend wanted to discuss the estimate. There was no upside for me, as all I could do at that point was lose the job, so I became inaccessible that day until after the final bid was in. If I didn't know I was the heavy favorite and we were both contending for the same job, I'd have likely gone over some of the issues, but would have held back any really unique ideas I'd have had about doing the job.

Sometimes you plant something in their minds that might give you an edge. And they do the same thing to you. You're sort of "frenemies." Friends, but still competitors. Don't get me wrong, sometimes you do both share good ideas, as it helps the job along. If you know that you want to shoot this from a cherry picker, let's say, to get a unique angle, you might want your friendly competition to also think about it and include it in their estimate, so yours doesn't seem too high because an expensive piece of production equipment is in your estimate but not in theirs. And if the third photographer's estimate doesn't have it, but your two

estimates did, then the third photographer looks like they don't have a good handle on the job. Their lower bid doesn't look as attractive to the art buyer. But then again, just to drive you just as crazy as we used to get doing these estimates, the art buyer may decide that the cheaper way is the better way. Art buyers don't always go with the lowest bid—low bids can scare them. If a bid is too low, they worry that the photographer doesn't understand what is really involved and they do not want to engage a photographer who will be in over their heads with producing a job. The art buyer's own job security can depend on them hiring the right people. But then they sometimes will hire the lowest bid. You just never know.

In the end, you win some bids and you lose some bids. Get used to it—no one bats a thousand percent in this game. Just like baseball, a .333 average can be very good. But I'd rather aim at over .500. And if your friends or people you like and admire get the assignment rather than you, it's not always so bad—it's when someone you really don't like or respect gets the job, then losing that job leaves a bad taste. But losing bids, being rejected, is all part of the game.

Negotiating to Win

Obviously, in order to come up with a bid you need to arrive at the "ultimate number," the fee you are hoping to get. In order to formulate that price you will no doubt need to do a little dance we like to call "negotiating." Real life experience tells us that the majority of photographers are poor at estimating the cost of a job and even worse at negotiating terms.

With the carrot of a job dangling in front of them, creative people will jump through many hoops to secure the work at almost any cost. Creatives want the work even if that job earns them less money than a teenager makes flipping burgers. In some cases, they are even willing to *lose* money to ensure they get the work. That's why we encourage photographers who are poor negotiators to retain an agent or representative, who possesses such skills, to do the talking for them. It's harder in smaller markets where there is not a large or even small pool of agents—you may need to find someone, such as a good salesperson, and nurture them to be

your agent. And don't laugh, there may even be a homemaker that posseses the skills to negotiate for you. Homemakers running a household with a budget can turn into some of the best and most ferocious negotiators. It is a matter of finding the right personality that fits your business. You might even use a lawyer to negotiate in unusual cases where you have, for example, captured a truly unique, historical image or have photographed a news event or celebrity, and where there is an immediate, time-sensitive demand for its use. The bottom line is if you are not a top-notch negotiator, someone else negotiating for you will add a lot more to your bottom line than you can, even after their commission is deducted.

Negotiating is a "black art." It's the alchemy that really turns your photos into money. Like psychiatry, negotiating is composed of science, art and luck. Unlike baking, there is no recipe that you can repeat to give you the same results each and every time. Finally, like jazz, negotiating is a language that requires the abilities to understand and work with others, to think on your feet and, most importantly, to improvise.

The art of negotiating has, for generations, been a subject of keen interest to folks residing most everywhere on the planet. Whether it is with our family, friends or business associates, all of us negotiate, in some form or another, daily. Sure there are occasions where you set your fee and terms and a client says, "OK, it's a deal." In other instances, where there is no such "love at first sight," expect to engage in some negotiations regardless of whether you choose to call it "back and forth," "give and take," or "haggling."

Countless studies show that the more experience—and especially the more success—a person has had in negotiating, the more likely they are to try to get what they want by, surprise, negotiating. It is very common to be nervous when the need to negotiate arises. People who are inexperienced in "doing" business deals, or fear the unknown, are understandably apprehensive. Those who have had bad prior experiences view the process much like a minefield fraught with danger. Whether you and/or your adversary (yes, adversary) view the process as a chess match, football game, a well intentioned attempt to achieve mutually satisfying results, or simply as an exercise in egomania, these strategies apply:

"Information is a negotiator's greatest weapon."

Victor Kiam, President of Shick Razor

You must understand who the other guy is and what he needs. Do your homework and do not assume that your opponent views the process in the same manner as you do. Learn about their finances, their bottom line and what they want from you. In pro football, coaches and players for both teams spend untold hours preparing for an upcoming game until they think they know everything about their upcoming opponent. They watch tons of video and run computer programs tailored to every play their opponent has ever run. Preparation is key, but it is not everything. Sometimes all of that preparation can go out the window when on the first play of the game a star player gets injured never to return to the field.

"The power to negotiate is the power to walk away."

Sid Hill, College Professor and
Professional Negotiator

If you are unable to say "no" under almost any circumstances and the other side knows or even guesses that this is the case, you will be a "sitting duck." If the other side knows you won't walk no matter what, they will not transmit their money to you just to be "nice." As your mother has likely told you a few thousand times, "You can just say 'no' ya' know!" Mothers are always right.

"You get what you negotiate."

Chester Karrass, Karrass Effective
Negotiating

People who "give away the store" are soon unemployed. Unless you are a charitable endeavor, nobody is simply going to meet your demands because of your good looks.

Appearance, talent, charm and business skills will get you nowhere in a negotiation unless you use them.

"Trust, but verify."

President Ronald Reagan

There are two things that have been on Ed's desk for decades. One is a gift from a client bearing the Reagan quote and the other is a plastic card reflecting that the holder has medical coverage. The card was produced by an archdiocese in a major American city and was provided to nuns, priests and other members of the clergy. The card looks "Kosher" but, alas, it was a fraud. Not a copy or fake, but a fraud. There was no such coverage in existence. Some of the older clergy who carried and used the card knew that it was worthless, while others were clueless. Ed keeps it on his desk to demonstrate that if even members of the clergy lie and use phony documents to deceive others, why would anyone rely on the representations made by a client?

Spouses, parents, children, heck all of us, have lied about something, sometime. While you may know the extent to which you can rely on those close to you, clients should not be treated similarly. Clients will lie for many reasons, money being just one. Don't believe anything a client tells you based merely on the fact that it was said.

With apologies to Lao-Tzu, "The journey of a thousand lies begins with the telling of just one." The late Andy Rooney said, "People will generally accept facts as truth only if the facts agree with what they believe." Every good magician, mentalist, or storyteller will set the scene so the audience can start with a single set of agreed upon facts before the "reveal."

In that spirit, let's agree on some facts of life:

1 People lie.

2 Advertising at its best is a form of deception.

3 People in business like money.

4 Not everything you see or read in any medium is accurate.

5 Certainty is not the same as accuracy.

"The single biggest problem in communication is the illusion that it has taken place."

George Bernard Shaw, playwright

Anybody who has been married or has had children knows what we mean. Most people are horrible listeners and whatever skills they do possess in that department will be adversely affected by their participation in any discussion. If given a choice, the FBI always prefers to use a taped conversation as opposed to the testimony of anyone claiming to remember what was said. Video evidence trumps eye witness testimony 99 times out of 100.

Many people are thinking about what they are going to say next while you are talking to them. Others simply ignore their opponent and commence thinking about what they are going to, say, prepare for dinner. Such a person may periodically nod and say, "fine," "OK" as you are speaking indicating agreement when, in fact, no "communication" has occurred as no message has been received.

"Perfect is the enemy of good enough."

Sergei Gorshkov, Soviet naval officer

Don't expect to get everything you want. Do not, however, assume that you won't. Play to win. In the history of Major League Baseball there have been about 350,000 games played, depending on how you compute it. There have been however, just 23 perfect games pitched. Despite those Power Ball like odds, every pitcher goes out on the mound hoping to pitch a perfect game and trying to do just that. Winning, although not perfect, is plenty good enough.

Opportunity may knock, but it is not going to stand at the door all day waiting for someone to open it. If you can't get everything, get what you can. At that point, you can decide whether what you "got" is good enough.

"Silence is golden."

The Four Seasons

Legendary jazz trumpeter Miles Davis knew how to use silence—he knew when not to play a note. Those people who rush to fill an uncomfortable silence will often fall right into a well-worn trap laid by the opponent—Dorothy Neville said, "The real art of conversation is not only to say the right thing at the right place, but also to leave unsaid the wrong thing at a tempting moment." Similar rules apply when negotiating. As they say in Spain, "Don't speak unless you can improve the silence" or, to choose the American cliché, "When in doubt, don't."

Avoid Using Emails and Text Messages While Negotiating

While there are numerous benefits in putting proposals, terms, and such in written form, there is a down side. Such messages do not carry the tones, inflections or affectations of oral discussions. It has been said that Jews speak to each other with an agreed upon set of mutual interruptions. Two people talking to each other at the same time will likely produce a different result than alternating text messages whose intended import or tone may be misleading or absent. We have seen texts that are flat out offensive although that reaction was never anticipated nor intended.

Few of us are gifted writers and some lesser number even bother to proofread a text message before firing it out. Heck, even a Pulitzer Prize winner needs an editor and, by the way, so do we. If you are in doubt about the quality of your writing, have someone you trust review what you intend to send. Pause, wait, and even sleep on your response before sending it whenever possible. Finally, whenever possible use plain English words rather than abbreviations, slang or Internet acronyms. Finally, keep this in mind:

**"You can't always get what you want,
But if you try sometime,
You might find you get what you need."**

The Rolling Stones

An Estimate Or a Bid?

Whenever you provide prices for a client, you are furnishing an estimate. However, if other photographers are also providing prices to that same client, then your estimate becomes a bid. Thus, a bid is always an estimate, but an estimate isn't always a bid. If you are the only photographer pricing the job, then it is simply an estimate.

There are two main factors involved in creating an estimate: the creative fee and the production expenses. Creative fees are based as much on a photographer's experience in pricing as their experience behind the camera. Depending on the photographer and the task at hand, a creative fee can range from, say, $500 to $15,000 or more. Buyers are usually familiar with where these creative fees should fall. What vary most, from estimate to estimate, are the production expenses involved. While one photographer might see the job as a studio shot, another might insist that he/she shoots on location. In these days of tighter and tighter budgets, the estimate or the bid become more and more important.

This shows the art director or client how much the job is going to cost. It also reveals how you plan to approach the assignment. Are you planning a luxury cruise when they only want a canoe ride? Are you setting up your best Cecil B. DeMille production when they really want a home movie? Or vice versa. While it may be rare these days, I have heard of photographers scaring away potential clients and losing jobs because the buyer knew the photographer wasn't estimating high enough for the level of production the client was expecting. Most buyers are well aware of the costs involved in shooting high- and low-end jobs.

Bid Rounding Requests

Sometimes an art buyer is using a bid to compare prices. She may have the photographer that she wants to use already in mind but wants to see how the shooter's estimate compares with other photographers of his caliber. Thus, if you are not her top choice, you are probably just "rounding out" the bid. This can be a tricky position to be in because you never know for sure if that's what

you are doing. My agent is pretty good at smelling out these bid rounding requests and will ask the art buyer directly if that is the case and if they have someone already in mind for the job. Usually the buyer is straightforward. If I am just rounding out a bid, I try not to spend as much time on it as I would if I were the "pick" photographer.

Past is Prologue

A time-honored and effective method employed by businesses of all types and sizes is to conduct periodic postmortems of prior deals, acquisitions, hiring/firings, product strategies, effectiveness of outsourcing, quality of advertising campaigns, and so on. By carefully and dispassionately looking at past

transactions and jobs, and by performing an objective financial "autopsy" on these transactions, you can learn a lot about your own business. Most successful business owners will tell you that there is a gold mine of information in those old records if you just take a careful look. You really can effectively analyze your past methods of doing business, pricing, promoting, etc., as well as your bright ideas that yielded the biggest profits. This type of knowledge is as good as gold. Few people enjoy analyzing and reviewing business disasters, or why carefully planned deals went bust. Every business of every size has its failures, no business of any size is immune. But those past disappointments can be turned into future assets.

Oft times the causes of a money losing endeavor are so obvious that no brainwork is required to understand the loss. For example: a given company lost X$ because the product

NEGOTIATING: 10 TOP TIPS

Negotiation is both an art and a science. Mastering it, or even getting pretty good at it, will ensure your survival. It will put more money in your pocket than any photography skill ever will. Here are some guidelines, tips, for those who want to hone their skills:

1 Smile. That's it. All of it. The monetary value of a smile cannot be under estimated. This is a lesson known to every successful restaurateur, hotelier, or shopkeeper. It has been perfected by the founders of Walmart, Disney World, McDonald's, and, of course, every teenager asking for the car keys. No one needs to teach you how to smile. Smiles transcend our ethnic and class differences. It is the same skill set that you use behind the camera to get your subjects to pose, react, or even smile.

2 If pushed to quote a price and you are not ready to do so—don't. This is a tactic buyers frequently use to back you into a corner, especially when you are unprepared or desperate. Beware of the phrase coming from their lips, "I won't hold you to it." It ties you like a sailor's knots to whatever price you quoted off the top of your head. That price you mention will be the only price they hear, no matter what you say later when you realize you overlooked something that could cost you several thousand dollars. When, on the phone, you are pushed to quote a price because your client is in a "super rush," still, do not quote a price. Get off the phone, even if it's for 5 minutes. Really think about it without someone pressuring you. Or, better yet, kick it around with someone.

3 Another important technique—difficult though it may be to perfect—is the ability to step outside yourself and be observant of what is happening. Envision the cool of James Bond or Miles Davis. This doesn't mean that you suddenly become laconic or reticent if you are normally effusive and outgoing. Forgive the sports cliché, but stay within and be yourself. You need to simultaneously be involved in the process while objectively observing it. In plain English, always keep your eyes on the prize. Don't get wrapped up in thinking, "Wowie, wowie, what a great assignment! Can't wait to shoot this!" Rather think, "What does this involve? What is a realistic timeline and production? Are there any hidden pitfalls?" and so on.

4 Beware of underestimating "amateur" negotiators. Mothers who clip coupons, fathers of the bride, contractors, real estate brokers, and any good salesperson, regardless of what they might be selling, are likely great negotiators. They are often so good that you don't even realize that they are stealing your skivvies until you feel that cold draft. It is what they do to survive. Recognize the talents possessed by your

opposition and do not underestimate them. They eat what they kill and you may be tonight's blue plate special. Lawyers and others who wear Italian three-piece suits can learn a lot from these "amateurs" about negotiating and getting what you want.

5 Eye contact is another simple thing that some people forget. It develops trust, makes a connection, and helps to achieve the single most important factor in any negotiation—creating rapport with the other person. Think of the multitude of clichés that spring from "He looked me straight in the eyes and . . . " Also, most sales people swear that, if not overdone, using the other person's name with some frequency during discussions serves much the same purpose. Do both.

6 Use of a common vocabulary, or as we like to call it "linkage," is another way of making a connection, as in "speaking the same language." If your client says, "I envision a shot that looks like . . . " You respond by saying "Yes, I see that." Client: "I'm bored to death of shots that . . . " You: "Yes, those cliché shots are better than sleeping pills," and so on.

7 Duplicate gestures also help, but they need to be subtle. If they fold their arms you fold yours. If they tilt their head, you tilt yours. Avoid the "monkey see, monkey do"

type of action. It's long been examined and known by those that study body language that duplicating general body gestures need not be an exercise in exact mimicry. It does, however, develop a connection between two people. Lean in towards the client when he/she is talking. It will make you appear interested in their message— even if you are not.

8 Shared experiences are another technique. "Did you see the movie *Invasion of the Giant Camera that Ate Cleveland*?" "Didja catch that baby that sings opera on YouTube?" "How 'bout them Yankees?" Hopefully, we don't have to explain about staying away from political or religious topics. Referencing common shared experiences utterly unrelated to the business topic at hand will help to form a rapport without an obvious motive. Is there a stronger bond in nature than that of two fans of a historically beleaguered sports team: for example, the Chicago Cubs?

9 Make your adversary feel important and a special key to the success of the project. Even if you do all of the work and deserve all of the credit, set it up so that he/she will be able to "put it on their résumé."

10 Finally, remember the first tip: Smile. So easy, even babies can do it. You can too.

it developed and promoted at a cost of Y$ yielded sales of zero or near zero because a well-branded competitor was selling the same product at half the price. Homer Simpson can do the math in such cases. Much trickier are those occasions where the creative, be they a photographer, designer, or illustrator, estimated the job at what sounded like a good price at the time, did the work, licensed the images, got paid in full and on time, but after talking to their accountant, realized they made little or no profit.

A list of possible contributing factors to an endeavor that turned into a "not for profit," might include such situations as: the estimate was too low; unforeseen costs arose which could not be passed on; did too much in the hopes of hooking a potentially huge and steadily repeating client or customer; underbidding a competitor (or sometimes a "ghost" photographer your client/customer simply made up); using lousy paperwork resulting in legal or accounting problems such as paying unforeseen taxes or fees; being out negotiated by the client; and on and on. The trick with some of these potholes in your business life is to really look at them, so you don't repeat them. Business owners making

mistakes comes along with the turf. Failing to learn from those mistakes and repeating them expecting a different result is what is called "the definition of insanity."

Everyone has viewed episodes of *Law & Order*, *Law & Order: SVU*, and *Law & Order: Criminal Intent*. The producers of these highly successful formula TV shows have profited mightily from taking a proven money maker, analyzing any weaknesses in the existing product, and re-working the basic formula to reach a new audience or simply keep the same audience for another similar or even new program. Photographers ought to do the same—performing an "autopsy" on the jobs you performed a week, a month, or a year ago—to help determine whether you really made money doing them and how you would do them differently in hindsight.

Take out your job folder. You do maintain a job folder and good records don't you? If not, stop reading and find someone to help you get organized. Jack can go back 30+ years and tell you what he shot, the names and addresses of the models, find the releases (critically important), know what was charged and how

many days it took from sending the invoice to depositing the check. When he had to locate and verify an eight year old model release for a re-use, it took him less than ten minutes. That's easy money in his bank account. Good, simple record keeping and filing is as important as maintaining your camera equipment. Actually more important, because without good record keeping, you may find out some day you can't afford your camera gear.

The cold light of day and well after the job has been done is the ideal time to answer the big question, "Was the job worth it?" If the answer is "Yes," great . . . ask yourself, "What did I do right?" If the answer is "no" or "not really," have a heart to heart with yourself about what should have been done differently and what you would change going forward. Not all jobs are worth it. Was the customer or client such a pain in the butt that the aggravation cost you a piece of your liver? Or did the job go so smoothly and you had such a great time with that client that your compensation made you feel like you were stealing the money? Were there any surprises? Did any issues come up that you hadn't planned on? Were there warning signs that

you could not spot ahead of time on future jobs?

If you work with an assistant or other staff member, or simply have a good friend in the business, it's a great idea to just sit back and kick around past jobs. Free association during these bull sessions can be very enlightening and something photographers, who tend to be lone wolf types, seem to avoid. But even wolves travel in packs because the lone ones often don't survive.

Your assistant may remind you, during a bull session, just how well you worked with an art director or a portrait customer. Then the question to ask is, "Why are you not staying in touch?" It doesn't have to be a full frontal assault or blitzkrieg, but just a gentle reminder that "Hey, we are still around doing good work." The old adage "Out of sight, out of mind" is oh, so true in photography as it is in any business.

Staying in touch is so simple, so easy, and yet so few do it, expecting that your customer is so impressed with what you did for them in the past that you are simply unforgettable. Well, let us tell you the hard truth. They

forgot about you. You're yesterday's newspaper. Out of sight, out of mind. Why do you think brands like Coke and Pepsi advertise so much? They are very sophisticated and knowledgeable marketers and they spend millions to remind you, hey, we're still here.

So slowing down, not getting caught up in a maelstrom of your own doing, and pausing to reflect is very profitable. Looking back on your past jobs in an "autopsy" style will highlight both your best profit making techniques as well as the practices which take money out of your pocket. There are a dozen famous quotes about not repeating bad behavior and they all apply if your goal is to make a profit. Our contribution to the buffet of clichés is "Looking backward helps you move forward." And while we advocate looking back with trusted people in your business life, do not ever do so online in social media. Never, never, ever. Did we emphasize that enough? This can be the kiss of death in so many ways. We are constantly amazed at photographers who put some things on a social media site, no matter if it's a private or open to the public site. While sharing is a good thing and discussing your business with

trusted friends is also a good thing, doing either online may well be disastrous.

So stop, look, and evaluate your past. Do it in person with an adult beverage and friends if you have people you trust and respect. And remember that great quote by William Shakespeare in *The Tempest*, which is also engraved in stone on the National Archives Building in Washington, DC, "What's past is prologue."

We Ain't Whistling "Dixie"

Ever get scared walking into the office of a prospective client to bid on a job? Does it remind you of that sinking feeling you get in your gut when you find yourself walking alone, at night in a neighborhood where "you shouldn't be?" Social psychologist Claude Steele authored *Whistling Vivaldi and Other Clues to How Stereotypes Affect Us.* The book is a discussion of how stereotypes shape the thoughts, feelings, and actions of those whom they target. He originated the concept known

as "stereotype threat." We think the concept has some practical applicability to creatives and their ability to make money.

Steele's thesis, simply stated, is that in certain situations all of us are subject to negative stereotypes because of identities we have. These negative stereotypes are not limited to race, religion, gender or ethnicity. A lawyer could be negatively stereotyped as aggressive or argumentative (can you imagine?), a math professor as an introverted geek, or a photographer/illustrator as a horrible business person with no concept of negotiating. According to Steele, the experience of stereotype threat occurs when a person becomes aware that, in a particular situation, he or she may be judged according to a negative stereotype. Sometimes that stereotype may be reinforced as a result of the words or actions of the target.

Think about some of the classic racial, ethnic, gender and class stereotypes that have bounced around for decades or centuries. Got a few in your head yet? Now think of some of the stereotypes concerning artists, photographers, models, illustrators, etc. OK, let's proceed and let's see how understanding this concept *might* help your negotiating skills and thus fatten your wallet.

Let's say you're bidding or negotiating for a job and the client/ad agency views you as clueless when it comes to matters relating to business. They likely possess this view without having had any prior contact with you, but rather it is based on prior experiences with illustrators, graphic designers, photographers, and other "creative types." Sometimes it is based on no previous experience of any kind—a "pure stereotype." Those of you who are comfortable doing this traditional "dance for work" probably view or even stereotype the other guys as the "suits." In private moments, members of both teams complain about having to deal with members of the other.

So how to use that "stereotype threat" to your advantage? How can you get an upper hand at the bargaining table while making *no effort*, at least not a *detectable* one, to neutralize the stereotype threat about to be aimed squarely at your balance sheet? *Assume* that the suits think you are putty in their hands, a "starving artist," bereft of negotiating skills, childlike in matters of business, and, most importantly, that you are desperate for the job. It doesn't

matter whether one or even all of the above are accurate. Assume that your adversary *believes them all with every fiber of his/her being*. Your job is to dispel as many preconceived notions as possible, as quickly and effortlessly as possible, all without breaking a sweat. Remember, in negotiating, you should never let them see you sweat. So here's how to get the advantage in negotiating:

1 *Paperwork/forms*. Have estimating materials, papers and forms at hand. Take them out as soon as is reasonably possible. They must appear (and be) detailed. They must contain lots of seemingly relevant information, blank lines and boxes to check. Make it look like you have used your estimating forms *thousands* of times. Your questioning of the client and use of the forms must be effortless, like second nature. Using the forms as your adversaries make their pitch will lessen your appearance of desperation, make you look and force you to act like a businessperson. What you are actually writing down is less important than conveying the appearance of an attentive, businesslike, experienced independent contractor who has done "this" a million times before. You are

projecting experience and *reliability*. Suits expect, but don't want, *drama* from artistes.

Use the invoices, billing materials, and model releases. Show them to the suits so they know you have every facet of the job covered "legally" for *both* sides. Explain how such documents protect both you and the client from future problems of both the non-legal and legal variety. Your paperwork is for *their* own good. How many creatives are conscious of protecting their clients? Clearly you have done this before and have thought of everything.

When Jack shoots at a company, using their employees as the models/subjects, he stresses that he needs an assistant to collect model releases from every employee photographed. Someone always chimes in that it's not needed because they're employees. Jack will then point out what could happen if that employee who didn't sign a release quits or gets laid off after the ad, brochure, annual report gets published? The person poo-pooing the releases now realizes that this will cover their exposed posteriors and the perception of Jack, "the photographer," goes up a notch or two to Jack, "the forward

thinking businessman." Future requests down the line during the job are now taken more seriously.

2 *Confidence.* Your theme here is "I'm Different." Emphasize that your approach to these assignments is akin to a mechanic, a pragmatist, problem solver, etc. who has been gifted with a unique vision to get the job done. Suits like the words "gift" and "vision" because they don't think artists are smart enough to learn and study like they did. Your businesslike manner will distinguish yourself from most, if not all, of the creatives with whom they have worked in the past. Or at least, dispel the stereotype threat of the "starving artist" who can be negotiated out of their intimate apparel. You are a "cut above" and that is what makes you *different.* Also, don't discount appearance. While it's "cool" to look like an artist, coming into a meeting room full of suits with torn jeans and a tee shirt will not instill confidence. As they say, dress for success. It does matter, it does work. If you wear a suit to a business meeting, you have on the same uniform as they wear and are viewed more as an equal on their level. Come in jeans and a tee shirt, and you're on the level of the workers on the line and the

"suits" will view you differently. On the other hand, if you are going to photograph a band or a rap star, a suit will look out of place and you are not at their level.

3 *Hiring* you *will put money in their pockets.* Most often assignments have a very simple goal, to sell a product or service. Remind prospective clients that photos of "Super Model" Cindy Crawford have sold more Omega Watches than all retail sales clerks combined. Actress Valerie Bertinelli in their ads *makes* Jenny Craig. In short, *remind them that advertising works.* You want to remind them of this fact so they can feel better about what they do for a living. You have complimented them by justifying both their efforts and travails, which heaven knows are of no interest to either their superiors or their families. Remind them again of how important advertising and promotion is to the company's bottom line.

4 *Be prepared to say "no."* We saved the best for last. It is a simple and straightforward sentence and advice. If you are not prepared to say "no" to a bad deal and mean it, expect your pockets to be picked. That's it. We can't emphasize this item enough.

So why is the book entitled *Whistling Vivaldi*? Seems that a young African American graduate student living in Chicago found that whites sometimes seemed fearful as he approached them while walking down the street. Eventually he found that whistling Vivaldi as he walked past served to prevent them from invoking the negative stereotype about young African American men being violent or dangerous. His whistling of classical music suggested to his "audience" that the stereotype did not apply to him. Rather it conveyed the illusion that he was a man of great education, culture and class. *He was different.*

Disarm the enemy without it realizing that you are doing so. At that point, you employ your own negotiating tactics and your clients will likely either A: have no clue that you have outdone them and eat up the professionalism displayed, or B: recognize your approach for exactly what it is. In "B" the suits are convinced that you know not only how to negotiate, but also how to be a professional and there should be no reason not to hire you. A win/win.

Some Dos and Don'ts When You're Infringed

In the back of your mind you knew this day would come. You have heard countless stories of other photographers whose works have been stolen. Now it's your photo that has been copied, appropriated . . . stolen. You are now the "other guy." So what to do? First off, don't get hysterical. You can remember that it's "just business, nothing personal" or that "revenge is a dish best served cold."

We like Aldous Huxley's line, "You shall know the truth, and the truth shall make you mad." Mad is good, *too* mad makes us forget how to best get even.

When photographers find out their work has been infringed, far too many succeed in doing all of the wrong things. Heaven forbid they should calmly plan their attack upon the thief by listening to their lawyer. We hear the same complaint from auto mechanics who tell their customers to shut off the engine immediately when a car is overheating just to find that the

driver thought it would be better to drive right over to the garage to get it fixed pronto!

Do :

1 Gather all evidence of the infringement(s). If on product packaging, buy the product using a credit card. If the item is on sale at a CVS store, then go visit Walgreens, Walmart, Kmart, and any store comparable to CVS after you have purchased it from CVS. If the use is on, say, a hair care product, go visit your local mom and pop convenience store where the product might be on the shelves, as well. Buy several packages, your lawyer will need them as evidence anyhow. Odds are if it is at CVS and it's not a house brand, it is being sold at competitive stores. Go on the web and see if you can order it via Amazon and if you can, do it.

If the infringement is in the form of an in-store poster, take a photo of that poster in such a manner, showing the environment, so that your attorney can show to a judge or jury how the photo was being used. Sounds obvious, doesn't it? You would be surprised at how many photographers don't take pictures in such situations, or they take just a close-up of just their photo. Seeing it in the context of

ASKHOLE

True story. Ed gets a judgment for a lot of money for one of his clients.

He emails the client and, in all caps, writes, "HE WILL CALL YOU DO NOT TAKE THE CALL, REPEAT, DO NOT TAKE THE CALL"

The client acknowledges receipt of the email.

One hour later the client writes to Ed, "I just spoke with *him* and . . ."

"Why do you pay me? Did you read the part where in caps I said don't speak to him?"

"Well, I thought . . ."

This is what's known as being an "Askhole." This is when someone is asking, or in this case paying, for advice and doing the opposite. Here are the "dos and don'ts" of being a victim and please don't be an askhole about it!

a busy store or in a well-traveled location makes a big difference.

If the infringements are in newspapers or magazines, buy copies of those publications. If on the web, print out screen captures, which clearly show the date. If you live in San Francisco and find the infringements on products sold in the Bay Area, call a friend or your mother (you know you owe her a call!) who lives elsewhere and ask them to visit their local CVS. Again, these stores tend to market nationally not locally, so if mom lives 3,000 miles away in Stroudsburg, PA where there is also a CVS, the odds are good the product is on those shelves as well.

2 Make sure you have registered that image then dig out your registration so you can provide it to your attorney who is going to need it ASAP. Remember, it is for moments like this that you registered in the first place

3 If you have licensed and/or published the image before, make copies of all model releases, invoices, estimates and uses of the image, especially your first use of the photo. Check to see to whom if anyone, you have ever given or licensed the image in the past.

4 Contact your lawyer, your new best friend in the world, and be prepared to furnish *all* of the information and items referenced above.

Do NOT:

A Contact the infringer. This will give the thief the opportunity to "circle the wagons" and destroy evidence. Yes, we did say "destroy evidence" and we mean it.

B Send a bill to the thief in any amount for "unauthorized use" or "infringement." This is one of the biggest mistakes we see photographers making over and over. You have no idea as to the nature and extent of any/all infringing activities so why assume that the infringement(s) are limited to just

the use that you or your spouse saw? The infringement you see might be just the tip of a large iceberg.

It amazes us how a photographer who would never dream of estimating the cost of a location shoot over the phone without knowing the number of models, the nature of the shoot, the location to be used, whether it was for editorial or advertising use and so on can nevertheless instantly make a demand for a precise amount of money resulting from a violation of federal law, the full nature of which is unknown to him/her. The value of your case can only be determined after you and your lawyer know of all of the infringing uses, the circumstances that lead up to the infringement, and can view them in light of the remedies that the copyright law provides. Otherwise, can you say, "A pig in a poke?" If the client pays right away, it usually means they think the amount for the infringement is cheap. Not to mention it gets them off the hook for a bigger liability about which you are unaware because you didn't dig deeper.

C Wait. Aside from possibly being prevented from bringing a lawsuit by the statute of limitations, you ought to strike

when the infringing image is in the market place. Remember that a federal court can grant an order directing that the infringing goods/images be removed from the market. This possibility provides considerable leverage for your attorney to negotiate a settlement should you be so inclined. Removing a product from "the stream of commerce" is a very expensive endeavor. Infringers would often rather pay you than incur the costs to take down thousands of items from the shelves of thousands of stores for the purposes of return and/or destruction.

D Discuss any of the facts or circumstances of your claim on social media. Anything and everything you post will be used against you. Nothing you post is privileged and all of it can be obtained by the infringer and/or its lawyers.

E Offer to give up your claim for money damages in exchange for a donation to charity. It has been said that a sucker is born every minute, don't be one. This seemingly warm and fuzzy, non-confrontational approach is made by infringers and their lawyers who know that artists fall for it more often than not. It is a method by which the

thief pays less than he/she should and gets a tax deduction to boot. You get zilch, nada, nothing because it is a con. Many of Ed's clients have won or settled cases and donated all or a portion of their awards to their favorite charity. Their money, their choice, their tax deduction and almost always more money goes to the charity than the infringer would have ever dreamed of paying. It bears repeating that artists are suckers for any scam that sounds non-confrontational and *appears* to benefit children or puppies.

*

Reps, Agents, and Lawyers

In the legal sense, there is a difference between agents and reps. An agent is someone who represents you with your best interests in mind. They act in your place as "agent for" and are therefore acting in your best interest. They are legally obligated to get you the best deal they can get.

A "rep" (short for representative) is not legally bound to act in your best interest. So, if your rep has ten photographers and a new job comes in that is perfect for you, the rep might try and steer it to a new photographer he just took on and who is not having such a good year. It could be that the rep has a more favorable commission with the new photographer, perhaps 30 percent instead of 25 percent of the fee, and thus steers the job to the new photographer, even though you are a better fit for the assignment.

As a rep, he is not legally obligated to act in your best interest, as opposed to an agent who would be legally obligated to do so. If you have a stock contract with an agency like Getty or Corbis, then you will see in their contracts that they never refer to themselves as agents. They might represent you and your work, but they will not be named as agents. For simplicity's sake, we'll refer to both reps and agents as "reps" for the rest of this discussion, but do be aware of the differences.

A relationship with a rep/agent is very much like a marriage. You spend a considerable amount of time together discussing your children and talking about your photos. A lot of the relationship depends on chemistry, mutual needs, and just plain likeability. While 50 percent of all marriages end in divorce, 99 percent of all rep/photographer agreements don't exactly last a lifetime.

A great rep can help guide your portfolio and give you counsel. They can set up your promotional schedule, and some reps will pay for the promotions along with you. They might pay anywhere from zero to 100 percent, but the most likely scenario is that they'll chip in the same percentage that they get for their commission. So, if they get 25 percent of the fee as commission, then they'll pay 25 percent of the promotion budget as well. Because reps are good negotiators, they will often negotiate to pay zero. Your reputation and how badly they want you also comes into play.

Many photographers think that the most important function of a rep is to get them jobs, thinking, "If I only had a rep, I could be shooting all sorts of things." But that's not really the case. Getting jobs is a multi-function issue that greatly depends upon your promotions. By multi-function we mean to say that it's not just having great images in your portfolio, it's not just sending out one promotional piece, it's not just one email blast, it's not winning one prestigious photo competition, it's not just getting a rep and sending them out into the wild, and so on. And it's not just doing one of these things numerous times. Getting jobs is the sum of all

these parts. It's about a sustained campaign utilizing all these activities.

The most important function of a rep really occurs when you get a job and they interact with the art buyer or art director. The rep handles all of the financial discussions along with the logistics. These days, for complex negotiations with complicated usages, this function becomes vital, and really good reps can easily raise your fees well beyond the amount of their commission.

A good rep can free you to do what you do best: make photos. A good rep also removes you, the artist, from dealing with issues that would normally be emotional ones for you. When negotiating fees, it's best to use a professional who is emotionally removed.

Photographers want to shoot and, as a result, are sometimes willing to accept lower fees when they think they might not get a job. Art buyers understand this and will push buttons to get you to drop your price, they might say something like: "Well, the client is looking at several other photographers who are quite talented, but we really like you and would really like you for this project. But . . . the fee."

An agent/rep might say, "That's our price," or an agent/rep might be able to find a middle ground to arrive at a price. Photographers, more times than not, will fold like a cheap tent. That's where having an agent can make a big difference in the amount you earn. Art buyers would also rather deal with middle-men (or women) during these negotiations. They sometimes will say things to a rep that they would never say to the photographer for fear of hurting the photographer's feelings, because they feel badly about asking for a lower price, or because of some such issue. How do we know these things? Because Jack's reps over the years have come to him with these comments.

Jack once sent a portfolio for a kids' shoot to an art director at a well-known design studio. His portfolio came back . . . and nothing. His rep at the time, the late Elyse Weissberg, called and asked about the viewing. The art director said, "Oh we all loved the book, but we don't have enough budget to hire someone like Jack." Elyse asked what the budget and usages were, then came back to Jack and shared the info. The fee sounded fair to Jack for the usage, not to mention that he'd love to work with the design agency. So he did the

job, the client loved it, and they even licensed it later for additional usage. He ended up with a great pay day. If his rep hadn't followed up and gotten that information, he would have never shot the job.

While it is common (not "standard") for a rep to receive 25% of the fees, there are many variations and twists to any rate and countless reps who use higher or lower commission rates. Are the promotions split 75/25 or 50/50? What makes up the fees? Does it include some of the miscellaneous fees, like casting fees? Casting fees can be very lucrative.

Then there is the question of "house accounts." A house account is an account that you already have before you sign on with a rep. The question becomes, how much commission, if any, does the rep get from your house accounts? Depends on how good a negotiator you are and how much work it is for the rep. Jack believes in being fair with his agents, but that doesn't mean you give it away either. Jack had one house account that he didn't pay any commissions on. The rep didn't do any work on it while Jack did all the negotiating and arranging and job delivery.

He had other accounts on which he would pay a reduced commission: 15 percent rather than 25 percent. If Jack signed with a rep and a new client came in, even because of something he did previously, like work with that art director at another ad agency and that art director was coming in with something new at a new agency, Jack would regard that as a new account, the rep would handle it and it was a regular, full commission. Jack has seen photographers trying to play "cute" with such accounts and if you aren't fair, if you aren't honest, it always leads to blowups, lack of trust between you and your rep, and nothing but heartache. The saying goes, "you can eat well or sleep well." If you stay honest and fair in your dealings, you can sleep soundly and the money will still come in. Now Ed is not particularly interested in "fairness." When his client is the rep he tries to get the highest commission rate the photographer will permit. When his client is the photographer the opposite is true.

Photographer/agent/rep relationships can be just as complex as any type of relationship. For many years, one of Jack's competitors had a wonderful rep who was nice and very

friendly, and then the rep retired. Jack's friend began working with a rep that had a reputation as, well, being a bit of a shark and not such a nice person (unless he was with a client). The second rep brought in a lot of work for the photographer. So, which was the better rep, the nice friendly one or the SOB who brought in more money? There isn't a correct answer to this one; it really depends on the individual photographer's needs. Knowing his photographer friend, Jack would venture a guess that, if given a choice, he would rather still be with his lower-income-producing friendly rep. For some people, it's worth making less money in order to have a drama- and aggravation-free relationship, but others might prefer the money.

Very briefly, here are just some of the key points for all photographers to remember:

1 There are *no* "standard" commissions/fees. The notion of 25 percent or 30 percent is put out there by reps as "standard" so the photographer will think that the fee is not negotiable. It is negotiable because there is no "going rate". Since Ed is privy to the terms of hundreds of these agreements, he can state with certainty, and

he has testified in court as an expert witness, that there is no "standard" nor should there be. Every business relationship is different. Why would lawyers, doctors, car mechanics, or electricians have fees that vary wildly, but photographers are to believe that there is a "standard" for photo reps?

That does not pass the laugh test? Stop and think about it.

2 Perhaps 2 percent of all reps know how to bill properly, are familiar with the law, and engage in solid business practices. That 2 percent is a stretch. *Never* let a rep do your billing. Give the rep the opportunity to do your billing and you are letting the wolf in the hen house. Odds are you will find yourself in a law office after your accountant has explained how you got ripped off. Ed has sued or made claims on over 50 occasions where reps have simply stolen from photographers. Ed obtained a judgment from a court for punitive damages where an agent took $14,000 of the photographer's money and spent it. The judge awarded $100,000 in punitive damages. In another case, the rep simply spent about $28,000 due a photographer when the photographer

elected to terminate their relationship. Ed has had two cases where the reps appropriated in excess of $200,000 that was due to the photographer(s). In one case a rep appropriated funds from several photographers, bought a house in another state and left town. That money will never be recovered. If reps didn't steal from photographers Ed would not own a vacation home.

3 Severance, payment to an agent for jobs that come in from past or listed clients after termination of the rep/photographer relationship, is a common item reps ask for in their contracts with photographers. Photographers should rarely allow a severance clause in their contracts. Severance clauses should be earned, not just given without a track record with a rep where you have maintained an extended and financially successful business relationship. Read more about severance in the "A Collar of Pain" sidebar below.

4 Most photographers hire a rep because they feel that the rep is a better negotiator than they are. The first person the rep out-negotiates is the photographer who typically

signs the "form contract" the rep gives them without so much as a look through by a lawyer.

5 *Beware* of signing away 15, 25, or 30 percent of your gross income to someone who typically need not produce one penny of new business to "earn" their commissions. An agreement should have thresholds or standards the rep needs to reach. Very few photographers require it, because of #4 above.

6 Finally, Ed represents several reps both in NYC and elsewhere. Jack has had very good relations with his agents. However, both could easily go on for pages about how reps can and do screw photographers, illustrators, stylists, and graphic artists. Never, never, ever sign any agreement with a rep unless it has been reviewed by *both* your accountant and a lawyer.

★

A COLLAR OF PAIN

Most photographers, artists, and other creative people are . . . well . . . creative. They depend on their agents and representatives in the commercial, fine art, and other areas to deal with those sticky negotiating and icky money things.

Ed once testified as an expert witness at a hearing between a photographer and their representative (rep). The issue in dispute was the severance provision contained in the written (now terminated) photographer/representative agreement. Severance is money and other considerations an employee receives from an employer, usually when they are laid off or are retiring. In commercial photography, severance is when an agent or rep continues to receive commissions after the photographer/artist severs their relationship. It's sort of like "alimony", but not as nice.

In this case, substantial severance was claimed by the former rep. These issues affect illustrators and other creatives who use or are considering retaining the services of a rep or agent. Severance is a product of negotiation. It is not a right bestowed on reps or agents by the Almighty. Reps will take whatever you give them.

The trier of fact (being the judge/arbitrator/arbitration panel, etc.) incorporated Ed's testimony into the decision saying that, "The severance obligation presented here was most succinctly stated by Edward C. Greenberg, the lawyer called by (Photographer) as his/her expert witness." That testimony appears below. To hear "Ed" and "Succinctly" in the same sentence left Jack just speechless. Quite a feat. Regardless of that fact, Jack still feels that Ed's testimony rocks when it comes to explaining the issues of severance.

Greenberg Testimony (Verbatim):

The other archaic—one of the other archaic assumptions is that the photographer has the ability, on 30-days' notice, to terminate. He can't if he perceives that he's going to be paying two reps. Many photographers don't consult attorneys, they don't consult experts. The perception is that

they are going to have to pay two reps, and they don't bother consulting with an attorney and, therefore, they are restricted in their movement.

The rep sold this concept to the photographer when first they met. The first thing any good rep will do is out negotiate any photographer, especially when the rep is negotiating solely for his/her own benefit. The rep says to the photographer, "Well, you know, it's going to take six, eight, nine months to get going. We're not really going to make too many sales for you or licenses for you in the first six to nine months." But then on the back end, after a rep has failed to produce work, they want credit for the six to nine months where they said, you know, it's going to take 'start up' (so no money is likely to be generated).

Next, there is no other industry, no other industry, where an independent contractor who works on commission would get severance on accounts never procured by them. For example, an independent contractor in the personnel business, a Hollywood agent, there is no industry where there's an independent contractor relationship, and business has never been procured, where severance is paid by mere virtue of a past business relationship, especially an unsuccessful one.

The trier of fact then wrote in the decision:

"Mr. Greenberg also described severance clauses such as the one in the Agreement as a *'collar of pain'* that forces the photographer to stay with the agency or retire or go out of business."

The decision was very favorable to the photographer. The rep obtained only a small portion of the sum sued for and the request for attorney's fees (allowable by their agreement) was denied in its entirety. We will not at this time disclose the facts and identities of the parties. But we both know a good photographer, a very nice person, who was driven out of business because of a severance agreement with a rep.

Severance is a product of negotiation. It is not a right bestowed on reps or agents

By the Almighty. Your rep is likely not your "friend." He/she thus should not be treated as one, but that may be part of your relationship and you might, in another parallel universe, actually be real friends. But you should really look at such a relationship as a business relationship with a business associate, with money being the motivating force behind each of you in this relationship. It might sound cold to some, but this advice comes from many years of Ed having to deal with these love fests after they end. Photographer/rep "divorces" are frequently only slightly less contentious than real divorces.

Think about it. You're starting a relationship with a person whose talent is "negotiating" and getting as much money as possible. Your talent is . . . being a creative person. When you have to sign a contract with a really talented agent/representative, not getting outside professional advice is like a ninety-year-old multi-millionaire with a bad heart not getting a pre-nup before marrying that 24-year-old "party girl." Trust us, the kids will not be happy.

BEWARE THE SHORT-SIGHTED REP

Other than closing the deal and bringing in that big photo shoot, a rep's job is to be the savvy businessperson and watch out for you. If a rep only sees the big commission they get and takes their eye off the ball, you can find yourself in a lot of trouble, as the following, very real and true, story illustrates.

The photographer gets a very big budget job from major agency for a major ad for a major consumer company.

Total budget for the job, over many days, many moving parts, lots of crew, and a lot of post-production work, comes to approximately $1 million USD. Great. Much jubilation by the photographer and the photographer's rep as the photo and usage fee will be $200,000. A great pay

day by any standard and a healthy commission for the rep.

We wish we could report a happy ending, but what happened next is where good business practices can make the difference between ecstasy and agony.

The rep, as a matter of habit, asks for 50 percent advance. No problem until you realize that 50 percent or $500,000 for expenses leaves the photographer $300,000 short to fund the expenses with a $200,000 photo/usage fee. Not a small sum. As Ed likes to ask in this situation, if your child was kidnapped, could you raise $300,000 in a day or two? A loan against your home would take more than a few days.

Now, some expenses can be put off a bit and on credit, and the photographer has some capital, so say the amount is only 2/3, and that's being generous in estimating. It's still $200,000 or so in cold, hard cash.

The big question in all this and the one that causes a panic call to Ed is this: Is the photographer exposed to being sued? Yup, drawn, quartered, and sued.

A purchase order has been issued, a check cut, and even if it wasn't deposited, the agency and the client have already incurred costs: agency personnel, airline tickets, and so on.

Unless the photographer has a trust fund they can get into, or a very high line of credit (a $300,000 line of credit costs 1 percent a year to maintain, or $3,000 before any interest on what you borrow), the photographer is in a real jam. The best solution is to have the rep go hat in hand to the agency and explain that they need another $250, 000 to $300,000 to produce the job. Not easy, not nice, but the adult and correct way to conduct business.

And the photographer should think about a rep who is a little more savvy and not blinded so quickly by a large fee or a high profile job.

Head Fakes and Other Lawyer Tactics

In sports and poker, having information about what the other side is thinking is pure gold. This is like being in the other team's huddle in a football game. So knowing how lawyers approach an infringement issue if they represent the infringing party is incredibly valuable information. With this information, hopefully you wouldn't fall for what we call "head fakes" by those that infringe your work.

Attorneys in New York (and most other states) are required to take continuing education classes to keep their licenses to practice law. Recently Ed took one such class which dealt with copyright issues or more correctly, how best to represent a client accused of copyright infringement. Likely 95 percent of the attorneys taking the class either represent infringers or are trying to snare such cases.

The class was taught by a sophisticated practitioner who provided what Ed will term

Knowing what the other side is thinking in any game of chance gives you an advantageous position.

a "check list" of techniques to beat back the typically valid claims of a photographer, illustrator, graphic designer or artist. He gave the game plan that a defense attorney ought to use and how to educate those relatively few clients who have "innocently" infringed. Have a look:

1 The presenter enumerated the factors and cases which deal with "fair use" making it abundantly clear that the defense is rarely applicable but should be claimed "even if there is a slight chance of success." He pointed out that since the fair use test is not a bright line test, i.e., a 55 mph speed limit, it's always worth asserting so as to scare off creatives especially when the artist has not hired a lawyer, choosing to represent himself.

2 When being confronted with an infringement by your client, send them a letter saying "We have taken it down. Thanks for letting us know. Goodnight." *Never* offer real money to a non-represented claimant. Few photographers hire lawyers. If you do hear from a lawyer then you can start paying real attention to the case.

3 Insist on being provided with a copy of the stamped Copyright Registration and *do nothing* regarding possible settlement until/unless you actually receive a copy because few artists register and even fewer register after the infringement.

4 Your client can always say "public domain" because they saw it on the Internet.

You as an attorney can't unless you have ascertained that the image is truly in the public domain. He informed the group that if the image looks like it was shot in the 1960s or more recently, one should assume that it is not in the public domain. Similarly he advised that just because the image looks old, don't assume it is in the public domain *but* a client unschooled in the law almost always says this to the photographer, keeping the artist at bay until a lawyer comes on the scene.

5 Always claim that since there was no copyright notice, your client who is not a lawyer "had no reason to know anything was wrong" and that "no malice was intended."

6 Run a "risk assessment" formally advising your client that *if* they elect to knowingly run photos without licenses and/or model releases, what the possible legal consequences could be. Most sophisticated clients will run the stuff anyhow, well knowing that running the risk is very worthwhile. The odds of being caught *and* paying a significant fee to a photographer are "remote." This is the most important aspect of such representation—to simply advise your client of the risk of infringement and then they will do whatever

in their judgment makes the most business sense. Often the result is copyright infringement with no penalty ever having to be paid.

This is just a snapshot of the things the lawyers who work for your clients tell them. All of the above is good advice when representing media companies, newspapers, magazines, and consumer companies. You know, the people who steal from you. Now that you know their game plan, hire a good lawyer and get what you're entitled to get. Don't get faked out by a lawyer head fake.

The Math of Infringement

> **"I never did very well in math—I could never seem to persuade the teacher that I hadn't meant my answers literally."**
>
> *Calvin Trillin*

We are often asked (by "we" we mean Ed), "Where can I find the formula the Federal Courts use to determine the amount of statutory damages I can get if my work was registered and I win my case?"

In other words, "How much can I collect?" The answer usually depends on the statutory damages awarded.

Remember that statutory damages are monies that you may receive only if you have registered your work in a timely fashion, i.e., before publication or within three months of publication.

While there is no specific, algebraic, or algorithmic type formula to compute such amounts, the United States Circuit Court of Appeals for the 2nd Circuit in New York provided a list of the factors the federal trial

courts should and generally do, employ in coming up with the amount(s) of such awards. In the case of Louis Psihoyos v. John Wiley & Sons, Inc. the court generated a decision which is quite good for photographers on several levels.

With respect to willful infringements and statutory awards this powerful Appellate Court re-stated some time honored interpretations of copyright law and made some notable rulings.

The Court stated that when a copyright holder proves that the infringement was willful, and statutory damages are available, the Court can, in its discretion award up to $150,000. The jury in this case had found that two willful violations occurred and awarded the photographer $100,000 on one and $30,000 on the other. The defendant appealed those awards claiming in effect, that such amounts had no rational relationship to the financial harm or "actual damages" suffered by the photographer.

The Appeals Court was not impressed with the infringer's arguments and upheld the awards ruling that:

A Revenue lost by the author may be relevant but there need not be any correlation between statutory damages and actual damages.

B In setting the appropriate amount of statutory damages the courts (whether by a judge or jury) ought to consider (at least) the following factors and then use its discretion in arriving at a final amount:

- the infringer's state of mind;
- the expenses saved, and profits earned, by the infringer;
- the revenue lost by the copyright holder;
- the deterrent effect on the infringer and third parties;
- the infringer's cooperation in providing evidence concerning the value of the infringing material; and
- the conduct and attitude of the parties.

The above list is not necessarily exhaustive. If, for example, the infringer could not have turned out the product, item, or image without violating some law that would play a role in the court's decision. So if the infringing product/image incorporated the face of a model or celebrity who would never

have given consent to such use *even if the photographer would have (if paid)*, that factor would play heavily in the Court's arithmetic.

So to create an extreme example of a common scenario:

Sally Photographer photographs Cardinal Timothy Dolan of the Archdiocese of New York. She promptly registers the image on May 2, 2014 the day after she shot the portrait. On June 3, 2014, "Enjoy Condoms and Birth Control Pills" comes out with a line of products called "Father No More" with Sally's photo of Timothy Dolan in his vestments, emblazoned on the product packaging. No consent or license to use the photo was ever sought from either the photographer or clergyman.

Let's assume for the moment that Sally would have agreed to having one of her *other* images used for this purpose for the right price. In no event would she license *this image* as she had no model release from the Cardinal for any commercial use nor would she even dream of asking him for consent to use his image on condoms. The Cardinal, we can all safely assume, would never under any circumstances have granted his permission to use his image for this purpose and that fact would be painfully obvious to the folks at "Enjoy" as well as to the members of any jury.

In such a scenario the fact that the infringer had engaged in activity that would have been impossible without trampling on the legal rights of others would play a considerable role in affecting the amount of any statutory award. These situations typically arise where a photo of a celebrity is stolen from the photographer and used for purposes without even trying to obtain the celebrity's consent because such consent would come at a price the infringer could not hope to pay. Welcome to the world of Internet commerce where such bogus goods are sold daily and crime pays.

Note: there is no precise formula for a judge or jury to use to compute an exact sum of money a prevailing party should receive resulting from personal injuries, libel, slander or a violation of his/her right of publicity and a buffet of other types of lawsuits. The courts have for centuries given judges and juries wide discretion in determining such amounts with the appellate courts there to reign in any runaway judge or jury.

Best Defense Is an Offensive Letter

One quote has been used so much it's now a cultural proverb: "The best defense is a good offense." It's been attributed to boxer Jack Dempsey (no relationship to Jack Reznicki), Vince Lombardi, and a host of bad TV sports commentators. Some say it's derived from Prussian soldier and military strategic theorist Carl von Clausewitz (1780–1831): "If you entrench yourself behind strong fortifications, you compel the enemy seek a solution elsewhere."

We bring this up because we've seen a lot of offensive, defensive lawyer letters to photographers. Photographers find an infringement of their photo and send off a letter to the infringer. What they get back is a scathing letter from either the infringer themselves or from the infringer's lawyer. The letters claim all sorts of things like "no basis" or "public domain," both of which are completely false.

Why do they send such letters even though their assessment of their right to infringe your work is completely wrong? Simple. It works. The result of many of these letters is what the infringer wants, the photographer backs off. As von Clausewitz stated, it makes photographers seek a solution elsewhere, which today means commiserating with fellow photographers on the Internet. To us that means not only did you take the wrong step by taking a step back, but by talking about it online on social media you placed yourself in a deeper hole than need be.

When you get one of these letters from your infringer's lawyers, we will wager that most of the time it will start off with this: "We are glad you have brought this to our attention. We take matters regarding intellectual property very seriously." The line—and it is a line—is employed as a "softener" by the writer. They have stolen someone's work; and as soon as these thieves get caught with their hand in the proverbial cookie jar, they commence morphing into altar boys or girls. If they were in fact concerned with matters of copyright and took them seriously, they would not be on the receiving end of a "gotcha" letter from some lawyer.

Solution? Don't back off. Hold your ground. Hire your own lawyer. So while a good defense for the infringer is a good offense, a good offense for you is simply a good offense and perseverance.

Also, what not to do? Don't panic when you get one of these offensive, defensive letters. And don't try solving this by yourself. A letter sent with a letterhead from "Joe/Jane Photo Studio" or from "Good Feeling Photography" doesn't carry the same weight as a letter from "Smith, Smith, and Jones, Big Ass Lawyers" or simply "Edward C. Greenberg, New York Jewish Lawyer."

Seriously, a letter from a lawyer on their letterhead makes the other side take the situation much more seriously. Usually, but not always. Jack has been privy to such conversations in Ed's office and there is nothing more fun than hearing two lawyers playing "who's got the bigger . . . case." Yeah, let's just say bigger case, but we're sure you get the idea of what we're saying here.

It goes somewhat like this;

Infringe lawyer: Just got this baseless letter.

Photog lawyer: That's not the way we see it.

Infringe lawyer: Just to avoid the hassle and as a sign of our magnanimous good will, we'll give your client a whole hundred dollars, American money.

Photog lawyer: Tell your client, the infringer, that my client suggests that offer would fit nicely in an intimate body cavity.

Infringe lawyer: We think the hundred dollars, American money, is the best you'll see.

Photog lawyer: Well, we'll see in court and what a judge and jury says to that offer.

Infringe lawyer: We'll get back to you.

At this point, the other lawyer usually tries what we call in NY a "come to Moses (or entity of your choice)" moment with their client. Many times, but not always, a real-world counter offer comes in and the sides reach a settlement. But not all the time. You sometimes need to go on to the next step. Settling an infringement claim is sometimes a series of steps and you have to be prepared that it may not be the quickie you feel entitled to have. Remember to keep your eyes on the prize and the twin joys of vindication and compensation. Perseverance, work, patience, endurance will win the day.

Hiring a Lawyer

Part 1

One of the things you can do to save both your behind and your business is to hire professionals who have expertise that you do not. This section will focus on professionals in one particular area of expertise—the law. We have pointed out to several groups of professional photographers, who cry to us that clients and customers are not using real, professional photographers and are instead using amateurs (see Uncle Harry, Cousin Sue) to do what they can do better. Guess what? Lawyers say the same thing about professional photographers: that we, in order to save money, go to non-professionals for the cheapest advice we can find.

There are a lot of sayings in many different countries that all mean basically the same thing, "Sometimes it's very expensive to save a little money," and "Nothing is more expensive than cheap and fast." Buying cheaper or avoiding an expense in the short run can prove costly in the long run.

In these hard economic times, we find that photographers are still scared to do some of the things that would help them avoid costly mistakes. We understand that there's a new reality, but some things, like the fear of lawyers, are still deeply rooted in the same old reality.

A well-known photojournalist who has covered several hot wars is fond of saying, "It's easier to deal with bullets whizzing over my head than it was to talk with a lawyer." These days, with the tight economy there is no financial room for error, and cutting some corners—like not seeing a lawyer when you should—will cost you dearly. Fear not. We're about to tell you what you need to know when looking for a lawyer.

Here are generic answers to the question, "I know I need to hire a lawyer to represent me in what may be, or is likely to be, a lawsuit. I've never been involved in a lawsuit. How do I know who to hire to represent me?"

It's your business, your money and your life, so ask:

1 Does he/she actually practice law and try cases in real courtrooms? Attorneys who write, lecture, negotiate or teach, but do not actually try cases in front of flesh-and-blood judges and juries, are of no use to you when you must go to trial. It's much easier to convince an audience than an opposing attorney, judge or jury. The fact is that many lawyers have to hire an "outside expert trial lawyer" to "better handle your case" when a case isn't settled and has to move on to trial.

What these lawyers are saying is that they don't try cases and need to bring in a lawyer who does because a trial is imminent. Avoid the middleman. Find a real trial lawyer on day one. This isn't just for intellectual property or copyright cases. This also applies to auto accidents or slip-and-fall cases. Attorneys without trial experience are of no use in real-life litigation.

Representing clients and trying cases is a skill set that requires daily use. Check via Google (or equivalents) to see how many cases your prospective lawyer has actually tried and how many of those went to verdict. Again, if he/she is not actively trying cases, then forget about him/her. Attorneys who do not litigate regularly understand neither the local adversary system, its current cast of characters nor the "unwritten rules" of the local road.

Attorneys who do not try cases erroneously believe that what is written in a law book is literally true, and then stick to that belief. That approach can cost you big time. Those who work in the trenches know that "What is written, may not be what is."

2 Is your lawyer utterly familiar with terms of art? No pun intended. If he/she does not demonstrate a familiarity with the terms used in photography, publishing, illustration, art, etc. move on. He/she may still be a great lawyer but likely not for your case.

3 Ask other attorneys for references. The word gets out in the legal community as to who is both knowledgeable and effective. Bad references from other attorneys should disqualify your candidate.

4 Ask the lawyer for the names of long standing client references and permission to talk with them. True, most if not all names given you will be people who view the lawyer favorably *but* you will be surprised as to what

personality traits and problems of the lawyer you can glean from such conversations.

5 Can you co-exist with this lawyer? How would you feel being stuck in an elevator with him/her? This is not a marriage but it is close. You need to tell this lawyer the truth (yes really!) and trust him/her with your fate. If you are not comfortable with him/her for any reason, move on. You need not love him/her but you need to have frequent, productive conversations in very stressful situations.

Don't get taken in by pure demeanor. A seemingly mild mannered, soft-spoken attorney may be just as or more effective than a so-called "pit bull"—or vice versa. Remember this is not a television show.

Jack once had to hire a lawyer who was the opposite of "pit bull" Ed, for a real-estate issue. This lawyer was extremely soft-spoken and calm, but just as thorough and tough as Ed, and extremely meticulous. But he would never strike you that way in person. This quality is a very effective tool for a lawyer, in a manner I like to refer to as "an iron fist in a velvet glove" (as opposed to Ed, who is an

"iron fist in an iron glove"). Both work well; it's just a matter of picking the right glove for the right occasion.

6 Does your candidate speak plain English? There is no legal concept that cannot be explained in plain language using words of three syllables or less. If you do not understand what the attorney is saying to you, what good is he/she?

7 Never hire an attorney based on an ad. Ignore each and every ad you ever see for an attorney. Would you hire a brain surgeon to cut open up your skull based on an ad? If your answer is "yes," then you deserve to hire an attorney based on an ad and furthermore, you will deserve the outcome. Don't forget, advertising is legalized lying.

8 Request a written fee arrangement. Ask questions about any/all of it. If the lawyer is anxious or not responsive, move on. Do not sign any retainer agreement unless you understand it, all of it. If the lawyer does not want you to "take it home to think about it" or show it to your spouse, do not hire him/her. If you are hiring an intellectual property attorney, show the fee letter to your

"regular" business attorney and obtain the benefit of his/her scrutiny.

9 If all else fails, and you can't find anybody, phone your local or closest law school. Ask for a professor who teaches copyright or intellectual property law. Get a referral from him/her. These folks generally know who knows how to try a case in your legal and geographic area. If they don't know, they can get you references real quick. In Ed's opinion this is a much, much better technique than calling the local Bar Association (or equivalent). On occasion— and do not rely on this— if your case is interesting, the professor may provide your private attorney with some (unpaid) assistance rendered by students. If you have seen the movie *Reversal of Fortune*, you know that Prof. Dershowitz, like thousands of other professors, used his students with great results for Mr. von Bulow.

10 Any attorney who assures or guarantees you a result should be ignored. No reputable attorney can or will do such a thing. Ask him/her to clarify the comment. If he/she is dumb enough to say it again, get up and leave. Before the other side has even been heard

from, some attorneys will frequently guess at what your case is worth in an effort to seduce you into retaining that lawyer. Such guesses are almost always useless and, if given with some eagerness, beware the source.

Remember, attorneys who do not try cases for other creatives should not be entrusted with yours.

Hiring A Lawyer

Part 2—The Other Side

While you are interviewing your potential legal representative and assessing his/her relative strengths and weaknesses, the odds are good that your new legal friend is sizing you up as well. Sure, there are plenty of lawyers (especially in this economy) who will take almost any case. They will do so regardless of the client if the lawyer thinks or knows there is a fee to be made. Experienced, reputable attorneys, however, assess each potential client using their own set of criteria. Just as a potential client routinely decides not to hire the first attorney they meet, attorneys

(yours truly included) frequently decline to represent a given client even if a preliminary review gives the attorney the impression that the potential case has merit.

If you are aware of the things that attorneys look at before your initial consultation, you can increase the chances of entering into a "happy marriage." If you know what your client is looking for going into a negotiation, you have an obvious advantage in negotiating terms. The attorney/client relationship is a far more intimate relationship and requires true team play to be successful. Knowing what the other guy on your team is thinking, as in any team sport, is key.

Here are some of those traits and behaviors that attorneys like and look for. For simplicity's sake, we will call you, the potential client, the "client":

1 *How does the client answer questions?* Does the client answer the questions being asked in a clear responsive way? Some clients want to vent or act as if the attorney is a shrink, there for the sole purpose of listening to the client's well founded (or bogus) complaints. Distilled to its essence, litigation

is all about questions and answers. How well these questions are constructed and posed, and the quality of the answers, often determines the winners and losers. Sometimes, the law in a given situation is not clear enough so as to dispense with the need for a hearing or trial.

Evasive answers, ignoring the question posed, providing partial or misleading answers by "selecting" what information the lawyer "needs to know" are all signs of evasion. Performing in such a manner during a deposition or trial (especially in front of a jury) can usually guarantee defeat. Failure to respond directly and clearly to the information that the lawyer deems important is enough for many attorneys to refuse to accept the client, even if the client wants to retain the attorney. Such behavior portends future problems in the attorney/client relationship. It is not unlike having a business partner with whom you are unable to have routine, simple two-way conversations.

2 *Does the client listen and/or does he/she put words in my mouth?* Lawyers suffer this idiosyncrasy but doctors have it much worse. The tip off is usually when following the

lawyer saying something like, "Under the law you are liable, on the hook and responsible to pay the other guy . . . " The client retorts, "So you are saying that he can't sue me and I am in good shape right?" Sounds funny here but in real life it's anything but. When it happens to us we always ask the client, "Where did you get that from? I just said the exact opposite so I need to know how you think." Doctors have relayed their own medical versions of this interaction. Here's a real one:

Doctor to patient: If you do not lose at least 50 pounds we cannot operate and you will without doubt die within a year, give or take a month if you stay at this weight.

Patient: So as long as I don't gain any weight, you're saying I can live for years. Great.

Re-read that exchange. We try to be as direct and blunt as possible. A client who re-phrases and re-interprets generally starts off with the famous, "So what you're really saying is . . . "

We cite the definitive source on the subject— *The Odd Couple* (movie/play versions)

Felix: So in other words Oscar, what you are saying is that . . .

Oscar: No, Felix. Not in other words, those *are* the words.

Sometimes even lawyers say exactly what they mean in the words they intended to use. If the client does not listen at the consultation odds are he/she won't listen later on and will "go off the reservation." Like a patient not listening to the doctor, the prognosis is generally not good.

3 *Ability to financially sustain the case?* Often the size of the initial retainer does not, nor is even intended to cover all of the legal fees and expenses which might/will be incurred if the case goes to and through trial. Does the client have sufficient means and/or income to pay any future bills in a timely fashion? If you have borrowed the amount of the retainer from a friend, how will you pay for additional legal fees and/or expenses, which will be incurred in the future? If you can't answer that question, don't expect your attorney to answer it for you. Your lawyer will not finance all aspects of your case *unless* you have a written, signed retainer agreement which specifically provides that your attorneys will pay for expenses, pending a monetary recovery via settlement or winning

verdict. Do not expect this arrangement in other than personal injury or malpractice cases.

4 *Is the client credible and likable?* Sorry to be the one to inform you that judges and juries are heavily influenced by both credibility and likability. For instance, if the jury thinks that a witness has lied about even something relatively insignificant, the jury may reject other or all testimony given by that witness. Judges instruct jurors of that option before they go off to deliberate. Juries and even judges tend to make greater monetary awards to litigants found to be likable. No comments please about how unfair this sounds—it's real life and all of us are guilty in one form or another of such behavior. We go to stores where they smile and reward those vendors who seem to care about us. Walt Disney and Sam Walton had a firm grasp of this obvious fact. If you come across as a bitter creep to your lawyer, such attitude will likely not serve either of you well in the litigation game.

5 *How does the client "present"?* While hardly a fashion show, judges and juries require and/or expect a certain minimum level of appropriate overall appearance by litigants, attorneys, and witnesses. If you look like you came to the lawyer's office directly from changing your transmission oil and smell that way to boot, your attorney is apt to think that you care little or not at all about how you are perceived by others. If you don't in fact care, swell. Just do not expect an attorney to bust his/her gut for someone who does not appear to care about the opinions of others. Remember judges, attorneys, and jurors all come under the category of "others." My favorite line is the gentleman who insisted that he "will not be judged by (me) or anyone else"! I asked him if he ever heard of the word "trial" and if he happened to know what judges and juries do at such events.

6 *Does/will the client read?* A large percentage of creative people suffer from dyslexia. Many others have an aversion to reading. They are able to read but simply choose not to. Lawyers send letters and documents to clients for them to review, approve, sign, critique, amend and so on. If the client does not choose to be involved in his/her own case by say, not reading, success is not likely to be achieved.

7 *Will the client work on his/her own case?*
We have had some clients who were
outstanding in their preparation of
documents, photographs, time lines and
making themselves accessible by phone or
email. Some clients want, assume, and expect
that the lawyer will "do all the work because
that's what I'm paying you for." On rare,
very rare, occasions the client's participation
in his/her own case is of minimal importance
and the lawyer can do most if not almost
all of the work. Ninety-nine percent of the
time, however, the client's involvement is
critical. If the lawyer believes the client
sitting before him/her is lazy or "can't be
bothered," the barrister is likely to shy away
from the case.

8 *Prior legal history.* How does the client
view the system, lawyers, judges, juries and
witnesses? Has the client sued, fired or been
dissatisfied by a roster of attorneys? Would a
prior attorney be thrilled by the fact that
he/she is the client's former lawyer? Does the
client by virtue of prior lawsuits consider
themselves an "expert" or virtual lawyer?
This is very similar to an ad agency, art
director or client with a reputation for being

difficult, impossible or a non-payer. Attorneys
don't want to buy themselves aggravation.
We get enough grief during the regular course
of business from sources outside of our
control thank you.

9 *The elevator test.* How would the attorney
feel if he/she were to be stuck in an elevator
with this client for, say, two hours? You need
not feel like a life-long friendship would be
born but if the mere thought troubles the
lawyer he/she would be wise to note such
feeling. There will be times when attorney
and client will be stuck together for hours on
end at trial preparation, depositions or even
trial. You ought to use the same test from
your side of the table.

The above is just a sampling of factors
many attorneys consider at an initial
consultation. Ask any experienced attorney
and we guarantee he/she can serve up a
dozen more. The attorney/client relationship
is both a two way street and partnership of
sorts. The economics and relationship work
both ways.

What Photographers and Artists Need to Know About Bankruptcy

The two of us have played in a "friendly" weekly poker game in New York for the last 30 years. We're talking first scene in Neil Simon's *Odd Couple* movie type of poker game. Characters galore. With everyone playing against each other for so long, like married couples, everyone knows what pushes whose buttons. It's as much about the junk food and the sports talk as the cards. Rest assured that ESPN won't be covering any of our games.

Poker, as we all know, is a game where bluffing your opponents is key. Often, when a photographer thinks or is told that a client is about to file for bankruptcy protection, they believe they are out of luck, their invoice is in the toilet, and their photos are gone. Often such a threat is simply a bluff. Let us explain

to you what bankruptcy means to you as a photographer. We think this information will be like pulling the last card to an inside royal straight flush. For those that are not poker players, that's a really, really good thing.

Particularly in this economy, a threat of "going bankrupt" abruptly changes the tone of any business discussion. Most people on the receiving end of such a threat will swear that their heart literally stopped beating, especially if you are owed a big wad of cash. It is right up there with "we're gonna sue you"

on the nerve wracking scale. It need not be so. A basic understanding of what a bankruptcy filing really means and specifically its effect on you as a photographer is essential.

Don't get nervous as the basics are well, fairly basic. No diploma required understanding them. These days the odds that a photographer is already involved in or has been threatened with a bankruptcy filing by one or more clients are big and getting bigger. Those of you interested in getting paid and retaining your intellectual property rights, read on. Stay with us. For your protection here's the skinny on bankruptcy.

You can "go to Chicago" or "declare love for the Cubs," but you can't simply "go bankrupt" or "declare bankruptcy." Neither statement is accurate. A person or business can exercise a Constitutional right to ask for protection under the Federal Bankruptcy laws in a Federal Bankruptcy Court. There are no state or local courts that are empowered to deal with bankruptcy cases because the United States Constitution says so.

The Constitution gives an individual, company or organization the right to seek protection from certain of its debts, obligations and responsibilities from the Court. You've got to ask the court, you can't simply "declare it" any more than you can become President of the United States by

merely "declaring" that you are. It is up to the Bankruptcy Court Judge to ultimately decide whether the applicant (filer) is deserving of being relieved from certain debts and obligations or be protected from some or all of them, and to what degree. The final, official decision that the persons or company seeking that relief has received it is known as being "adjudicated a bankrupt."

In order to ultimately receive that protection from the Court, the applicant must prove certain things and demonstrate its worthiness of receiving such relief. The analogy of seeking absolution from one's priest has been employed and is not terribly off the mark.

Simply put, among many other things, the applicant must demonstrate that it can no longer pay its bills on an ongoing basis, is "without sin" by making improper payments to some creditors and not others, and that it has acted in a legal and appropriate fashion. Any property owned by a third party (like your photography) that it happens to be in possession of at the time of filing does not automatically become an asset of the applicant.

Bankruptcy judges are very powerful. They can tear up, amend, or extend existing contracts. You may even be directed to return monies already paid to you by the company that has commenced a bankruptcy proceeding. It is often said by lawyers that bankruptcy judges are more powerful than U.S. Supreme Court Judges and that statement is substantially correct.

Some bankruptcy proceedings presuppose and are designed so that the applicant will survive, re-organize, and re-emerge to live on in some form after the proceedings are over (like General Motors did). Still other filings, frequently termed "straight" bankruptcy, sound especially scary as they assume that the company will stop doing business "forever." For the moment we implore you to ignore that distinction, as it may have little to no effect on whether you get paid or retain your rights. It is at the point of filing with the Bankruptcy Court that almost all photographers (and many unsophisticated lawyers) falsely assume that they will "get pennies on the dollar" or nothing, zilch, nada, goose eggs, donut holes. Fear not, as it ain't necessarily so.

If GM can file for bankruptcy protection, what makes you think that any of your clients could not do likewise? So, how do you protect yourself from being blindsided? Great question! Simple answer—good paperwork. Words matter even to the all-powerful Bankruptcy court. Concept Uno is that the Copyright Act and The Bankruptcy Act are both Federal Laws, rooted in the United States Constitution and are co-equal. One does not outweigh the other. That's an important point that even many lawyers miss. The lack of that knowledge can cost you big bucks or, even worse, cost you control over and/or physical possession of your images. If you preserve and properly protect your copyright via your paperwork, a bankruptcy court will likely be very limited in what it can do with them, nor (quite often) can it permit others to use your images without your consent and (drum roll here) paying you.

If you receive any document from a Bankruptcy Court or attorney referencing a bankruptcy of one of your clients, do not attempt to respond via telephone, email, or letter without the assistance and consultation of an attorney familiar with bankruptcy law. Such a lawyer need not be a bankruptcy

"specialist" but he/she must have some familiarity and experience with bankruptcy proceedings. So if you receive such a writing we leave you with these words of wisdom: A. Don't panic and B. Call a competent attorney right away.

People with little to no training in bankruptcy law, other than having been burned by a deadbeat, offer their "expertise" on the subject via the net and otherwise. Believe it or not, the Bankruptcy Law and the Bankruptcy Court can be a copyright holder's biggest friend. Here's an actual case tried in a real courtroom by people on all sides who actually knew what they were doing—including the judge.

Now some of this may make your hair hurt as you read it, but stick with it as we think you'll find it's quite educational and, since it's a win for the good guys, has a happy ending.

As you know, the Copyright Act gives the owner of a copyright (with certain exceptions) the exclusive right to exploit the copyrighted work. The issue presented was whether a former client, Patient Education Media (PEMI), could transfer the non-exclusive license granted to it by the photographer

David Katzenstein to use his copyrighted work. Mr. Katzenstein objected to this transfer of copyright. After a trial, Judge Stuart Bernstein of the Bankruptcy Court in Manhattan found that it could not.

A little background first:

PEMI filed for protection under the Bankruptcy Act. PEMI created and sold educational products including videos under the trademark "TIME-LIFE MEDICAL." C. Everett Koop, M.D., former Surgeon General of the United States, starred in PEMI's videos distributed nationwide in countless stores. Each video addressed a particular illness or condition, i.e., diabetes, back pain, and so on.

Years before, PEMI hired David Katzenstein to take photographs for use in the production of the videotapes. Katzenstein's photos were eventually incorporated into the title, "bumpers," and as part of the set design seen on the videotape. It was undisputed that Katzenstein, through his paperwork, granted PEMI a written, non-exclusive license, unlimited as to time, to use the photographs for the purposes set forth on the invoice only

and that PEMI still held that non-exclusive license if it (and only it) wished to produce more videos.

David's invoices clearly stated the non-exclusive license and also contained specific printed conditions on the reverse side. One condition stated that, "Client may not assign or transfer the rights granted herein." PEMI claimed that it never consented to and was not bound by this condition, especially since the all-powerful Bankruptcy Law and Court can pretty much do as it pleases to maximize the assets of one seeking protection. Retention of his copyright was clearly stated on all of David's paperwork.

PEMI was given an option to extend the expired license by paying $20,000 at the end of the year, and would, by so doing, acquire unlimited worldwide use, in perpetuity. PEMI offered the $20,000 but David refused the money because PEMI had agreed to sell all of its assets and assign all of its contracts to another pharmaceutical company, Glaxo. David did not want (for many reasons) to have his images employed for the benefit of or by Glaxo. PEMI's assets included the master

tapes for the 34 videos which incorporated Mr. Katzenstein's photographs. So Ed, as Mr. Katzenstein's lawyer, objected to Glaxo's acquiring the right to acquire or use the photos on several grounds.

First, Ed maintained that PEMI could not assign or sell its rights to use his photographs without David's consent, under both federal copyright law and the anti-assignment clause of his invoice. Second, Ed contended that PEMI could no longer use the option to extend usage and, even if it could, PEMI could still not assign or sell any extended, non-exclusive license to any third party without David's consent without his copyrights being violated.

Glaxo was simply trying to obtain the right and ability to reproduce and sell new videotapes using David's photos but without his permission. The wise judge ruled in Mr Katzenstein's favor. It is a textbook example of how the inclusion of a few sentences in your paperwork can protect your copyright, keep your images, go almost to the top of the creditor's list and get paid or even get paid more than you might be owed even though your client is "bankrupt."

A "transfer of copyright ownership" includes the grant of an exclusive license, but not so with a non-exclusive license. So if you have given your client an "exclusive" and your paperwork is sloppy, you lose the right to sue for infringement during that "exclusive period." By contrast, a non-exclusive license does not transfer any rights of ownership. Ownership remains in the creator/copyright holder. A client who receives a non-exclusive license cannot sue for copyright infringement of "your" photo but you can. A client with a non-exclusive license cannot assign any rights to it to a third party without the consent of the copyright owner if you put that in your paperwork, and you should.

Bankruptcy law does not change copyright law. The bankruptcy court's goal of maximizing the estate and the ability to change, extend, or even "tear up" otherwise perfectly legal contracts may be stopped dead in its tracks by a copyright registration. Ed successfully argued that Federal Copyright law prevented the Bankruptcy Court or Bankruptcy Law from changing David's rights as the copyright holder. Judge Bernstein held that Mr. Katzenstein had copyright protection and terms in his contract preventing the use by others of his images without his consent.

Generally, state laws, such as those covering contracts, fall to federal ones. The court found that federal policy designed to protect the limited monopoly of copyright owners and restrict unauthorized use, while being a "non-bankruptcy law", was the law that applied. This prevents a bankruptcy court from assigning a non-exclusive license to a third party without the copyright holder's consent, especially as David's invoice stated, among other things, that it was non-transferable. While the fundamental policy of the federal patent system is to encourage the creation and disclosure of new advances in technology, the court stated that federal law should govern the assignability of non-exclusive patent licenses because if such weren't the case, every licensee would become a potential competitor with the licensor/creator in the market.

Thus, any license a patent owner granted would be subject to the danger that the licensee (client) would then assign it to the patent owner's most serious competitor, who would never get that license directly from the creator in a zillion years.

The Court used the same reasoning with regard to copyrights and copyright holders. It ruled that the same conclusion applies with equal force in the similar arena of copyright law. Although the assignment of the Katzenstein license would have made more money available to creditors, that goal gave way to the considerations expressed in the Federal Copyright Law, which is no more (or less) important than the Bankruptcy Law. PEMI could not assign or sell its non-exclusive Katzenstein license to Glaxo without Katzenstein's consent on terms acceptable to Katzenstein—if any. The use of the photos as the backdrop for the set used by Dr. Koop in about 40 percent of the footage rendered the videos utterly without value unless David's approval was obtained. Great bargaining position, dontcha think?

Now take a deep breath. You deserve it. "What does this mean to me?" you ask. It means that the simple insertion of a no assignment clause, careful wording of any exclusive licenses, and vigilant protection of your rights can mean that your work will not be used without you getting paid. Additionally (and it's a biggie) since Bankruptcy Law does not trump Copyright Law, if a company in bankruptcy infringes on your copyright, you can sue it in Federal Court and the Bankruptcy Court is virtually powerless to stop you.

If you then prove infringement at trial, the judgment you obtain is likely fully enforceable and it is very, very unlikely that the Bankruptcy Court can give the "debtor" a pass. A finding of intentional, willful, or statutory copyright infringement cannot be disregarded by a Bankruptcy judge. And, oh yeah, one more thing—you now go with judgment in hand to near the top of the list of creditors and typically just behind the government on the payment line. If the bankrupt is to continue in business under Bankruptcy Chapter XI rules the odds are great that you will get paid. If the business is being taken off life support by the bankruptcy court you still can get paid and your odds are infinitely better than just about any creditor other than the tax guys.

So use the proper invoice and estimate forms.

★

The Myth of Arbitration

It is a commonly held myth that arbitration as a method of dispute resolution is faster and cheaper than litigation. Entertainment companies, publishers, and ad agencies who financially benefit by screwing photographers and illustrators frequently insert an arbitration clause in their agreements, requiring that any disputes (often including claims of copyright infringement) be arbitrated via a private arbitration service rather than litigated in our courts. Photographers who cling to the notion that arbitration is cheaper and better often sign such agreements requiring arbitration without consultation with a lawyer or having a second thought.

Little do they know that arbitrating disputes is a far more expensive proposition for a photographer or illustrator than filing a legal action. The costs are frequently prohibitive and prevent the creator from ever seeking redress via the arbitration process.

Here's why:

Say a photographer files a copyright infringement suit in the Federal Court in New York. The court's filing fee is $350. Regardless of the complexity of the case or whether the case is settled early on or ends after a trial lasting one month, the photographer's court fees will likely total $350.

Judges do not get paid for their time in deciding motions, reading papers, or presiding over trials. Court fees are essentially a one time, flat, affordable fee.

Arbitrators, on the other hand, get paid for all of the time they spend on a case. Fees generally range from $2,000 – $4,000+ per day, per arbitrator. There are additional fees that are payable to the various private services such as the American Arbitration Association or JAMS who run these hearings and provide

the venues. The arbitrators get paid to read papers, decide motions, and to hear a case if there is ever a hearing. Some agreements provide for more than one arbitrator. While amounts vary, it is not at all unusual for a party to incur $20,000 – $40,000 in arbitration costs before any hearing on the merits ever commences.

These fees are, of course, in addition to sums paid to attorneys. Even if an agreement provides for the recovery of all or a portion of such fees by the prevailing party, one still needs the resources to lay out tens of thousands of dollars, which would not be required if the matter were in the courts.

The amount of time spent by lawyers on similar type cases, whether arbitrated or litigated, is virtually the same. It is worth repeating—legal fees in controversies whether litigated in the court or arbitrated are utterly comparable. No legal time is saved via arbitration. Clients of creators are nearly always better capitalized than individual creators. They can lay out the money win, lose, or draw. Can you? Can you afford to lay out, say, $25,000 in arbitration costs, plus attorneys' fees, betting that you will ultimately

be successful on your claim? That same case would be $24,650 cheaper in a Federal Court.

A few additional surprising items about arbitration:

1 Typically an arbitrator's decision is not appealable absent extreme circumstances, i.e., proof that the arbitrator accepted a bribe. So a wrong decision will remain a wrong decision.

2 An arbitrator need not base his/her decision on the applicable law(s). Yes, you did read that statement correctly— misinterpreting the law or not applying it in making a decision are rarely, very rarely grounds to toss out an arbitrator's decision by going to Court.

3 Entertainment and media companies put arbitration clauses in contracts to deter creators from bringing claims but when claims are brought, the arbitration service is getting paid thanks to the inclusion of the clause by the media company/publisher. The media company/publisher is thus a customer of the arbitration service. The bigger the company the greater the number of disputes, the more disputes, the more fees paid to the

private arbitration service. Some of us lawyers may be cynical but we think that tips the scales in favor of the big companies and against the little guy who is virtually always a solo creator with limited financial resources.

4 You lose your right to a jury. Juries are the great equalizer—they tend to side with the "little guy," the David not the Goliath. You have a constitutional right to both your copyright and to have a trial by a jury. Why would you possibly give up your constitutional rights before you even know what the nature of your dispute would be? You might have a lousy judge but a great jury. If you have a lousy arbitrator you are completely out of luck. Arbitration as a concept strikes just the right warm, fuzzy, non-confrontational tone that appeals to the sensibilities of creatives. Perception is not reality.

5 Isn't arbitration a lot faster than going to court? Sometimes this is true . . . sometimes. Remember a speedy decision is not necessarily in your interest nor does it mean you save any money in attorneys' fees while you will almost always pay an arbitrator. Again, judges and magistrates try to settle cases with much more fervor than arbitrators. Settlement is the fastest method of dispute resolution. Most Federal Courts have non-binding mediation. It's free and often results in settlements.

6 They can shorten the time to bring an action against someone? Really? You don't have forever to bring an infringement suit. While the time within which to bring an action is (essentially) three years, you can by contract shorten the period to say 90 days (or some other time period less than three years). If you agree by contract to shorten the period, the Courts will generally uphold your agreement to bring a suit within that shortened period. Result: you are far more likely to be time-barred from bringing a claim typically because you, as the creator, didn't discover it (for whatever reason) within that shortened period, hired a lawyer and filed a claim. Advantage—stock agencies, publishers and clients.

★

IN THE JUDGE'S OFFICE

Often a federal judge will hold an initial conference where the facts, laws and defenses relative to a recently filed copyright infringement case are informally discussed. The judge has invariably read the papers filed by all sides and has a good, or even excellent, grasp of the essential claims.

At most such meetings it is clear that the image was used by the defendant(s) without the consent or authorization of the creator. As a result, the sitting judge will typically turn to the defendant's attorney and ask, "OK, what is your client's defense(s)?" Having attended countless such conferences, below is a list of actual responses from lawyers who in each case were representing substantial corporate infringers. None of these fairly typical defenses passed the judicial "laugh test."

1 *Defense Lawyer*: Well judge we just don't think that the case is worth what the photographer wants to settle it.

Judge: Last time I looked that was not a legal defense to copyright infringement under any law that I have ever seen. Then again, maybe I am wrong about that—am I counselor?

2 *Defense Lawyer*: The picture was placed on our site by a third-party contributor over whom we have no control.

Judge: So if a third party contributor sent you a photo of two children having intercourse you would have had no choice but to publish that picture too?

3 *Defense Lawyer*: We received no benefit from publishing the story in our newspaper.

Judge: What is your client in business for if not to disseminate news, sports, and information so it can sell ads? I am old fashioned and read newspapers made out of paper. I see lots of ads for travel and new cars. Does your client receive a benefit from including those ads— because if it doesn't please ask it to stop.

4 *Defense Lawyer*: We did not make any money by publishing this (news) photo.

Judge: Mr. Greenberg says other publications pay a license fee to use this photo but your client didn't. Seems to me they saved money and therefore, according to Ben Franklin, they earned money.

5 *Defense Lawyer*: The plaintiff is a fine art photographer (only) who sells his/her work for thousands of dollars.
We ran the photo in a magazine which costs $4.95. So the plaintiff can't prove that he/she lost a single sale.

Judge: Let's say I was one of the ten people who I see had purchased this photograph in the last 12 months each paying $15,000. My husband would be very unhappy to discover that picture being used to advertise a $15 boat ride for tourists. Perhaps you can come home with me and explain to him why I spent the $15,000.

CONVERSATION IN A LAWYER'S OFFICE

A while ago, a photo editor from a respected newspaper/web site wrote to Ed stating that Ed's client's registered, iconic news image "Was so famous that it has become part of the public domain and as such the (paper) has a fair use right to use it." Direct quote.

Ed wrote him back suggesting that he consult with his legal counsel and cited that the photographer had licensed the image dozens upon dozens of times for significant bucks and successfully sued those who didn't get permission or pay.

Further, Ed told him, his attorney could Google some of the cases. So the photo editor says, "Let me get this straight— you want me to believe that this (photographer) actually sues when his news image is used without someone calling him first to ask permission? What world is he living in?"

Ed finally heard from the paper's lawyer. He's normal, knows the law. He says, "You need to understand that (photo editor) doesn't get many of these types of complaints."

WARNING: SETTLEMENT TERMS

There was a hoax story floating through the Internet (what a shock) titled "Lawsuit Paid in Full: Samsung pays Apple $1 billion sending 30 trucks full of 5 cent coins." The title summarizes the entire story. Very cute, but completely false.

If you stop to think about it, that would be 20 billion nickels to pay off $1 billion. The U.S. mint produces less than a billion nickels a year. Samsung would be looking for nickels in kid's piggy banks to find that many nickels, and still probably run short. Not to mention that 30 trucks would not be anywhere near enough to transport 20 billion nickels, which would weigh approximately 110,000 tons.

It does bring up and point to an important issue of watching details in a legal settlement. Any competent lawyer should have wording in any settlement agreement specifying that payment can only be made by "certified check, bank check, attorney check, or USPS money order." Otherwise, legal tender is legal tender, meaning pennies, nickels, and dimes, and you could be spending a lot of your time rolling coins into little paper tubes.

The Wedding Bell Rules

> "We, the unwilling, led by the unknowing, are doing the impossible for the ungrateful. We have done so much, for so long, with so little, we are now qualified to do anything with nothing."
>
> *Konstantin Josef Jireček*

Wanna shoot a wedding? Hey, that's easy money? "Piece a' cake" assignment, right? You just circulate the room, take the usual photos of aunts, uncles, and drunken friends. You click the shutter a few hundred times, grab some free food when no one is looking, and collect a big check. Yeah, right! Dream sequence now over, let's cut to real life.

Being a wedding photographer allows you to be your own boss. While that role gives you the responsibility of being in charge, along with that title comes the obligation to know a lot about just about every facet of the business. The preparation to create thoughtfully composed images also requires the preparing and creating of equally well-composed paperwork.

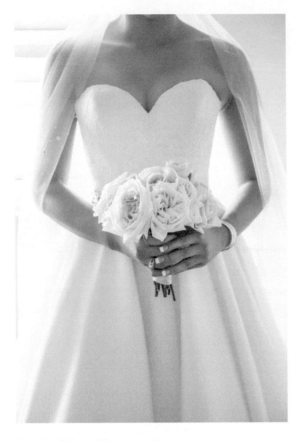

© Mike Sidney Photography

Occasionally a photographer comes in clutching a lawyer's letter explaining why payment will not be forthcoming, and oh, yes, "We are suing you to boot." We can tell you that the only type of photography that comes close to being as terror filled as wedding photography is doing photojournalism in a war zone. Some wedding photographers will actually debate which task is more stressful.

While photojournalists and wedding photographers both depend on their wits and social interaction skills, at least a photojournalist can wear a helmet and flack jacket. A wedding photographer can't take any comfort or protection in wearing a tux or a dress. While not nearly as expensive as body armor, good paperwork offers a wedding photographer all the protection that's needed.

Jack has heard many a tale of woe while serving on an ethics committee arbitrating dozens of cases where photographers and customers did not exactly see eye to eye. Ed has had his share of photographers who have shot countless celebrity, high society, or politicians' weddings over the years.

Simple, effective forms, like the template we show below, serve as offensive and defensive protection for photographers shooting any assignment, particularly social events like weddings, Bar and Bat Mitzvahs, Quinceañeras, and various other parties. While our template is a wedding job contract, note that it is easily adaptable to any business-to-consumer type of job.

When Not to Sue

Perhaps no area of the business is more geographically and demographically diverse than wedding photography. It is critically important that you have a sense of what your community and customers expect from a wedding photographer. Those expectations vary widely not only by price but by many other factors including, but by no means limited to, geography, economic class, and the cultural background of the celebrants. Your personal relationships and business reputation in a community deserve your considered attention. The responsibility to know your market and your competition rests with you alone, so do your homework—relying solely on assumptions can force you out of this competitive field in a heartbeat.

Circumstances may require you to be nimble and deviate from the clear terms of your signed legal contract. If a week before the ceremony the bride is seriously injured by a drunk driver speeding down Main Street, it would likely not be beneficial to your business or reputation to insist upon strict enforcement of your contract. On the other hand, there is no need to suffer financially just because the groom went off to Tahiti with the Maid of Honor before the rehearsal dinner.

You need to arm yourself with a good contract with the bride and groom, or whoever it is who will be writing the check. That contract can and should include a release. It doesn't have to be the usual anything and everything release. If all you want is use of the images for your promotional use, you don't need intergalactic rights. That will scare your clients and frankly, you'd be crazy to plan on commercially licensing your wedding or Bar Mitzvah work, so why look for trouble? One well-known photographer did license such work with a frame company and regretted doing so. It's easy to have modified releases built into your contracts that permit limited uses of your photographs.

Your contract is your first line of offense in the event you need to collect your money. And it's your best line of defense when your client doesn't want to pay you. Those two

postures are not the same. For some weird "reason" unknown to us, some photographers feel that a contract should either be a bit vague in order to protect themselves (it doesn't) or not be so "lawyered up" that any sane person would think more than twice about signing it. Both of these approaches are seriously flawed. A simple, well-drafted, understandable agreement is always better and cheaper in the long run than shooting based on a nebulous or verbal agreement. That includes having a contract with friends and family.

In the case of high profile celebrity weddings, the clients may insist that no images of any of the guests be distributed to any media or displayed anywhere . . . no matter what. There may be an allocation in the contract for use of one "approved" photo, chosen by the client, for the photographer's website or other limited publicity.

Doing wedding photography without a written, signed contract is like being in a Warner Brothers cartoon in a coyote costume holding a stick of dynamite and looking for a match. Nothing good will happen and there will be no laughs in it for you.

THE MOB

<u>Warning</u>: Remember that nobody but nobody negotiates with more skill than the mother of the bride (MOB). The U.S. State Department would do well by hiring some "All American moms" to give instructions on how to negotiate with our enemies abroad. Do not assume that a "stay at home mom" has no business savvy and will agree to just anything because her baby is getting married. The more likely scenario is that, if you are not careful, when she leaves the room your undergarments will have gone missing.

The Wedding Contract Fundamentals

So where do you get a contract? There are a lot of contracts available online and from various trade associations. Some are awful while others represent a good outline, but using any of them without being tailored and modified to your state's laws by a local lawyer is an invitation to a disaster. A major problem with any generic contract is that local laws are not generic. Each state in the United States, and even within some counties or cities within a given state, has its own laws with respect to the form, style, requirements, and contents of contracts. While copyright law is federal and, thus, does not differ substantially from state to state, contract and privacy laws vary widely. Local consumer protection laws also vary greatly. Some state laws treat wedding photography as a consumer matter worthy of special laws while others do not. Just as wedding dress sizes greatly vary, so do local laws.

We have provided a generic template for a contract below. We require you to customize it to address your needs and the laws where you do business. Remember to make sure that whatever paperwork you use includes at *least*, the following absolutely essential terms, clearly set forth in plain English.

1 What is the date, time period, and location(s) where you and/or your staff needs to be physically present? Is the wedding at a church at noon with the reception cross-town at a catering hall at 8 p.m.? Whatever it is, put it in the agreement.

2 What is expected of you as photographer? For example, the number of shooters who are being hired. Is there a list of "mandatory shots"? A shot list is vital. For example, it should spell out that you will take photos of the guests at each table, shots of Uncle Joe with great grandpa, the bride and groom walking up the steps of the church alone and then coming down those same steps as a couple. The more particular and specific the shot list, the better. This will eliminate claims that you failed to get that all important shot of Aunt Sally with Uncle Al (who left her for a Vegas showgirl back in '92). Often clients will claim fairly or unfairly that you missed a key shot(s), so they don't need to pay you "the

whole fee." Use the list during the festivities and check off each requested image after you have shot it. Ring being placed on bride . . . check, father of groom presented with bill and faints . . . check.

3 You are designated as the "official" photographer and that no other person can represent that they were hired to shoot the job. Credit is also important. It's very important in making or keeping a reputation as the premier shooter in a particular geographic area or venue or for particular types of events. If you want to be the "go to" shooter for the local landmark waterfall or any prestigious venue, then you want your name on the images in the local newspaper. If you want the top catering hall to recommend you to prospective customers or to even become that venue's "official" or "preferred shooter," then you want your name on as many images shot there as possible. Its just basic PR.

4 That you will not be responsible for any obscene gestures or embarrassing moments in the images. Unless instructed in writing to the contrary, you are permitted to photograph anyone attending.

5 Images shot by you may be used in self-promotional advertising for your business.

6 A clause prohibiting the use of any image shot by you to be used in connection with the sale or promotion of any product, service or organization. For example, the bride can't give your photos to the catering hall or the florist. It can read something like: No images created by Photographer may be employed by any catering hall, hotel, facility, vendor or any other third party for purposes of advertising or promotion without the express written consent of photographer, the copyright holder.

7 Payment. How much for what? What percentages are due when? Be very specific and stick to your price list and timetable. If there is no payment when due, no photos. *Do not* deliver final images before final payment.

8 What types of payment are acceptable? Avoid, if at all possible, accepting personal checks as the final payment and don't be shy about requiring other, more reliable forms of payment.

9 An award of attorneys' fees to you, if you are required to hire an attorney to collect any and all monies owed to you under the contract.

10 Cancellation terms/payments due to bad weather, family health emergencies, or just plain cold feet. Cold feet and runaway brides happen more than you can imagine.

11 Model releases—assume that no adult can give written consent to employ the pictures of another adult regardless of any blood relationship they may have. So while the father and/or mother of the bride is paying your fee and signing the contract, they can't sign for either their daughter the bride or for that no good bum she's marrying. You should have the bride and bum each sign a release.

★

In the end, the best protection is to simply hire a local lawyer. Have a consultation and tell the lawyer how you go about your business. There is no such thing as giving the attorney too much information about how you make your living. The lawyer will go over your paperwork and customize it to your needs and the local laws. Don't limit the task to just your wedding contracts and second shooter contracts, but all of your paperwork—invoices, change orders, model releases, everything. Yes, it will cost you a few bucks for this one time project, but trust us, it's a lot cheaper than hiring that same lawyer to defend your behind when you get blindsided by a lawsuit or have to hire a lawyer to collect your fee. Your set of correct forms should last you a long while and have you avoid the "Wedding Bell Blues."

★

TRUE STORY

This is a story about a marriage of the daughter of an über-wealthy owner of a famous business. The family name is synonymous with food and it appears on every package. Virtually every supermarket in America carries it and consumers buy it by brand name. The family name is emblazoned on all of its products and is so big and so synonymous with a certain *type* of food that people use the family name rather than describe the item, i.e. "Hey mom, get me a Hershey's please."

The wedding is held at a very pricey hotel. So picture 400 guests, black tie, designer gowns, lobsters aplenty, 14 piece live orchestra and a high priced society wedding photographer who brings two second shooters for the biggest pay day of the year. Everything runs like a Swiss watch and most importantly, daddy is very happy.

Personal checks are written by dad—each one practically a collectible. The check to the band bounces and the check to the photographer bounces twice. The band had a big deposit, the photographer's was substantially smaller. Given the pristine reputation of the father of the bride and his obvious financial resources, never in their wildest dreams had the photographer and band imagined a personal check from dad would bounce. It was noteworthy that the hotel, florist, and caterer got paid on time and in full. So why not the musicians and the photographer?

Well, musicians and photographers have—like other artists—traditionally been doormats and reluctant to talk to a lawyer. A letter from Ed advising that he was filing suit in 72 hours got them all paid pronto. The ever-cynical Mr. Greenberg believes it had more to do with the fact that these days it takes the news media "about five seconds to report on the filing of such lawsuits" than with any of his legal brilliance. When Ed told that story at a lecture, a producer at TMZ came up to him and said, "We would have picked it up in *four* seconds." Some people like to think that dreams can come true. We like to say that nightmares can and do come true.

The Contract Template with Explanations

Clauses in our suggested contract template below are followed by our explanations in numbered boxes. *The form or agreement you provide to your client should not contain those explanations.* We know to say this clearly, but some photographer out there will just cut and paste and leave it all in. Please don't. They are there for your benefit and to assist you in explaining your agreement to inquisitive clients. Since weddings shot on film are exceedingly rare those days, we leave, for the purposes of simplicity, assumed a digital shoot. It bears repeating that you must tailor these forms to the realities of your own business. You can use these forms as a template regardless of what type of weddings you shoot. Whether it's a beer soaked wedding at a VFW hall, a champagne and caviar catered affair at the Ritz or something in between, the concepts remain the same.

XYZ PHOTOGRAPHY, INC

570 Milburn Ave.
Namath, NY 66666
(508) 555–5555
E mail:_____
Fax No.:_____

AGREEMENT FOR PHOTOGRAPHY SERVICES

AGREEMENT made as of the ___ day of _____, 20___

By and between the Photographer: **XYZ PHOTOGRAPHY, INC.** (hereinafter "Photographer") a _____ (state) corporation with offices at 570 Milburn Ave. Namath, NY 66666

and the Client(s): Mel Finkelstein (father of bride and hereinafter "Client")

123 Blazing Saddles Rd.

Rockridge, NY 10001

Upon signing of this agreement each party agrees to reserve the dates referenced below for the purposes set forth in this agreement and not to contract or otherwise obligate themselves to attend any other event or be in any location which will prevent the parties from performing under this agreement. For that reason (and others) any fees designated as "non-refundable" or due Photographer shall be considered fair and reasonable.

1 This language helps you to preserve your right to retain any down payment or advance in the event of any problems preventing full performance and/or full payment. Whether to use the word "retainer" or "down payment" or "advance" or some other term should be determined by your local attorney as some local laws treat the meanings of such words differently. You don't want to have to refund any money against your will. As discussed, you may want to refund all or a portion of monies received because you perceive doing so as a wise business decision.

Client as named herein shall be the sole person with authority to advise, suggest, or request that Photographer perform any services not specifically set forth in the Plan and to execute any agreements for such additional services or items.

2 This language helps prevent Uncle Harry, who just bought a good camera, or cousin Brucie, who knows photography, from directing you to perform services which the client did not want and thus justly refuses to pay you for them. You can of course designate more than one person with authority to direct that certain shots be taken.

Event(s) To Be Covered:

Ceremonial wedding of Harvey Lamar to Joan Finkelstein and wedding party/reception immediately following ceremony

Date, Location, and Time of Event(s):

November 22, 2020. Ceremony to commence at Noon at Producer's Church located at 123 No Way Out Street, Dismal, NY 10001. Reception to commence at 12 Chairs Restaurant, 1917 Moscow Street, Kugel, NY at 3:00 PM and concluding at 6:00 PM, November 22, 2020.

3 Be specific. Some photographers think being specific ties their hands for some reason, but, in reality, it protects you. So if the bride or client wants you to go to some out of the way location to do a trashy "trash the dress" shoot in a pool three hours after the reception, you have what you are responsible to shoot clearly spelled out.

Weather Provisions:

Client represents that the entirety of photographer's services will be performed indoors and/or in a "weather protected area."

4 Some venues have "permanent tents" or indoor chapels, which are routinely used and always available in the event of inclement weather rendering an outdoor ceremony or shoot impossible. If such is the case, have the client represent that such default arrangements are in place so you won't get caught unprepared, blamed, or held at fault for coming to the event unprepared for the site, without the proper equipment or set up, etc. This will eliminate a possible excuse for the client to use for the purposes of not paying you.

Client has made reasonable accommodations in the event of adverse weather.

5 For example, a tent for a backyard wedding has been rented or the ceremony will be held indoors at a country club (which may not have a chapel) in the event of rain.

Cancelled & rescheduled due to weather upon consultation with Photographer and subject to Photographer's schedule, to perform such services at the rescheduled date and time.

6 Whether and how much to charge for this type of situation is something to be determined by you as a businessperson. Your lawyer has great latitude in what conditions you can have your client agree to. What may be enforceable in court may not be in the best interests of future business. You need to consider just how busy you are and to what extent you are booked weeks or months into the future. The value of good references from happy customers cannot be overestimated.

Client acknowledges that Photographer has no control over any adverse weather conditions that may affect or prevent Photographer from creating the images in the manner set forth by client in The Plan. In such event, Photographer agrees to consult with client on an ongoing basis so as to create imagery in a manner as close as is practical to client's wishes given the prevailing and/or changing weather conditions.

Services To Be Performed:

The parties agree that the Photographer shall perform all of the services set forth in the "The Plan" attached to this agreement as follows:

1. Photographer will appear at church at _____(time of day) and at _____(time of day) at 12 Chairs Restaurant on the date of the event and will remain until_____(time of day) at the church and _____(time of day) at 12 Chairs Restaurant unless the parties may otherwise agree in writing. Any/each additional hour worked by photographer at either or both venues at client's request shall be billed at the rate of $X per hour (or portion thereof).

2. Photographer will be accompanied by one photographic assistant at both venues.

3. Photographer will produce photos at both venues in accordance with the shoot list (inc. groups) inclusive of any requested shots as provided by client and attached to this agreement.

4. Photographer will provide suitable imagery in the form, manner, media, and quantity as is set forth below.

5. Photographer and client will communicate with each venue to determine what if any restrictions such venue(s) may impose on the taking of photography on the subject premises. Client agrees that Photographer shall have no obligation to attempt to change, amend, or otherwise circumvent any such restrictions imposed by a venue and/or government agency.

6. In the event any permits or licenses of any kind are required to enable Photographer to render the services set forth herein, it shall be the responsibility of client to timely obtain and furnish same to Photographer at client's sole cost and expense.

7 Here is a chance to show off and get paid for your knowledge and expertise. If it is your regular practice to secure permits to shoot in, say, a local park, gazebo, or scenic overlook where time must be reserved and/or a permit required to take photos, then it is good practice to perform this work for your clients and build that service into your fee. If you are to be working in a town or location with which you are totally unfamiliar you may be better off having the client be on the hook for getting any permissions. Before committing yourself or your client to this task, check out the requirements.

Cooperation

Ensuring the appropriate and sober behavior of all guests and persons, at the events, towards Photographer and Photographer's assistant shall be the sole obligation and responsibility of Client. In the event Photographer and/or Photographer's assistant experiences any hostile, threatening, belligerent, or offensive behavior irrespective of causation by such attendee and/or attendee performs any act(s) which serves to impede, impair or prevent Photographer and/or Photographer's assistant from performing the services hereunder, Photographer will request that Client have any/all such person(s) removed from the event. In the event such person(s) and/or client have not been removed from the event, rendering Photographer unable to perform and/or complete the services hereunder, Photographer shall be entitled to all fees as if Photographer had completed the entire assignment as contemplated.

8 Drunken brawls, fist fights between attendees, food fights, and the like may prematurely end the event or serve to make it dangerous or even foolish to try to continue filming. Whatever images have been created and services rendered up to such point can be treated in various manners. Below are two options we have seen

that you can add if you believe it will be needed. Such language incentivizes the client to toss out unruly guests via a burly relative, security personnel, or even the local police. No client wants the wedding to dissolve into chaos and be obligated to pay the photographer, band, caterer, etc. to boot.

NOTE: This is optional language. You must have your local lawyer review and add language we are suggesting to assure that it complies with your state's law.

Photographer shall be deemed to have completed the entire plan, shall receive all fees and monies due, and client's selection (or the delivery of "all" images) shall be restricted to those images created prior to such incident(s).

or

Photographer shall be deemed to have completed the entire plan, shall receive all fees and expenses provided for in this agreement except for those fees associated with the creation of prints, bound books, and other deliverables listed as "items" in this agreement, and need not deliver or make available any image which may have been created prior to the termination of the event due to circumstances beyond Photographer's control.

9 If you feel you need either of the above clauses above, add the following to the end of either clause:

Client holds Photographer harmless from any claims arising out of Photographer's inability or justified refusal to complete the assignment under such circumstances.

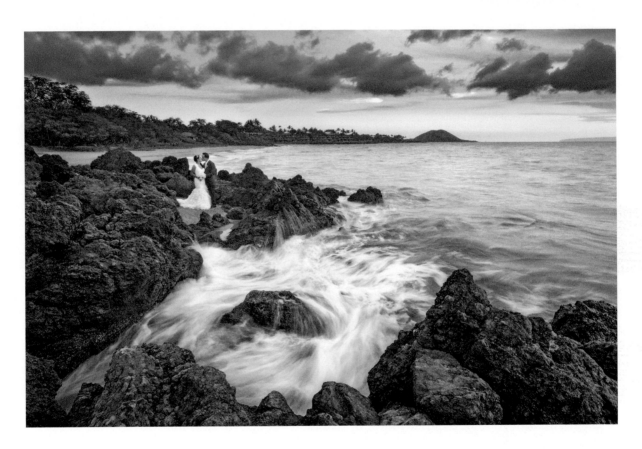

Location wedding photo © by our friend, Hawaiian photographer Mike Sidney.

Destination Wedding:

In consideration of the time, expense and vagaries of travel from Photographer's place of business to the event location at: Paradisus Resort, Punta Cana, Dominican Republic client agrees to provide and pay for the following expenses to be incurred by Photographer:

1. Two round trip direct flights from JFK Airport to Punta Cana Dominican. Departure date: _____ Return Date: _____ inclusive of any re-ticketing, extra charges, ground transportation charges due to flight cancellations, delays, re-routing or other circumstances beyond Photographer's control.

2. Ground transportation from/to JFK from Photographer's place of business and ground transportation from Punta Cana Airport to/from Paradisus Resort.

3. Three meals per day for Photographer and assistant on the following dates _____ .

4. Food for Photographer and assistant at Paradisus Resort 2 hours prior to Photographer's commencing preparation for photography.

5. Any air or ground charges/extra charges/overweight excess baggage transportation charges for any equipment or props required by Photographer to perform the services under this agreement.

Payment:

Client agrees to pay Photographer X$ for photographic services for any and all services, expenses, and items specifically set forth in this Agreement (the "Price") and any other written agreement providing for additional services, expenses, or items by and between the parties. Client shall deposit Y% as a retainer/down payment (see above) upon signing of this contract.

The entirety of the balance due shall be received by Photographer not later than 14 (fourteen) days prior to the date of the event. No services will be performed and no part of any order will be delivered until the entirety of any balance due inclusive of any late fees or finance charges due is paid in full. Photographer shall have the right to cancel this agreement in the event the balance is not paid and retain the retainer of X$ provided for above.

10 Many wedding photographers insist upon full payment having been received and cleared prior to the date of the event. This is of course an ideal option but one which some customers might not be inclined to agree to. In no event should you deliver or transmit images to the client without full payment having been received by you. No exceptions and no excuses. A client has no incentive to pay you once they have possession of their pictures.

Late Charge

Interest at the rate of __% per month on any/all unpaid balances will be billed and charged.

11 For interest on any late payment, the rule is the same as we wrote about late charges in the invoice section of Chapter 4. In nearly all states, commercial parties can set interest rates on unpaid sums at rates higher than those permitted in consumer transactions. If this rate is not written in your agreement, then you may be entitled to no more than the so-called "legal interest" rate in your state. Check with your local attorney to determine what the maximum rate your state's law allows. This increased rate of interest adds up to substantial bucks rather quickly.

Payment Schedules:

X% on signing of this Agreement; and

Y% in no event later than 14 days before ceremony/event; and

The entirety of the remaining balance *upon* delivery of discs, flash drive, etc and/or "finished, bound photos." There shall be no delivery of any images in any format unless and until Photographer has received all payments due Photographer in full.

12 Again, this is largely a business decision for you to make keeping in mind the payment concepts we have tried to bang home in this section. Don't leave home without money in hand, don't hire an assistant unless you have received the money to pay him/her. Get as much as you can as early as you can.

Plan/Shot List:

Photographer has provided client with a "Plan" and/or "shoot list" form to be filled out by client in consultation with the bride and groom and returned to Photographer signed by the client not later than _____ days prior to the event. Such Plan should include any persons, groups, or special events, locations, photographs, and so on specifically desired by client to be photographed by Photographer. The Shot List also provides for the names of persons, pets, and groups to be photographed as individuals, couples, and/or groups as the case may be and the venue(s) at which such images should be created. The Shot List also provides for enumerating any structures, buildings, inanimate objects, or views capable of being shot from the location that client would like photographed.

13 Some photographers put in their plan or agreement some number or percentage of "candid" or "photographer's choice" shots. Shots of entertainers especially band members, a DJ, clowns, or magicians for children, or of some celebrity who is attending, whether paid to do so or otherwise, should be listed on the plan.

Exclusivity and Priority:

That in order for photographer to perform the services contracted for, there shall be no other professional or amateur photographer used to cover the event and Photographer shall have absolute priority over any other photographer or videographer in the positioning of cameras and equipment. Wedding guests may (and it is contemplated that one or more guests will) shoot photographs so long as by so doing they do not obstruct or impede the work of Photographer and/or Photographer's staff (if any).

Any image created by Photographer and released by client to any newspaper, press or media of any kind inclusive of Facebook, Twitter, personal websites, and/or similar social media sites shall prominently bear the copyright credit "Photograph by _____ 20__." Client may release only _____ such images to such sites unless photographer agrees otherwise in writing.

Cancellation:

In the event of a postponement or cancellation of the ceremony and/or reception, for any reason within thirty days of the event and is not re-scheduled to a date upon which photographer is available and within sixty days of the planned date, the retainer paid is **not refundable.** Client acknowledges that among other things, Photographer has reserved the shoot date and is unlikely to retain "replacement work" on short notice. If Photographer secures another paid wedding assignment at least _____ days prior to the shoot date for work to be performed on the shoot date set forth above, Client will receive a refund equivalent to

X% of all sums paid to photographer_____. Should the event be postponed to a date *within* 60 days of the original planned date, the submitted Plan shall remain substantially similar if Photographer's schedule permits the performance of services on such new date *and in such event client agrees to pay photographer an additional fee of* $_____ *as a result of such postponement representing* _____.

14 Here again you must make a business decision. Some photographers charge a nominal fee for such delay to cover various unrecoverable costs, i.e., payment to an assistant or for rental equipment. If that is your preference, it is best to set those costs or reasons in the blank space provided above. Still others, especially those with busy schedules who are less forgiving and can charge cancellation fees, which must be in accordance with state law but often run to as much as 50% or more of the total fee. Also consider the size of your total fee when considering what percentages clients are likely to agree to. Retaining a significant portion of a $5,000 assignment will sound far more reasonable than that same percentage of, say, a $55,000 gig. Also consider who the client is and the promotional value of making a favorable impression on that person and the attendees, each of whom is likely to be viewing (and judging) your work in the near future and may be a potential customer. All things considered, while you must remain within the limits of local laws, these issues are essentially dependent on your sense of public relations and what is in your best financial interests at the time of the postponement with an eye toward future business.

Emergency Cancellations:

Emergencies such as serious injuries, serious illness or death of a signing party and/or member of the wedding party causing cancellation of the event(s) permanently or for a period in excess of 90 days from the planned date will cause this agreement to become null and void at the option of either party. In the event of such cancellation by client it is agreed that Photographer shall retain a sum equivalent to X% of the sums received by Photographer up to the date a written cancellation notice is delivered to Photographer. The canceling party shall provide documents to the other reasonably adequate to establish that such death, serious illness or injuries have in fact been sustained by a signing party and/or member of the wedding party.

15 Sensitivity to such situations is likely in your best business interests. Word of mouth in communities can make or break you in the wedding game.

Other Cancellations:

Should the event be cancelled in writing by client for any reason whatsoever not attributable to death, illness, injury or weather (as referenced in this agreement), the following payment schedule is agreed to by the parties:

A. 120 or more days before the event _____

B. 60–120 days before the event _____

C. 31–60

D. 30 days or less

16 It is up to you to set dates/schedule and amounts. Consider what your demographic will bear, what your competitors do, and your own shooting schedule. This is an area that you need to sometimes hold firm with, or people will walk all over you. There is a whole industry out there that advises brides how to take advantage of a wedding photographer. Or you might need to have some flexibility in some communities as we explain in number 15 above. You need to find the balance that works for you, your business, and your reputation.

Original Photographs:

Photographer has offered client a variety of photographic formats upon which the images will be delivered and/or reproduced. Client has selected and specifically requests that photographer provide:

A. Books/Proofs/Photos will be provided to client in the form of a "proof book." Client has examined Photographer's sample proof books from prior events shot by Photographer. Such proof books contain _____ images with ____ numbered photographs per page. Photographer will deliver such proof books to the bride and groom (or client if client so requests in writing) within ____ days of the date of the event.

B. Photo Discs/Flash Drives and/or _____

C. Photographer will provide at no charge a number of small JPEGs with photographer's logo for client's use in social media sites. If logo is removed, client will pay photographer $_____ per site.

17 Change this section to whatever fits your business model. Note that "A" states a time period to deliver a proof book, etc. Make sure you give yourself a generous period of time to deliver. If you deliver early, you're a hero, but if you're even a day late, you're a bum. Under-promise and over-deliver. "C" solves an issue with clients posting on social sites, which trying to stop is harder than trying to stop the ocean. Fish have to swim and clients have to post on social sites. Rather than fight it, work it to your advantage, and get the publicity. Getting publicity from a job you've been paid for and when it's on your terms is a good thing.

Price Protection:

Photographer warrants all prices quoted for professional services, photographs, related items, and albums to remain unchanged until at least December ____, 20____ or one year following the date of the wedding whichever is later.

Albums and Prints: If applicable

Client shall submit orders for albums, cds, DVDs, and prints from time to time accompanied by full payment but not later than ____ days after the event. In such event, Photographer will deliver such items in a timely fashion. Delivery of orders received after such time period will be subject to photographer's schedule, availability and are likely to be delayed.

Orders received will be processed and delivered. An album of the event will be made available to view online by Photographer in a ____(i.e. pdf) form. Password protected and is for inspection/ordering/selection purposes only and may not be reproduced.

The Plan shall be performed by Photographer. Client or bride/groom may make up to ____ changes in the Plan without charge up to the date of the wedding. Any additional Plan changes shall incur a charge of $____ each.

18 Here again it is your option as to what to charge, if anything, for such changes. Consider the amount of work involved and whether such changes will adversely affect your performance of the balance of the agreement.

Client will approve in writing and "sign off" on any such extra charges which might have been incurred prior to Photographer delivering final product. Photographer will bring "change orders" to the event for the purposes of obtaining client's signature and approval for such changes/additions.

19 Make up a pad of change orders on carbonized paper sized about 4 x 6 inches. Such pads are commonly used by contractors and home improvement people. As they walk through the building the customer decides to add a light switch. Contractor whips out pad, writes "Install additional light switch @ SW corner of living room. Cost $50." Customer signs on "approved" line and each has a copy. Works like a charm. The only difference here is the change order might read, "Picture of Harry Bernstein holding lotto ticket praying at statue of St. Jude on church steps—$50." Client signs or initials on the "approved" line. Whether and how much you want to charge for these type items is your call.

Retention of Digital Files:

Unless otherwise indicated on Exhibit A, Photographer is the copyright owner and is entitled to copyright register the images solely in its name, owns and retains all digital files created and/or produced in connection with this Agreement.

Compact discs and/or other digital media may degrade over time and Photographer may not retain such discs for more than two years following the event. CDs included in your package or purchased may not be color corrected nor retouched. Client acknowledges that maximum quality of any prints can only be achieved via Photographer in Photographer's own studio. Photographer cannot assist nor guarantee the quality of any prints made by any one other than the Photographer. Photographer retains copyright over any such prints, which may be employed for the private use of client, friends and family only. No image created by photographer may be employed in connection with the sale or promotion of any product, service, business or entity without the written consent of the Photographer.

No photograph regardless of photographic format may be reproduced or copied for any purpose not set forth in this agreement.

20 In the old days of negatives and print, photographers held on to all the film and negatives in case they could make a reprint sale. Talking to photographers, we know this represented less than 5% of their income. And usually much less than 5%. All those file cabinets of negatives took up a lot of room, which is an expense. Smarter photographers in this age of digital files know that storage, as media changes, can be an issue. Storing files on a Syquest system seemed like a good solution at the time, but finding a reader today is like finding an 8-track tape player. Savvy photographers will contact their clients and remind them that as per the contract

they will be removing the files (and the responsibility of maintaining them) from their computers. Few actually destroy them, but it does remove you from the storage responsibility. At this point offering a disc, flash drive, or whatever media is in vogue, with all the files for a reasonable amount, can be a win/win scenario for photographer and bridal couple. Assuming the marriage held. Such sales can add up to a lot more money than reprints will two years after the ceremony.

Rights to Ownership and Reproduction:
Photographer reserves the right to use any image in any photographic format created at the event for display, publication, Photographer's website or other self-promotion purposes. Client agrees/does not agree to the use of the name of the bride and groom in connection therewith.

21 Have client give you specific consent for the use of his/her name if you want to use it. Likewise the bride and groom—if the happy couples are not the clients, have them agree in writing to your use of their names.

Notice of Copyright:
Photographer retains the copyright in all images created by Photographer. Physical delivery and/or possession of photographic material, such as digital files or prints, by the Client does not include copyright ownership or the right to reproduce or copy the images. Copying or reproduction of these photographs elsewhere without Photographer's permission constitutes an infringement of Photographer's copyright and may subject any violators to penalties under federal law.

22 Unless you are being paid an enormous amount of money, you ought never relinquish the rights to your files. You simply never know when the images or even a single image taken at a wedding may exceed in value the entire fee you received for shooting the event. See the "Ya' Never Know: Wedding Edition" sidebar in this chapter.

Limitation of Liability:

While every reasonable effort will be made to produce and deliver professional quality photographs of the event, it is agreed that Studio and Photographer shall only be liable for an amount *not to exceed* the total sum due Photographer under this agreement in the event of a breach of this Agreement by Photographer and/or any claim, loss, or injury determined to be caused by a court of competent jurisdiction by Photographer's actions or inactions.

23 This clause ought be tailored by your attorney to conform with your state's laws. The intent is to limit your exposure to an amount of money not to exceed the sums you can earn from fully performing the agreement without any complaints from your customer.

Governing Law, Agreement and Venue:

This Agreement shall be governed by the law of the State of _____.

The Parties agree that any dispute arising out of this agreement and/or the duties of the parties hereunder shall be adjudicated in the _____Court, in the City of _____. The

Parties specifically consent to submit to the jurisdiction of such court and agree that any judgment issued thereat shall be enforceable in any State of the United States. Each party agrees to pay and that the Court may determine the nature and extent of any attorney's fees and expenses reasonably incurred by the prevailing party in any such litigation and award same to the appropriate party as may be determined by the court.

This Agreement and its annexations referred to and made a part hereof represents the entire and integrated agreement between the parties hereto and supersedes any prior negotiations, representations, or contracts, either written or oral.

The Parties agree that should any part of this Agreement be unenforceable or against governing law, that part, and only that part, of the Agreement shall be held to be unenforceable, with the remainder of the Agreement remaining in full force.

Successors and Assigns

The Parties respectively bind themselves, their partners, successors, assigns and legal representatives to the other party hereto and to partners, successors, assigns and legal representatives of such other party in respect to covenants, agreements and obligations contained in this Agreement. Neither party to the Agreement shall assign the Agreement in whole or in part without written consent of the other. If either party attempts to make such an assignments without such consent, that party shall nevertheless remain obligated under the Agreement.

XYZ PHOTOGRAPHY, INC.

_____ Date:_____
BY: Your Name, President

_____ Date:_____
Client

SAMPLE WEDDING PLAN

1. Photographer shall be present at the event for not less than _____ hours. _____ hours will be performed at the ceremony located at _____ and _____ hours at the reception located at _____. Bride, groom, members of the wedding party, and the photographer will allow ample time to capture the intimate moments of the wedding ceremony and reception. All parties agree to be present and ready to commence photography not less than one hour prior to the scheduled ceremony and one hour prior to the commencement of the cocktail hour at the (restaurant/catering hall).

2. Photographer will have ____ assistant(s) for _____ hours on the shoot day.

3. _____ shall be the person designated by Photographer to shoot the event and client, bride and groom approve such selection.

4. Additional hours or any portions thereof shall be billed at the rates of ___$ for Photographer and _____$ for each assistant for each hour or any portion in excess of those set forth in paragraphs "1" and "2" above and the agreement.

5. Client will receive all of your photographs in a unique hard covered proof book in the same form and style as examined and approved by client prior to signing this Agreement.

6. All photographs will be uploaded to your own personal website that you can edit and then forward to all of your friends and family. You agree to display our copyright notice and warning that "No publication of any photo is permissible without the consent of _____Photography." Photographs can be purchased individually and independently directly from the website or directly from our studio.

A CD/DVD/Flash Drive containing _____ will be provided to you by Photographer on your first anniversary at no additional cost.

24 Adjust and flavor to your taste. The last one, delivering the files after a period of time, is up to you to include or not. Some photographers do this, other photographers charge for the files a year or two after the wedding. It can either be a small cash flow or a goodwill gesture to help your word of mouth. Either way it relieves you of the burden of maintaining the files, but you should always keep the rights and a copy yourself, in case someone in your photos becomes famous or infamous.

Below is an example of a Wedding Day Plan that you should always have. Again, you should tailor this to the way you shoot. It would be best to go over with bride and groom and then have them sign off. That way, if the "Uncle Paulie's famous coin in the groom's ear" shot is important to them, you have it in the plan. Or, on the other hand, if they never told you and you missed Uncle Paulie, you are not on the defensive.

The following section is not a contract, but simply a menu of charges. But note that it still "sells," as with the sentence "We use only the highest quality, simplest, and most elegant hand bound leather books made with Italian book binding techniques passed down for generations." You are reassuring the clients that this is special and why it is so special. Sounds simple, but doing extras like that will help seal the deal.

Wedding Day Plan

Before Ceremony:

☐	Wedding dress on hanger
☐	Bride getting made up.
☐	Bride putting on dress with mother of bride helping
☐	Closeup of rings
☐	Groom putting on tie
☐	Groom with groomsmen
☐	Groom with his father/parents
☐	

Before ceremony in church/synagogue/hall

☐	Empty interior
☐	Close invitation
☐	Flowers
☐	Room shot of reception
☐	

During Ceremony

☐	Groom's first look
☐	Wedding party walking down the aisle
☐	Bride walking down aisle
☐	Second shooter gets reaction as bride comes down aisle
☐	Closeups and wide shots of vows
☐	First kiss as husband and wife
☐	Reaction shots during ceremony
☐	

Reception

☐	Close up of seating cards
☐	Centerpieces and flowers
☐	B&G walking into reception
☐	The first dance
☐	Best man and Bridesmaid toasts
☐	Father Daughter dance
☐	Mother Son dance
☐	Parents dancing
☐	Cutting the cake
☐	Bouquet and garter tosses
☐	Grandmom Aggie with bride
☐	Head Table B&G alone
☐	Head Table Full
☐	Table group shots of tables 1 to 15
☐	*Note table 1- Grandmom Jenny - Shoot with B&G
☐	*Note table 1 - Grandmom Jenny with B & B's parents
☐	*Note table 3- Uncle Joe - Shoot with Bride
☐	*Note table 6 - Judy and Louie - Shoot with B&G
☐	*Note table 8 - Kids table
☐	*Note table 12 - Parents & Kids- flowergirl and ringbearer
☐	

Group Shots

☐	B&G
☐	B&G extended famlies
☐	B&G with groom's family
☐	B&G with bride's family
☐	B&G with entire wedding party
☐	B&G with maid of honor, best man
☐	B&G with flower girl and ring bearer
☐	

After group shots

☐	Close up of back of car
☐	Rice toss
☐	B&G departing

If/When Possible

☐	Unclle Paulie's coin trick
☐	Bride making her famous "scrunch face"
☐	Flowergirl and ringbearer dancing together

CUSTOM DESIGNED ALBUMS

We use only the highest quality, simplest, and most elegant hand bound leather books made with Italian book binding techniques passed down for generations. Our albums are designed by us and then manufactured in _____.

CLASSIC ALBUM

With you as our editor, we will create your wedding story in an elegant library bound book. You simply pick your favorite photographs and with our experienced eye and attention to detail we will design a unique and beautiful book documenting your special day. Includes top grain leather, engraving of names and date, and dramatic center panoramic print.

Large Albums start at $3500

Medium Albums start at $1845

COLLAGE STYLE ALBUM

A unique and visually captivating alternative to our Classic Album, this exclusive and cutting edge album allows us to use our professional and creative vision to tell your wedding story. Using our innovative design software, we can easily create album miniatures once we complete your custom album. These smaller duplicates of your wedding album make great albums or gifts for parents. Since the design work has been completed, they can be produced at a significantly discounted rate. Includes top grain leather, three dramatic panoramic page spreads, as well as three lines of custom engraving.

Large Albums start at $2645

Medium Albums start at $1415

FINE ART ALBUM

Our Fine Art Album is a combination of the Classic and Collage Albums toting its unique classical beauty of photographs mounted in individual mats combined with edgy modern full bleeds. This book really embodies the old and the new with one dramatic photograph on the right side of each spread. Each photograph comes with a lacquer finish that ensures lasting beauty. Finally, the pages are hand bound with a leather cover engraved with your names and wedding date and a cover photograph if you choose. Includes top grain leather, three dramatic panoramic page spreads, as well as three lines of custom engraving and a cover photo if you choose.

Large Album with 50 photographs is $3400

Please inquire for a full listing of album prices.

During the event, you will have to hand write the specs of any change, but do get it signed off. This is a good idea for any photography job, no matter which area of the industry you work in.

CHANGE ORDER

I request that Photographer perform additional services or take pictures not set forth in our Agreement or Plan as follows:

Picture of Father O'Malley drinking scotch with Rabbi Goldstein on church steps.

Pictures of tables 14, 15 and 18 together in one shot.

Client:_____

Date:_____

Photographer_____

REAL-LIFE EXCUSES FROM NON-PAYERS

Beware of begging and promises from deadbeat clients. They don't pay the rent and foretell collection problems to come. Here's a real-life "Top Ten" list we've actually heard of unfulfilled promises to pay a balance due made long after the cleaning crew has gone home. These excuses came to light only because it took a lawsuit or some other collection tactic to get the hollow promises fulfilled:

1 "You know me for 30 years, would I screw you?"

2 "Where do you think I'm going?" a.k.a. "I'm not leaving town" or "You know where I live."

3 "I've known you since you were in diapers."

4 "Did you forget that I was in Nam with your father!"

5 Have I ever beaten you out of a dime in my life?

6 "What's the emergency? You into a bookie?" "Don't you trust me?"

7 "My God what would your father/mother think if they were alive today to hear you say that to me?"

8 "Is this what they taught you in college?"

9 "Do you do and say everything your wife tells you to do or say?"

We don't have to get creative as these all come unedited from the deep well of real-life experience. Each of these bogus excuses was used with success. Each appeals to photographers as sensitive human beings and infuses them with guilt. In short, clients use excuses like these because they work—at least for a time.

YA' NEVER KNOW: WEDDING EDITION

Our friend Ken Knight shot a wedding in Louisiana many years ago where a photogenic pre-teen captured his eye. That young lady "became" Britney Spears and that image, copyright registered by Ken, has come to be in great demand. Other photographers have unknowingly captured or could not possibly have predicted that their wedding, Bar/Bat Mitzvah, Quinceañeras, graduation portrait, engagement parties' photos, etc., captured the image of:

1 A fugitive who had starred on *America's Most Wanted*.

2 A bride who shortly after the blessed event shoved her husband off a cliff.

3 A stunning school teacher bride who within months of the ceremony was arrested and eventually convicted for having sex with her underage student.

4 A reception held on a yacht which was short one passenger when it returned to shore.

5 Husband's fourth marriage, wife's third, both parties qualify for AARP membership. Very opulent, intimate wedding with about 50 politicians, high-society types and celebs present. Band plays for couple's first dance as husband and wife during which husband says something to wife who responds by kicking new husband in his favorite body parts. He hits the floor where he attempts to breathe. After an eternity he recovers, the band plays on, they kiss and make up. Images captured—priceless.

6 Certain of photographer's wedding photos purchased by an attendee of the wedding to assure that they would remain unseen by his spouse.

Each of the above images became far more valuable than the entire fee paid to the photographer who shot the event. Lots of people with all sorts of back stories attend such events, so ya' just never know!

Chapter 8

The Online World and Their TOS

Brave New World

Social networks are a new phenomenon of the twenty-first century. We can now connect with many people we would not have had the chance to interact with in the pre-Internet days. We can find old friends and classmates; we can argue; we can pontificate . . . we can even meet our mates. Via the Internet, people have made a splash, shown their work to those who would have not seen it otherwise, and accelerated their careers much further than by any other means. The Internet is an accessible, cheap media that has leveled the playing field for many who, otherwise, would not have been able to play.

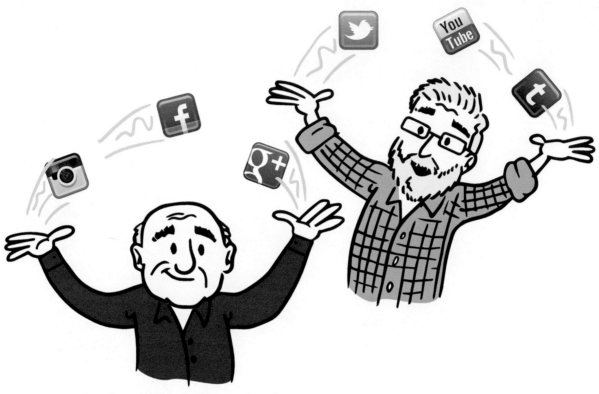

Trademarks are property of respective registered owners

Trademarks are the property of their respective owners

There are Internet stars who have made their names online and people who have made lots of money promoting themselves or their products online. Some industries have even changed forever because of the Internet, not just the photography industry. Many brick-and-mortar stores have closed their physical shops, opting to go virtual instead. One example is the antique business, because buyers and sellers can find each other much easier now than they ever could before. Once upon a time, if you had a unique

"whatchamacallit" antique, you hoped that a "whatchmacallit" collector would come through your door to buy it. Today, that collector can easily find you using eBay, Amazon, or another search engine.

When it comes to our industry, photography and stock photography have become more accessible than ever to sellers and buyers. Without a doubt, this trend will continue as time goes on. The genie has left the bottle and will never go back in.

The lesson from all of this? Change is the only thing that remains consistent. Change seems to be coming at us at a frantic pace these days. What were once dominant companies in their field are today distant memories. Is Behance today's Pinterest and tomorrow's Montgomery Ward? Will Google+ turn Facebook into tomorrow's Tower Records? Or will another site, maybe one that's being developed in a dorm room today, leave Google+, Facebook, and LinkedIn in the dust?

The lesson for all of us in the photo business is to constantly look forward and not be complacent when times are good. The only thing that is consistent in the photography

industry is change. Be ready to change with it. Airline pilots like to say that the most dangerous time for pilots is when there are clear skies and smooth air. They say that's flying "fat, dumb, and happy." So, when you all become successful, don't forget about Montgomery Ward and Kodak; always be aware and try to keep ahead of the industry trends.

Good News, Bad News

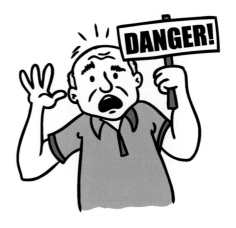

The good news about the Internet is that it reaches millions of people, connects us via social media, and is great for conducting commerce. The bad news is that there is also

a dark side. There are many good and some great reasons to expose your work on the Internet, but in this chapter we'll address the pitfalls you might encounter. Hopefully, this will keep you out of trouble, out of a lawyer's office, and out of the poorhouse. Some pitfalls are obvious; but some of them are not so obvious—the not-so-obvious ones can really bite you in the behind and can potentially remain a problem forever.

Since the Internet is relatively new, we really don't know the "half-life" of how long posts will live, but we think it's safest to assume that they will live forever. This means that any stupid thing you might upload in your wild, impetuous days will dog you forever. The worst thing you can possibly find to say about someone seems to arrive on that person's computer in lighting speed, even if you think they will never see what you said. Trust us, the worse you talk about someone, the faster it gets to them. And don't think you can take it down or remove it from the Internet. Newsflash: it doesn't go away. There already are "wayback machines" that take a "photo" of the Internet which can be fully accessed. They are a lawyer's new best friend in this fast-moving digital era.

To Facebook, tweet, pin, link, chat, or blog— or not to Facebook, tweet, pin, link, chat, or blog? Should I try and be the mayor of my neighborhood Starbucks on Foursquare? Maybe I should start my own circle on Google+? These are the questions. The answer is to proceed with extreme caution. Never, ever Facebook, tweet, chat, blog, or use other social media to voice your complaints about jobs, clients, or business situations.

Don't ever discuss touchy business matters online with others, because you never know with whom you're talking. Beware of people claiming to be "experts" online. We've seen photography "experts" in chat rooms who turned out to be one step (or less) beyond Wayne (from *Wayne's World*), typing "expert" advice from their mother's basement. And sometimes, because that "expert" gets a following in a particular chat room, people will believe whatever they say and then back them up if confronted. Someone might come on the chat to challenge the local expert with actual facts but they get shouted down by the false expert's loyalists. It could be a classic case of the blind leading the blind, mixed with a mob mentality. This sort of thing happens every day on the Internet.

Researching a piece of equipment or software online is a different story. Getting advice on equipment and software online has generally been tremendously helpful, although if you read an online review that seems very biased you may conclude that a competitor posted it.

When it comes to information you acquire on the Internet, it almost always pays to get a second opinion.

The one thing that is consistent on the Internet these days is change. Some issues you will read about here were very "hot" issues when we wrote about them, and today, not so hot. And some issues, no matter how old, are still very relevant, like a story about employers looking up prospective employees on social networks or Google searches. What are the odds today that employers are not doing a Google search to see what comes up about a prospective employee? We think those odds are slim to none. Anybody not Googling a prospective boyfriend or girlfriend? Those odds are about non-existent.

Getty announced it would release millions of "free" images into the world. Well, it's not really "free," as they expect so much more,

in return for using their free images, other than money. Information is what they will harvest from your Website because one of their terms, buried away in the small fine print most people don't read, is that they can track anyone coming to your site and looking at their free image. And because it's imbedded, they can also later add advertising at the bottom of that photo. Or if there is a problem, they can delete that free photo at any time. What does this all mean to us as photographers, what does it mean to the value of photos? Too early to tell; only time will tell.

The Good Stuff

Getting Ripped Off

One of the first worries photographers have about putting their images online is that they might get ripped off. Let us relieve your fears. There is absolutely no question at all—we're 100% sure, we're positive, that your images will get ripped off when you place them online. That's the bad news. Now that we (hopefully) put the fear of God into you to be very cautious online, we can also in good conscience tell you the benefits of showing

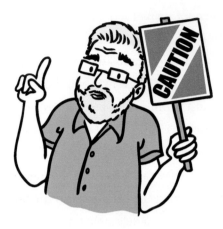

your photos on the Internet. The good news is that, percentage-wise, 1 or 2 percent of your images will be ripped off. Remember, people also ripped off photos in the pre-Internet days, it's just the Internet makes this a whole lot easier to do.

If we worry about such a small number of rip-offs and let that stop us from doing anything with our images on the Internet, then we'd be allowing the "tail to wag the dog," as the saying goes. We'd be letting 1 or 2 percent of people stop us from reaching out to the other 98 percent or 99 percent of the people that we really want to see our images. It sounds obvious, but some people are so paranoid about getting ripped off that they become frozen right out of the market.

So, basically, if you won't put images on the Internet because you're scared of getting ripped off, then you may as well keep all of your beautiful photographs locked in a box so no one will ever see them. Everything worthwhile comes with some risk, and you should be more than willing to take the chance of being ripped off so you can show your work to a wider audience. Frankly, we think you shouldn't mind getting ripped off at all, as long as you find the infringements. This, of course, means that it's extremely important to register *all* of your images.

Jack was ripped off in the analog days and he's been ripped off in the digital age. The large checks he deposited as a result of those rip-offs made him realize that getting infringed may not be such a terrible thing.

While the Internet makes it easy to be ripped off, it also gives us tools to more easily locate the infringements. When you upload images to the web, try not to label them 'image1' or 'photo1,' but rather with a unique file name that can be Google-searched. That's because a lot of rip-off artists don't bother changing file names. There is software such as Tin Eye, at www.tineye.com, that can visually search for

images utilizing image-recognition. This software allows you to upload an image or right-click on an image (after you install their free plug-in) and search to find matches.

Google Images offers another visual-recognition tool, which can be used to search the Internet for your images. Inside the search bar, there is a tiny camera icon all the way over to the right. When you click on that icon, you can link to—or, even better, upload—the image you want to search. You can also drag-and-drop an image into it and search that way. When this feature was first introduced, Jack tried it out and uploaded one of his images. The search revealed that there was an infringement by a designer of the uploaded photo. Ed sent out demand letters the next day.

The infringement doesn't even have to pertain to the entire image. The algorithms in both Tin Eye and Google Images will find partial matches. It may not find every single infringement, but when it works, it's phenomenal.

Benefits

Now that we've warned you of the perils of the Internet, let's look at the benefits of being connected. Although our warnings may sound dire, the benefits of being online far outweigh the pitfalls. When using the Internet, you should dive in with your eyes open and with an awareness of what can go wrong.

The Internet has made stars of people who previously would not have had a platform to showcase their work. In the past, photographers usually took a very traditional route, assisting a photographer in a big market. Today, it's possible to be in a small town or even in a small country and find a following and a career. But how do you make that jump? The Internet is always presented as a great, inexpensive means to promote and market yourself and/or your product, but if you try to utilize it in only that way, your efforts can easily fall short of what the Internet can do for you. You can best leverage the power of the Internet by using it to influence people, make you an online "expert," and develop that community of followers. You need to communicate and

present some of who you are—your persona. Being personable and honest is critically important, because people can quickly sense insincerity and being "sold to" by someone. The end result of leveraging the Internet this way, to market and expose yourself and your work, will probably make you more money than if you just used it as an elaborate direct-mail system.

So what does this all mean to us as artists? While your portfolio is still your portfolio, your website, blog, and anything else that makes you more accessible to your target audience are wonderful ways to distinguish and differentiate your work to the marketplace. However, art buyers and the people who hire photographers do not want to see a spinning beach ball or an hourglass on their monitors while waiting for a site to load up. They generally have a lot more work than time and, as a result, long load times, like 10 seconds, will drive them to other sites. In addition, they hate sites that are too "cutesy," where they have to figure out where the controls are. And they want to be in control. We've heard from several art buyers that they don't like slideshows where they can't control the flow of images.

The important thing though, no matter how you are presented on the Internet, is it's very important to be in the game. Being indecisive and trying to create the "perfect" site will hurt you a lot more than just going ahead and creating the best site you can. As we like to say to indecisive artists, "Do not let perfect be the enemy of good." Sometimes being in the game is more important than having the best looking and best tailored uniform to play in.

As, on a long-ago TV show about police, Sgt. Phil Esterhaus on *Hill Street Blues* always said to his charges before they started their daily shift, "Let's be careful out there." Words to keep in mind on the Internet.

Analyzing Your Website

You have your site up, it includes all of your great images, you've added metadata on your images before you uploaded them, and you have a blog to keep your fans informed about what you're doing. Now you want to find out how people are following you.

Google Analytics is a great way to get the information about the activity your website or blog is generating. You can find out how many hits you're getting, where your visitors are coming from (broken down by country), what pages they are starting on, what pages they go to, and on and on. This is all great information for evaluating your website. Many providers that host websites, such as Squarespace or Wordpress, also have their own analytics. Either way, look and analyze that information regarding your website or blog.

You can hire specialists to optimize your status on the search engines. This service is called "Search Engine Optimization" and is known by the acronym SEO. (I see this acronym most frequently in the multiple emails I get from companies saying they would love to improve my SEO—for a slight fee.) SEO specialists can employ many techniques for you, if you can afford it. For instance, they can advise you to take out ad space on a popular website. If you decide to place an ad on a weather information website and the weather site gets a ton of hits, then it will reflect on your status as a linked site. As a result, you'll rise up on search-engine lists when people look for photographers. Another

method is to create many ghost pages that are never seen by anyone who visits your website, but exist hidden away on it. Some search engines are wise to this and will lower your ranking rather than raise it.

If it's important for you to be high up on a search site for, say, "Photographer in Des Moines" or "aerial photographers," then this might be an important tool for you. If, however, you're in a field of photography where you want the people who seek you out to be qualified buyers, and you only want business-to-business work, then being high on a search engine list may not be a priority for you. A good friend of ours in Atlanta hired an SEO company for his website. He was skeptical, but will always try new things. He told me it was the best business decision he made in a long time and they really did help move his website toward the "front of the line" and it's brought in more new work for him than anything else he's done.

But be careful whom you hire. It's best to ask around and see if you have a friend that can recommend one. Or do your research on any company, as there are many bad players out there in the SEO game.

Social Media Terms of Service

Just what rights do you give up in those social media Terms of Service (TOS) agreements? To be fair and in an ideal world, social media sites generally do need your permission to have your image on their servers and to have subcontractors possess those images so they can be seen on their network(s). Great. Then why not ask for just those rights? Instead, the social media site's lawyers do what we call an "over reach." Their lawyers—and they have lots of them—advise their clients to get many more rights than their clients reasonably would need. There is no downside to giving or taking such advice.

Typically, social media sites do not state that the rights they are getting are only for specified purposes. They write the terms to their "agreements" in such a way that they obtain for themselves the right to use your images as they see fit, for any purpose, *including* selling those rights to third parties without your knowledge, consent, and certainly without you getting any money.

We would have no problem if the rights they wanted were broad enough to cover their needs to service their sites. That's easy enough to write, in plain English understandable by all. But we know from their actions (like stripping out metadata) that they see your images as content they can leverage. In other words, sell, use, or license them for real money and not pay you a cent. So a majority of social media sites take a bucket full of your rights so they can make money on what you have created and produced.

Think that's far fetched? Look at *The Huffington Post*'s business model. Arianna Huffington made many millions of dollars by selling her site, which was built and "kept fresh" by bloggers and photographers providing free content daily. Although Ms. Huffington made tens of millions of dollars, the photographers and journalists whose work she used received zero, zip, nada. Instagram or Facebook's valuations, IPOs, etc. are in the million/billion dollar ranges. What they are selling are shares of stock in a company whose inventory and assets were/are provided to them free of charge.

So if I, as a homeowner living near a stadium, offered "free parking" on game days, with the open stipulation that I could use any parked car for my personal use and people actually parked their cars there, why wouldn't I use those cars for my trips to the market or beyond? (Rolls Royces preferred by the way.) Customers were told the rules and agreed to them. Saves me a car payment, gas, and insurance. Great deal for me. And hey, you got some free parking, didn't you?

In the end, do we tell people to not post anything? Jack knows that this would be foolish and like spitting into the wind to tell photographers that. Where you are in your career helps to determine how you want to use social media. Jack, as an established photographer with many years in the industry, doesn't need to promote his work on social sites at this point in his career. For a photographer in the beginning or middle of his/her career, or a photographer who photographs high school seniors who live on social media, then it might be a critical marketing tool. For best results, social media should be used wisely.

When Jack posts anything (but he's more likely to put it on his website and then link to it rather than upload to a social site), his number one rule is to have everything registered before it's on any social site. With the very rare exception of personal happy snaps, where time might be a factor and the images are something he wants to share, for whatever silly reason. But as Ed can tell you from the cases he gets, even happy snaps on the Internet have been appropriated (stolen) for commercial advertising. Successful advertising can, and often does, use mediocre or even lousy photography.

We are not intentionally being almost as vague as the social sites, TOSs themselves. Rather Jack's best advice is—be cautious, really read the TOSs, especially regarding the licensing of rights. Be cautious, and be willing to say "no" sometimes. But always, always, register all your images. If Ed the lawyer had his way, no photographer would ever post anything ever unless it had been registered—no exceptions.

TO FLICK OR NOT TO FLICK

Whether you are a seasoned pro or a budding amateur, uploading photos to social media sites, like Flickr, might just place you smack dab in the middle of a legal minefield. Here are some tips for your consideration, as well as things to think about before sending your creation off to the masses.

Flickr offers a buffet of licensing options for individual or batch photos which can include what it defines as: "attribution," "noncommercial uses," "derivative uses," etc. But what do all those options mean with respect to what rights you relinquish (in English, "give up") and those which you may want to retain (which should be "all")? Flickr has partnered with Creative Commons, which boldly represents itself as a non-profit organization (this does not mean that it is photographer friendly, indeed quite the opposite) to offer "premade licenses" to "give" photographers like you a way to give nameless, faceless third parties (a.k.a. potential clients) advanced permission to use your work in limited ways with little or no input from, nor money paid to, you.

Take a look for their explanation of the licensing process and types of licenses offered on their website at http://creativecommons.org/licenses/. It is a fine example of some of the jargon you will find in any given "Legal Code" version of a Creative Commons license. "Subject to the terms and conditions of this License, Licensor hereby grants You a worldwide, royalty-free, non-exclusive, perpetual (for the duration of the applicable copyright) license to exercise the rights in the Work as stated below." Huh?

What all of this really means is that uploading your image under any of the licensing options permits any user to use the image under the terms of the license, forever, provided they do not breach the terms of the license. In a word, these licenses are "non-revocable." Stop, think, and ask yourself, "Why would I permit this?"

You might be thinking, "Well I can just go in later and change the licensing option on Flickr and make everything go away even after I made my submission." You would be wrong. Once issued, a Creative

Commons license *will not* be revoked unless the user breaches the terms of the license. "Licensor reserves the right to release the Work under different license terms or to stop distributing the Work at any time; provided, however that any such election *will not* serve to withdraw this License (or any other license that has been, or is required to be, granted under the terms of this License)." In plain English, you are likely stuck.

You must also be wary as Flickr does not really track the changes in the license, so if you do change to a more restrictive option, proving someone used your image under a less restrictive license may prove to be darn near impossible or, just as bad, not worth the effort. Of course, you can stop distributing your image with a Creative Commons (CC) license on Flickr to prevent others from obtaining a license to use the image, but this will not remove the license of those who have already obtained use of the photos you created. If you want to place your images on Flickr, for a variety of reasons, we think that can be fine. It's with the CC license that we take issue.

The Fallacy of Private

Many people incredibly still believe that there is some privacy or privilege attached to certain emails, posts, and web communications. Some think that because a chat room is password protected the exchanges are "private." Ed has repeatedly advised his clients over the years that such posts are neither "private" nor "privileged." A person can be forced to produce such conversations and postings in the context of, for example, a lawsuit.

There are only a very few, carefully enumerated privileged communications in each state of the United States. Typically they are: doctor/patient, psychologist/patient, attorney/client, spouse/spouse, priest/penitent. Some states have created privileges that deal with certain situations. For example, there may be a privilege for counselors who work at domestic violence shelters, even if they are unlicensed.

A privileged communication (oral or written) by law cannot be produced in a courtroom

PROTECTING YOUR SOCIAL MEDIA CONTENT—NOT

The following are several posts, which went viral, and appeared all over on Facebook:

"In response to the new Facebook guidelines I hereby declare that my copyright is attached to all of my personal details, illustrations, comics, paintings, professional photos and videos, etc. (as a result of the Berner Convention). For commercial use of the above my written consent is needed at all times!"

or

"In response to the new guidelines Facebook and under articles L.111, 112 and 113 of the code of intellectual property, I declare that my rights are attached to all my personal data, drawings, paintings, photos, texts etc. published on my profile. For commercial use of the foregoing my written consent is required at all times! People reading this text can copy it and paste it on their Facebook wall. This will allow them to place them under the protection of copyright.

By this release, I tell Facebook that it is strictly forbidden to disclose, copy, distribute, broadcast, or to take any other action against me on the basis of this profile and/or its contents. The actions mentioned above apply equally to employees, students, agents and/or other staff under the direction of Facebook. The contents of my profile includes private information. The violation of my privacy is punished by the law (UCC 1 1–308–308 1–103 and the Rome Statute)."

or

"For those of you who do not understand the reasoning behind this posting, Facebook is now a publicly traded entity. Unless you state otherwise, anyone can infringe on your right to privacy once you post to this site. It is recommended that you and other members post a similar notice as this, or you may copy and paste this version. If you do not post such a statement once, then you are indirectly allowing public use of items such as your photos and the information contained in your status updates.

PRIVACY NOTICE: Warning— any person and/or institution and/or Agent

and/or Agency of any governmental structure including but not limited to the United States Federal Government also using or monitoring/using this website or any of its associated websites, you do NOT have my permission to utilize any of my profile information nor any of the content contained herein including, but not limited to, my photos, and/or the comments made about my photos or any other "picture" art posted on my profile.

You are hereby notified that you are strictly prohibited from disclosing, copying, distributing, disseminating, or taking any other action against me with regard to this profile and the contents herein. The foregoing prohibitions also apply to your employee, agent, student or any personnel under your direction or control.

The contents of this profile are private and legally privileged and confidential information, and the violation of my personal privacy is punishable by law. UCC 1–103 1–308 ALL RIGHTS RESERVED WITHOUT PREJUDICE.

Wow, sounds like you should post this yourself, like right away. And tons of people did just that. After all, they read it on the Internet, so it must be true. Actually, it's a complete hoax. Placing any of these notices does nothing, other than make some prankster amazed at how viral it's become and how gullible people can be. We love that the notice misspells the International "Berne Convention," spelling it the "Berner Convention."

You simply can't copyright your personal information as these declarations claim. To be copyrighted something has to be a creative output or creation. Simple information, names, titles, personal data, and so on generally cannot be copyrighted. And you can't suddenly abridge a social site's TOS simply by making a declaration. It's their property, their house, their rules. It's like renting an apartment and the landlord specifically tells you, "No pets and especially no dogs except service dogs," and the lease signed by you confirms a no pet policy. Luckily you don't need a service dog but nevertheless you bring home a

Marmaduke look-a-like. So you stand in your apartment and "declare" loudly that you are no longer following the bourgeois landlord and his rules and you hereby declare your apartment the sovereign nation of Meade according to the Constantinople Treaty of 1912 (amended). The Constantinople Treaty of 1912 is as accurate as the Berner Convention.

No one is forcing you to deal with any social media site. As the owners, Facebook, or any other site, can have whatever rules they want. Like having you grant them a license to do all sorts of things with the content you upload. Facebook even controls and uses content you own which you might not realize has value, like what you "like" on their site, what ads you looked at, and who is in your address book. It is hardly a secret that if you look at a Land's End jacket while online, some of your friends will be told about it in the hope they will look at the same item. More clicks, more money for Facebook. And it's not just Facebook. Jack bought a plug-in for Photoshop and that software at

installation asked permission for access to his contacts. Why would a software company want to look at his contact list? Could it be that it's worth big bucks? You think? Jack declined their offer to give up his contacts.

What you can't do is negate any company's "terms of service" (TOS) that you physically approved when you installed the software or when you register to use a social site. The TOS is that page with lots and lots of tiny type. Where you click "approved," you are now legally approving their terms. And, of course, the software will not load and social sites will not let you in, unless you do approve their terms.

★

unless the person(s) involved elects to, in effect, waive their own privilege. For example, the fact that a person was actually at confession and admitting to certain sins at a particular time to a particular priest may serve as the basis for a perfect alibi to a crime he did not commit. A priest, however, can not be forced to violate the sanctity of the confession nor an attorney violate the confidences of their client—with the rare exception that if the advice is sought by someone who is in the process of or intending to commit a crime, then it may not be privileged. These privileged communications are very narrowly drawn. If your state law does not provide for it, you don't have it.

People post things on chat boards, message boards, and elsewhere on the Internet all the time under the false assumption that use and reproduction is restricted to members, and thus privileged or otherwise private. Even if something is password protected and allegedly "private," you might as well post it on a billboard for everyone to see. Photographers will solicit opinions about clients, pricing, and practices while naming names and providing other information making it easy for other readers (including

the very people they are posting about) to identify who the poster is. It's like giving the other team your playbook for the big game.

The New York Bar Association, unsurprisingly, once ruled that it is perfectly ethical for an attorney to access Facebook and similar social network pages to gain information about a party. Opinion 843, handed down by the Committee on Professional Ethics of the New York Bar Association, stated that it was ethically acceptable that "an attorney representing a party in pending litigation may access the public pages of another party's social networking website for the purpose of obtaining information about that party."

In another case in New York (Suffolk County), a judge ruled that what people post on Facebook behind privacy settings can be used as evidence in court. Facebook initially fought a subpoena and refused to produce the sought-after information. The Court ruled that the privacy settings indicated that personal information would be shared with others and, in fact, such was the very reason that Facebook existed and the person posted on it. The "information" sought in that case consisted (in part) of photographs demonstrating the plaintiff enjoying a trip to Florida while at the same time engaging in a lawsuit for personal injuries, which allegedly caused her to be unable to "enjoy life."

These rulings merely substantiate and confirm the warnings we have been issuing for a long time. Litigators always Google everyone involved in any litigation they are about to commence—always. They are hardly alone in this practice. We have advised photographers, illustrators, models, and others that when seeking information or advice in a non-privileged setting not to use real names or disclose sufficient facts to reveal to the dumbest among us just who is being talked about. Or it can come back and bite you in the wallet.

★

Our Last Word on Various TOSs

We both debated about reproducing a lot of TOS terms from various sites. The problem we've run into is that most of them get changed more often than our wives change their minds. Let's just say we can't keep up with either, so any TOS we would write about, would be outdated before our manuscript gets to the printer. Best practice would be for you to carefully read the TOS and pay close attention to the rights sections. Buyers and users beware.

★

The following are basic forms to get you started and to help you think about the paperwork you should have for various situations. As always, best to consult with a local lawyer familiar with intellectual property law.

Whenever possible it is a good idea to make a photocopy of the model's driver's license or passport and make that copy part of the release. The next best thing is to staple the copy to the release. Give the model both a copy of the release and of the driver's license or passport. Volunteer to cross out some of the numbers on the license or passport if the model is reluctant about you having a "complete" copy of their identification.

LIMITED MODEL RELEASE

Dated: _____

I give _____ ("Photographer") and his/her designees and those acting with Photographer's authority or permission to use the photographs created or made on _____ for the sole purpose of fine art gallery shows and exhibits, photography books, and for use in photographer's portfolio, self-promotion, lectures, and books.

I waive any right to inspect or approve the finished images, or other printed matter that may be used in connection therewith. Except as stated above, I do not give permission for the use of my name or said photographs for the purpose of advertising or endorsing any goods or services.

Model acknowledges that he/she has read this release and has received a copy of this release.

_____ _____
Model Name **Model Signature**

_____ _____
Model Address **City, State, Zip Code/Province, Postal Code**

_____ _____
Model ID (Driver's License # or Passport #) **Model Email Address**

_____ _____
Witness Signature **Print Witness Name**

_____ _____
Witness Address **City, State, Zip Code/Province, Postal Code**

STANDARD MODEL RELEASE

Dated: _____

1. I irrevocably and absolutely consent to the unrestricted use by _____ and his/her/its successors, assigns, and designees ("Photographer"), and those acting with his/her/its permission and authority of any and all photographic or other images ("Images") of me that Photographer creates/created or makes/made on _____
for all purposes, in any form, and in any and all media, including, without limitation, advertising, solicitation, stock photography, or trade, to copyright same in Photographer's own name or any other name that he/she/it may choose, and the right to use my name in connection therewith if Photographer so chooses.

2. I waive any right to inspect or approve the finished Images, advertising copy, accompanying text, or any other printed or visual matter that may be used in conjunction therewith, or to inspect or approve any version of any use(s) to which the Images may be employed or used in conjunction therewith.

3. I release and discharge Photographer and those acting under his/her/its authority from any and all liabilities, claims and demands arising out of or relating to any blurring, distortion, or alteration, whether intentional or otherwise, that may occur or be produced in connection with the Images, or in connection with any processing, alteration, transmission, display, or publication of the Images.

4. Model represents that he/she is not affiliated with any model agent or agency and has made no other agreement, whether written or oral, pertaining to the creation, use or publication of any of the Images.

5. Model acknowledges that he/she has read this release, understands the terms and conditions contained in it, and has been given a copy of it. Model further acknowledges that Photographer, as defined herein, relies on the accuracy of Model's representations.

_____ _____
Model Name **Model Signature**

_____ _____
Model Address **City, State, Zip Code/Province, Postal Code**

_____ _____
Model ID (Driver's License # or Passport #) **Model Email Address**

_____ _____
Witness Signature **Print Witness Name**

_____ _____
Witness Address **City, State, Zip Code/Province, Postal Code**

Note on this release, #4 is for independent models (or just regular people), those not with an agent or agency. If the model is with an agent or agency, simply remove or cross out this item.

SIMPLIFIED ADULT RELEASE

Dated: _____

With respect to the photographs that _____ ("Photographer") has taken of me on/about this date or in which I may be included with others, the undersigned hereby gives Photographer and his/her successors, assigns, and designees and those acting with his/her permission and authority the absolute and irrevocable right and permission,

(a) To copyright same in Photographer's own name or any other name that he/she may choose;

(b) To use, re-use, publish and re-publish the same in whole or in part, individually or in conjunction with other photographs, in any medium and for any purpose whatsoever, including (but not by way of limitation) illustration, promotion, advertising, trade, and use in DVDs and instructional materials.

(c) To use my name in connection therewith if Photographer so chooses.

Model hereby releases and discharge Photographer and those acting under his/her authority from any and all liabilities, claims and demands arising out of or relating to any blurring, distortion, or alteration whether intentional or otherwise, that may occur or be produced in connection with the Images, or in connection with any processing, alteration, transmission, display, or publication of the Images.

This authorization and release shall also enure to the benefit of the legal representatives, licensees and assigns of Photographer as well as, the person(s) and/or entities for whom Photographer took the photographs. Photographer agrees to provide at his/her sole cost and expense, prints and/or digital images of photos incorporating my image the number and format of which shall be at his sole discretion.

This Agreement constitutes the sole, complete and exclusive agreement between Photographer and me regarding the Images and I am not relying on any other representation whether oral or written.

I model am over the age of twenty-one. I have read the foregoing and fully understand the contents thereof. I acknowledge that I have received the copy of this release.

_____ _____
Model Name **Model Signature**

_____ _____
Model Address **Date**

_____ _____
Model ID (Driver's License #, Passport, etc.) **Model Email Address**

_____ _____
Witness Signature **Witness Address**

_____ _____
Witness Name (Print) **Witness Email Address**

This model release, which uses the word "simplified" in the title, provides slightly alternative wording to the "standard release." Having the word "simplified" gives you a psychological advantage. That one word added in the title, makes your subject more likely to sign the release feeling that this is a simpler "less legal" version of a model release. Either this simplified release or the standard release is good to use.

MODEL RELEASE FOR STOCK PHOTOGRAPHY

Dated: _____

1. I irrevocably and absolutely consent to the unrestricted use by _____ and his/her successors, assigns, and designees ("Photographer"), and those acting with its permission and authority of any and all photographic or other images ("Images") of me that Photographer creates/created or makes/made on _____, for all purposes, in any form, and in any and all media, including, without limitation, advertising, solicitation, stock photography, or trade, or trade, to copyright same in Photographer's own name or any other name that he may choose, and the right to use my name in connection therewith if Photographer so chooses.

2. I waive any right to inspect or approve the finished Images, advertising copy, text, or other printed matter that may be used in conjunction therewith, or to inspect or approve the eventual use(s) to which the Images may be applied.

3. I release and discharge Photographer and those acting under its authority from any and all liabilities, claims and demands arising out of or relating to any blurring, distortion, or alteration whether intentional or otherwise, that may occur or be produced in connection with the Images, or in connection with any processing, alteration, transmission, display, or publication of the Images.

4. This Agreement constitutes the sole, complete and exclusive agreement between Photographer and Model regarding the Images and Model is not relying on any other representation whether oral or written.

5. Photographer will pay Model 10% of the net license fee actually received by Photographer in connection with the commercial use of any Image, provided I am recognizable in the end use of the Image. All payments will be made quarterly. If more than one recognizable person appears in connection with the use of any Image, the royalty payment to me shall be apportioned on a pro rata basis between such recognizable persons. Model acknowledges that he/she has read this release and has received a copy of this release.

_____ _____
Model Name **Model Signature**

_____ _____
Model Address **City, State, Zip Code/Province, Postal Code**

_____ _____
Model ID (Driver's License # or Passport #) **Model Email Address**

_____ _____
Witness Signature **Print Witness Name**

_____ _____
Witness Address **City, State, Zip Code/Province, Postal Code**

Note that this is not a regular release. This release may be used for those situations where the photographer and model work on a "spec" job typically intended for stock photography. If the images are eventually licensed, the model will receive some money. This possibility of future payment will often be enough to induce a model to participate in a shoot where he/she will not be receiving any money up front.

MODEL RELEASE: MINOR

Dated: _____

1. I irrevocably and absolutely consent to the unrestricted use by _____ and its successors, assigns, and designees ("Photographer"), and those acting with its permission and authority to use any and all photographic or other images ("Images") of me that Photographer creates/created or makes/made on _____, for all purposes, in any form, and in any and all media including, without limitation, advertising, solicitation, stock photography, or trade, or trade, to copyright same in Photographer's own name or any other name that he may choose, and the right to use my name in connection therewith if Photographer so chooses.

2. I waive any right to inspect or approve the finished Images, advertising copy, text, or other printed matter that may be used in conjunction therewith, or to inspect or approve the eventual use(s) to which the Images may be applied.

3. I release and discharge Photographer and those acting under its authority from any and all liabilities, claims and demands arising out of or relating to any blurring, distortion, or alteration whether intentional or otherwise, that may occur or be produced in connection with the Images, or in connection with any processing, alteration, transmission, display, or publication of the Images.

4. This Agreement constitutes the sole, complete and exclusive agreement between Photographer and Model regarding the Images and Model is not relying on any other representation whether oral or written. Model acknowledges that he/she has read this release and has received a copy of this release.

_____ _____
Model Name **Date**

_____ _____
Model Date of Birth **Social Security Number**

_____ _____
Model Address **City, State, Zip Code/Province, Postal Code**

** If model is a minor, parent or guardian must sign below:

I, the undersigned, being parent or legal guardian of the minor whose name appears above, hereby consent to the foregoing conditions and warrant that I have the authority to give such consent.

_____ _____
Parent/Guardian Signature **Parent/Guardian Signature**
(circle appropriate designation) (circle appropriate designation)

_____ _____
Parent/Guardian Address/Phone **Date**

_____ _____
Witness Signature **Witness Address**

325

CELEBRITY RELEASE

Dated: _____

 As a subject to be photographed by _____, I hereby give _____ the photographer, his legal representatives, assigns, and his/her authorized agent the unconditional right to present any and all images taken on this date(s) _____in the photographer's personal portfolio or self promotional materials, in exhibitions, in galleries and/or museums, and to publish and republish my image and name worldwide in periodicals, books, and the following additional uses:

_____, _____, _____.

 This release does not grant to _____ legal rights to use images from this shooting for advertisement purposes (unless set forth above) without signed written permission from me or my legal representative or my agent.

By signing below I acknowledge that: I have had sufficient time to consult with my manager or agent or legal representative regarding this release, understand and agree to its terms and have received a signed copy of this release.

_____ _____
Celebrity Name **Celebrity Signature**

_____ _____
Agent/Representative **Date**

_____ _____
Agent/Representative Email **Agent/Representative Phone #**

_____ _____
Witness Signature **Witness Address**

_____ _____
Witness Name **Witness Email Address**

Some celebrities are reluctant to provide personal information like phone numbers or email addresses. No problem. Simply have a line(s) with the name, address, phone number and email of their agent or manager.

YOUR LOGO OR LETTERHEAD SHOULD GO HERE

PROPERTY RELEASE

Dated: _____

1. I irrevocably and absolutely consent to the unrestricted use by _____ and his/her successors, assigns, and designees ("Photographer"), and those acting with its permission and authority to use any and all photographic or other images ("Images") of the property that Photographer creates or makes, in whole or in part, individually or in conjunction with other photographs, for all purposes, in any form, in any and all media, including, without limitation, advertising, solicitation, stock photography or trade.

2. I waive any right to inspect or approve the finished Images, advertising copy, text, or other printed matter that may be used in conjunction therewith, or to inspect or approve the eventual use(s) to which the Images may be applied.

3. I release and discharge Photographer and those acting under its authority from any and all liabilities, claims and demands arising out of or relating to any blurring, distortion, or alteration whether intentional or otherwise, that may occur or be produced in connection with the Images, or in connection with any processing, alteration, transmission, display, or publication of the Images.

4. I am the legal owner of the property or have the right to permit the making and use of the Images, as provided herein, and represent and warrant that this Agreement shall be binding on any and all successors-in-interest of the Property. I acknowledge that I have received a copy of this release.

5. This Agreement constitutes the sole, complete and exclusive agreement between Photographer and property owner regarding the Images and I am not relying on any other representation whether oral or written.

_____ _____
Owner Name **Owner Signature**

_____ _____
Name/Address of Property **Date**

_____ _____
Owner Email **Phone Number**

_____ _____
Witness Signature **Witness Address**

_____ _____
Witness Name **Witness Email Address**

Property releases are for any type of property including animals, cars, real estate, and so on. While some non-lawyers write that property releases are not needed, we emphasize that they are needed to fully protect yourself.

YOUR LOGO OR LETTERHEAD SHOULD GO HERE

SECOND SHOOTER/WORK FOR HIRE AGREEMENT

Dated: _____

This agreement is by and between _____("IC") and

YOUR NAME GOES HERE doing business at YOUR FULL ADDRESS GOES HERE.

This agreement covers and applies to the submission, preparation and/or creation of any and all photographic images, illustrations, ideas, tangible expressions in whatever medium or media which IC may participate in while performing any tasks for or in connection with YOUR NAME GOES HERE ("Studio") which shall be deemed for all purposes to include its employees, licensees, assigns, clients, customers or any other party or entity including but not limited to YOUR NAME GOES HERE.

_____ acknowledges that he/she is an independent contractor. Any/all work performed by IC while working for, with or in association, under the direction of or with Studio in any form or manner shall be considered a WORK FOR HIRE under The United States Copyright Law (USC Title 17) as it currently exists or as may be amended. All photographs, concepts, ideas, illustrations, electronic files in whatever format and any and all other materials including any derivative work(s)prepared in whole or in part by IC while working in conjunction with and/or under the supervision of Studio shall be deemed the property of Studio. IC shall make no effort of any kind to claim or assert any rights to any of the property under Copyright or other law(s).

IC acknowledges that any and all copyrightable materials created may be subject to and/or included in a formal copyright registration filing made by Studio and that Studio specifically relies on IC's representations in this agreement in making any such registrations and/or transactions relating thereto. Studio is under no obligation to use any works of any kind nor acknowledge IC's participation (if any) in any form whatsoever.

IC represents and warrants to Studio that to the best of his/her knowledge, none of the concepts, images, sketches, illustrations, electronic files and or any other materials supplied by or worked on by IC do not infringe upon any copyright, proprietary rights nor any personal rights of any third party and that IC is free and authorized to enter into this agreement with Studio.

328

IC agrees to fully indemnify Studio from any damages, loss or liability(s) arising out of IC's breach of the terms of this agreement including but not limited to the warranties contained herein. Any proprietary information inclusive of any and all media whether they be trade secrets, negotiations, documents, pricing, correspondence and/or their substantial equivalents had by and between Studio and any/all of Studio's customers, clients, employees and/or independent contractors shall be considered strictly confidential and may not be disclosed to any third party either directly or indirectly.

Any and all controversies and/or disputes arising out of the terms of this Agreement shall be governed by the laws of the State of New York in a court located in the State of New York County of New York or in the United States District Court for The Southern District of New York (OR REPLACE WITH STATES AND COURTS APPROPRIATE TO YOUR BUSINESS) as may be appropriate.

IC acknowledges that he/she has received a copy of this Agreement and will retain such copy in his/her files.

_____ _____
Studio By **Studio Signature**

_____ _____
IC Name **IC Signature**

_____ _____
IC Address **City, State, Zip Code/Province, Postal Code**

_____ _____
IC Phone Number **IC Email Address**

_____ _____
Witness Signature **Print Witness Name**

_____ _____
Witness Address **City, State, Zip Code/Province, Postal Code**

EMPLOYEE NON-DISCLOSURE AGREEMENT

Dated: _____

FOR GOOD CONSIDERATION, and in consideration of being employed (paid or unpaid) by YOUR COMPANY NAME GOES HERE (further named as Company), the undersigned employee hereby agrees and acknowledges:

1. That during the course of my association with the Company there may be disclosed to me certain trade secrets of the Company; said trade secrets consisting but not necessarily limited to:

 (a) Technical information: Methods, processes, formulae, compositions, systems, techniques, inventions, machines, computer programs and research projects.

 (b) Business information: Customer lists, pricing data, sources of supply, financial data and marketing, production, or merchandising systems or plans.

 (c) Creative Material: Images, text or video both published and unpublished.

2. I agree that I shall not during, or at any time after the termination of my association with the Company, use for myself or others, or disclose or divulge to others including future employees, any trade secrets, confidential information, or any other proprietary data of the Company in violation of this agreement.

3. That upon the termination of my employment from the Company:

 (a) I shall return to the Company all documents and property of the Company, including but not necessarily limited to: drawings, blueprints, reports, manuals, correspondence, customer lists, computer programs, and all other materials and all copies thereof relating in any way to the Company's business, or in any way obtained by me during the course of employ. I further agree that I shall not retain copies, notes or abstracts of the foregoing.

 (b) The Company may notify any future or prospective employer or third party of the existence of this agreement, and shall be entitled to full injunctive relief for any breach.

 (c) This agreement shall be binding upon me and my personal representatives and successors in interest, and shall inure to the benefit of the Company, its successors and assigns.

I represent that I am over the age of twenty-one years and that I have read this release and fully understand its contents. I acknowledge that I have received the copy of this release from Company and agree to retain that copy. I acknowledge that permitted users of the image(s) are relying on the accuracy of the representations made by me in this release.

Employee Name	**Employee Signature**
Employee Address	**City, State, Zip Code/Province, Postal Code**
Employee ID (Driver's License # or Passport #)	**Employee Email Address**
Witness Signature	**Print Witness Name**
Witness Address	**City, State, Zip Code/Province, Postal Code**

NON-DISPARAGEMENT AGREEMENT

Dated: _____

1. _____ nor any person or entity acting or speaking on his/her behalf, shall make, or cause to be made, any statement, observation or opinion or communicate any information (whether oral or written) to any person or entity, in words or substance with respect to YOUR NAME, YOUR COMPANY NAME that disparages or is likely in any way to harm the reputation of YOUR NAME or YOUR COMPANY NAME and/or any current or former employee of YOUR NAME or YOUR COMPANY NAME. In the event of a breach of any condition of this agreement, the aggrieved party shall have the right to petition a Court of competent jurisdiction for money damages and/or equitable relief.

2. _____ nor any person or entity acting or speaking on his/her behalf, shall not for a period of _____ days from the date of this agreement whether then in the employ of YOUR NAME and/or YOUR COMPANY NAME or otherwise, hire, solicit, approach, induce or attempt to induce any employee of YOUR NAME or YOUR COMPANY NAME to seek or obtain employment whether on a full or part time basis, from any person and/or entity other than YOUR NAME or YOUR COMPANY NAME

I represent that I am over the age of twenty-one years and that I have read this agreement and fully understand its contents. I acknowledge that others are relying on the representations in this agreement.

_____ _____
Studio By **Studio Signature**

_____ _____
Name **Signature**

_____ _____
Address **City, State, Zip Code/Province, Postal Code**

_____ _____
Phone Number **Email Address**

_____ _____
Witness Signature **Print Witness Name**

_____ _____
Witness Address **City, State, Zip Code/Province, Postal Code**

This agreement helps prevent those 2nd shooters or assistants you hired from undercutting your reputation and/or taking credit for your work as if it were their own. It also helps to prevent them from try to solicit or steal your clients. We still advise to contact a local lawyer to fine-tune this form, as certain terms vary greatly from state to state. Certain states for example, strictly limit the amount of time these agreements can set to prevent such solicitation. Local laws require local lawyers.

Index